WORLD PRESS PHOTO 06

 Thames & Hudson

It took the jury of the 49th World
Press Photo Contest two weeks of
intensive deliberation to arrive at the
results published in this book. They
had to judge 83,044 entries
submitted by 4,448 photographers
from 122 countries.

World Press Photo

World Press Photo is an independent non-profit organization, founded in the Netherlands in 1955. Its main aim is to support and promote internationally the work of professional press photographers. Over the years, World Press Photo has evolved into an independent platform for photojournalism and the free exchange of information.

In order to realize its objectives, World Press Photo organizes the world's largest and most prestigious annual press photography contest. The prizewinning photographs are assembled into a traveling exhibition, which is visited by over two million people in 40 countries every year. This yearbook presenting all prizewinning entries is published annually in six languages. Reflecting the best in the photojournalism of a particular year, the book is both a catalogue for the exhibition and an interesting document in its own right.

Besides managing the extensive exhibition program, the organization closely monitors developments in photojournalism. Educational projects play an increasingly important role in World Press Photo's activities. Seminars open to individual photographers, photo agencies and picture editors are organized in developing countries. The annual Joop Swart Masterclass, held in the Netherlands, is aimed at talented photographers at the start of their careers. They receive practical instruction and professional advice from leaders in the profession.

World Press Photo receives support from the Dutch Postcode Lottery and is sponsored worldwide by Canon and TNT.

World Press Photo of the Year 2005

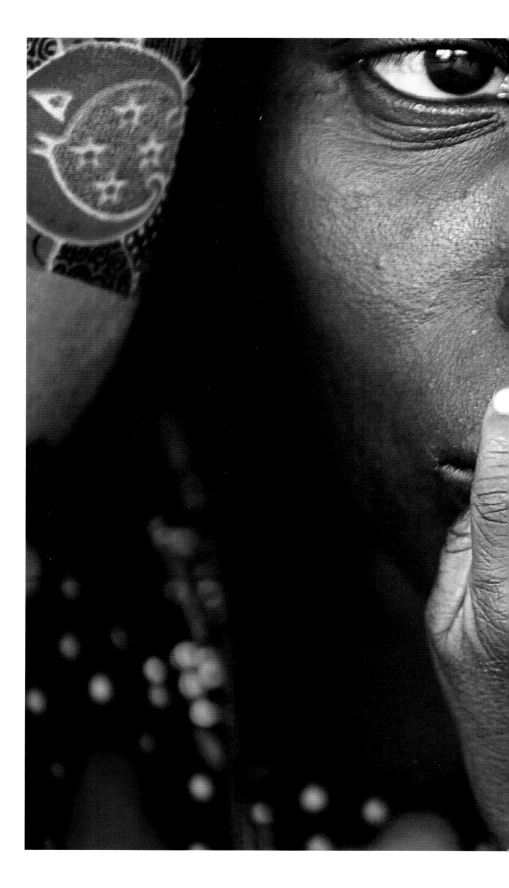

Finbarr O'Reilly
Canada, Reuters
2nd Prize People in the News Singles

The fingers of malnourished one-year-old Alassa Galisou are pressed against the lips of his mother Fatou Ousseini at an emergency feeding center in the town of Tahoua in northwestern Niger, on August 1. One of the worst droughts in recent times together with a particularly heavy plague of locusts had destroyed the previous year's harvest, leaving millions of people severely short of food. Heavy rains promised well for the 2005 crops, but hindered aid workers bringing supplies. Relief had been slow to come. Accusations were leveled variously blaming the United Nations, Western governments, the international aid community and officials in Niger itself for failing to respond early enough to an imminent crisis. Just weeks before the photo was taken leaders at the G8 summit of the world's richest nations had resolved to make poverty history by doubling aid to Africa by 2010.

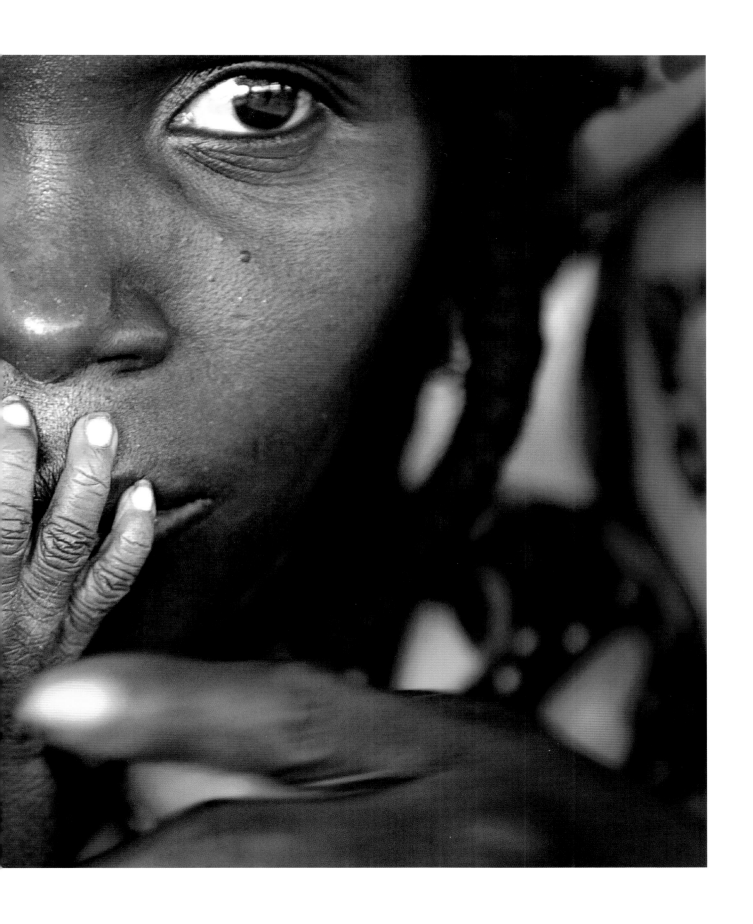

Finbarr O'Reilly started journalism as an arts writer for national newspapers in Canada in 1998. He left North America in 2001 to join Reuters as a freelance text correspondent in Kinshasa, Congo, and spent two years covering Central Africa's Great Lakes region, from Kinshasa and from Kigali in Rwanda. He received a Canadian Award for Excellence in Journalism for a magazine article on Rwanda, and was associate producer of a documentary film on Congo that won a Gold Medal at the New York International Film & TV Festival. He took up photography full time in 2005 and covers West and Central Africa for Reuters. He is based in Dakar, Senegal.

FINBARR O'REILLY

Finbarr O'Reilly

Finbarr O'Reilly, winner of the World Press Photo of the Year 2005, responded to questions about his work.

How did you first become interested in photography?
It was my uncle Michael who really switched me on to looking at the world in a visual way. His way of looking at ordinary things in an unusual way has really pushed me to try and do the same.

How did you become involved in photojournalism?
I started working with Reuters as a text reporter in Congo in October 2001. There was no photographer available to illustrate my stories and since I liked the idea of being a photographer, I tried to supply accompanying photos. They weren't much to begin with because I had only a point-and-shoot camera, not much experience, plus Congo is a difficult place to work as a photographer. But a year or two later while working out of Rwanda, I got a better digital camera and then spent a month travelling around Darfur in Sudan, both writing and photographing the conflict there for Reuters. I noticed that my images were getting more play than my stories and that the message I was trying to convey had more immediate and emotional impact in the form of images. Sometimes stories in Africa are complicated and difficult for an outside audience to grasp, but pictures can quickly drive home what is happening and allow people to relate on a personal level.

When I returned from Sudan and finished my posting based in Rwanda with Reuters text, I began freelancing for the picture desk, working out of Dakar in Senegal covering West and Central Africa.

How do you find being a text-journalist and a photojournalist compare?
In both cases you're trying to tell a story as best you can. You have to do your research, reporting and travelling before you can get the details — whether pictures or quotes — that will provide the meat of the story. When I was writing, I probably had that writer's bias that using words was more cerebral than photography, but now I know that's not the case. You really have to think things through when approaching a story as a photojournalist.

What or who has guided your development as photographer?
I've been lucky to know some excellent photographers who have taught me a lot about the job along the way. My Reuters boss Radu Sigheti and AFP's Marco Longari were instrumental in getting me started. When I asked another photographer friend, Marcus Bleasdale, for some shooting tips, he told me that photography is all about finding relationships between people. That's what I've tried to do.

In terms of subject matter, I've tried not to fall into the stereotype of only portraying Africans as victims. I try to illustrate the richness and diversity of life in the places I visit. Of course we must cover the negative aspects of conflict and poverty in Africa, but we also aim to show the dignity and strength of people living under often trying circumstances. Africa is an amazing place to live and work — frustrating and depressing at times too, but rarely dull.

Can you describe the circumstances that led up to taking the winning photo?
It was around the time of the 2005 G8 Summit and Live 8 concerts, both of which were aimed at focussing the spotlight on African poverty. There was a lot of media coverage of politicians and celebrity musicians in the West, but we heard very little from Africans themselves.

I traveled with Reuters reporter Matthew Green to Niger to report on what turned out to be a dramatic food shortage. Billions of dollars in debt relief were being promised by Western governments, as were millions in future aid, but in the meantime, thousands of children in Niger were starving to death for want of a few cents worth of food.

The picture of Fatou Ousseini and her son Alassa Galisou was taken in an emergency feeding center. There were about a dozen mothers with their severely malnourished infants receiving treatment. Most of the children were dangerously emaciated. I was feverish from food poisoning, so was resting in a chair when I saw Alassa's hand reach up from his mother's lap and rest on her nose. As his hand slid slowly down her face, I shot a few frames and caught his tiny, wrinkled fingers resting on her lips, as you see it in the frame.

What does winning the award mean for you?
Perhaps the most gratifying thing about the award is that it recognizes a picture from Africa. The last time that happened was in 1996. Hopefully the award will help focus some attention on what is happening in Africa and allow me to keep telling important stories from there.

This year's jury.
Front row, from left to right:
Wen Huang, People's Republic of China
Janine Haidar, Lebanon
Paula Bronstein, USA
Eliane Laffont, France
Kathy Ryan, USA
Magdalena Herrera, France/Cuba
James Colton, USA (chair)

Back row, from left to right:
Per Folkver, Denmark
Ricardo Mazalan, Argentina
Simon Njami, Cameroon
Gary Knight, UK
Stephen Mayes, UK (secretary)
Stephan Vanfleteren, Belgium
Greg Marinovich, South Africa

BASTIAAN HEUS/HOLLANDSE HOOGTE

Foreword

We are only temporary inhabitants of this planet of ours and many times we are humbled by forces greater than we can imagine. Last year, the world was once again held hostage by the greatest superpower on earth...Mother Nature. While the people of Southeast Asia were struggling to rebuild their lives after the tsunami, hurricane Katrina slammed into Louisiana and Mississippi and proved just how helpless and unprepared the United States was to respond to such a disaster. A powerful earthquake devastated the Kashmir region leaving tens of thousands dead, and the worst drought in Niger's history left millions of men, women and children without food.

We were also reminded last year that terrorism has not vanished. Man's inhumanity towards his fellow man became evident as suicide bombs killed innocent civilians in London, Baghdad, Beirut and elsewhere. And the continued US-led intervention in Iraq and Afghanistan resulted in many of its young men and women going home to their families...but only in flag-draped coffins.

Throughout all of this, thousands of professional photojournalists put themselves directly into harm's way to bring home the images of these events to better inform the world of the tragedies that are occurring on all of our shores. The power of photography and its lasting impact were clearly seen in this year's contest. Over a two-week period, thirteen judges worked tirelessly into the night to come up with the photographs which are included in this yearbook, a balanced and visually compelling representation of the events of the year past. Provocative images, timeless images, haunting images.

Perhaps most haunting of all was the face of a young mother at a feeding center in Niger as the hand of her one-year-old baby covers her mouth. A photograph that is both simple in its appearance and complex in its meaning. A photograph that asks as many questions as it answers. Some will see helplessness and despair...others will see compassion and hope. The photograph is both beautiful and horrific.

According to relief agencies around the world, a child dies of hunger every five seconds. Ten million people die of starvation every year.... more than Aids, tuberculosis and malaria combined. Finbarr O'Reilly's World Press Photo of the Year is a stark reminder of a story that got very little attention last year. In addition to all of the other natural disasters, famine should never be placed on the back burners of life.

The combined work of the photographers in this year's contest is an acknowledgment that photography is as vital today as it ever was. The images will be filed into the recesses of our brains for future recall along with thousands of others. Icons. Moments. Snapshots. That is the power of photography. It turns history into our own personal photo album.

JAMES COLTON
Chairman of the jury
New York, February 2006

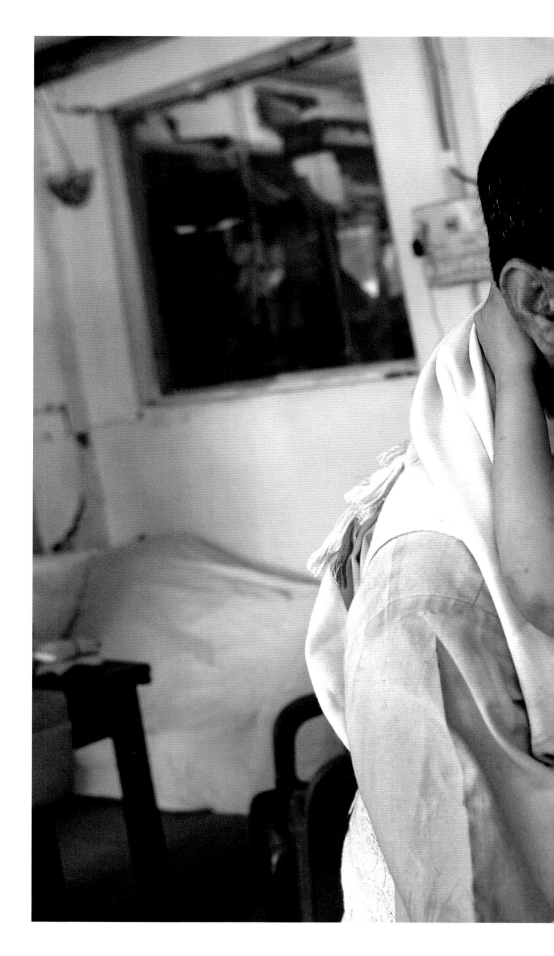

David Guttenfelder
USA, The Associated Press
1st Prize Singles

Sabir Hussein Shah holds his nine-year-old son Zeeshan, who is being treated after having his arm amputated in a field hospital on October 30 in Muzaffarabad, Pakistan. The regional capital was close to the epicenter of an earthquake measuring 7.6 on the Richter scale, which had shaken the area three weeks previously. Around 70 percent of the city's buildings were destroyed. It was estimated that more than half of those injured throughout the region were children, crushed in their classrooms and homes.

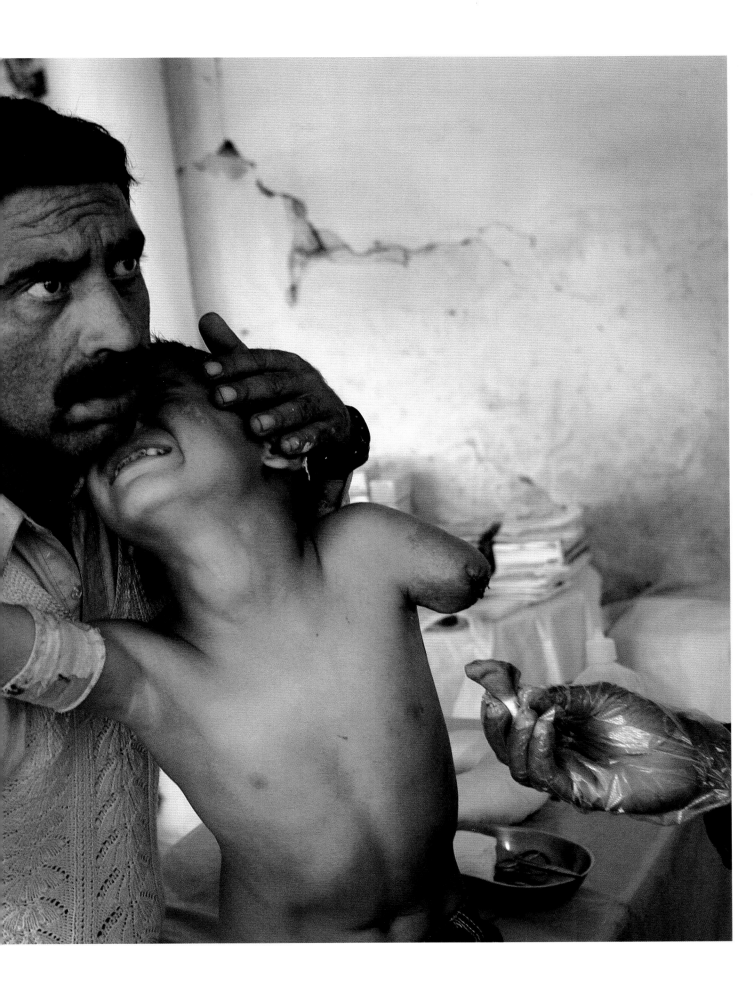

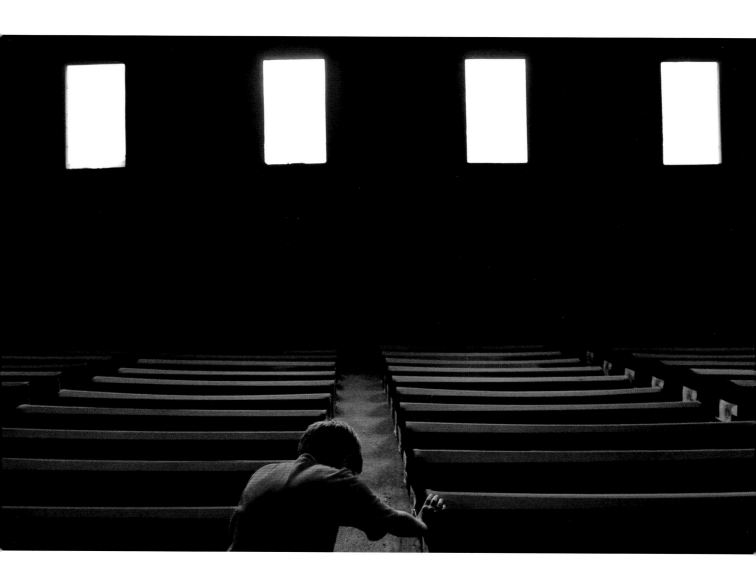

Andrew Testa
United Kingdom, Panos Pictures
for The New York Times
2nd Prize Singles

A Bosnian boy prays over one of the 610 coffins stored at a factory in the village of Potocari in preparation for their burial on July 11, the tenth anniversary of the Srebrenica massacre, when Serbs killed more than 7,000 Muslim men and boys in ambushes and mass executions. The bodies in the coffins laid to rest in the commemoration ceremony ten years later had been exhumed from mass graves, and identified by DNA testing. The search for mass graves is ongoing. Some 1,300 bodies had already been buried at the two-year-old memorial site.

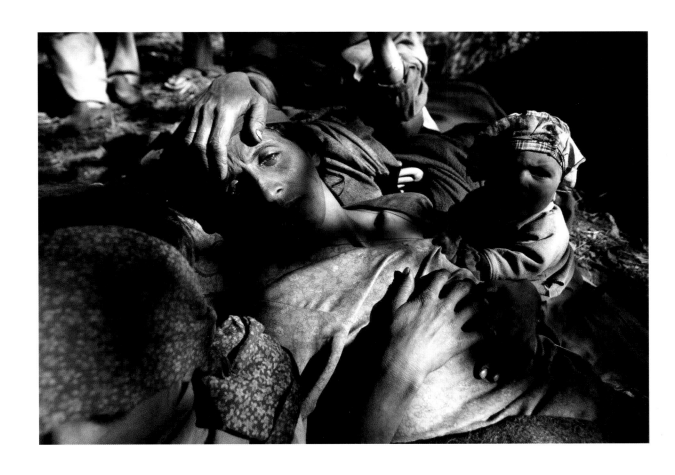

Rafiq Maqbool
India, The Associated Press
3rd Prize Singles

A wounded woman waits for medical help on October 9 outside her collapsed home in the village of Jabala, near Uri, in Indian-controlled Kashmir. All the houses in the village had been damaged by the earthquake, which struck near the Indian-Pakistan border the previous day, causing immense destruction across the region. Emergency services struggled to reach many remote villages in the mountainous terrain, and landslides caused by aftershocks made the situation even more difficult. Early relief efforts were spasmodic, with civilians assisting in efforts by government, the military and aid organizations.

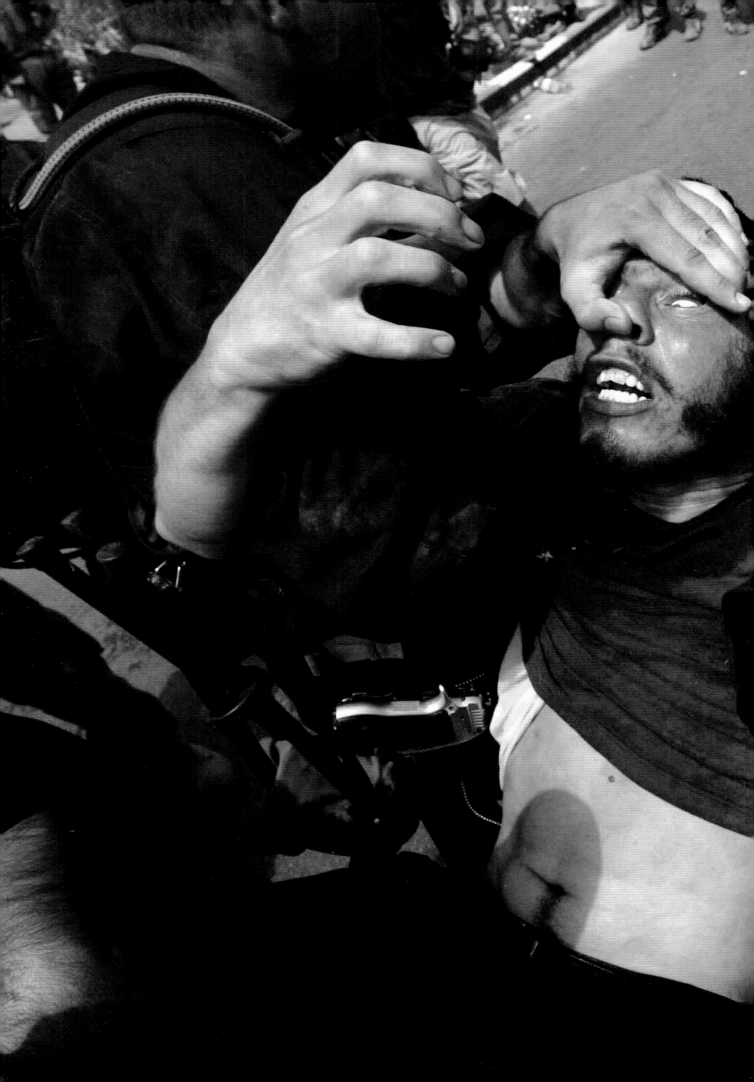

Uriel Sinai
Israel, for Getty Images
1st Prize Stories

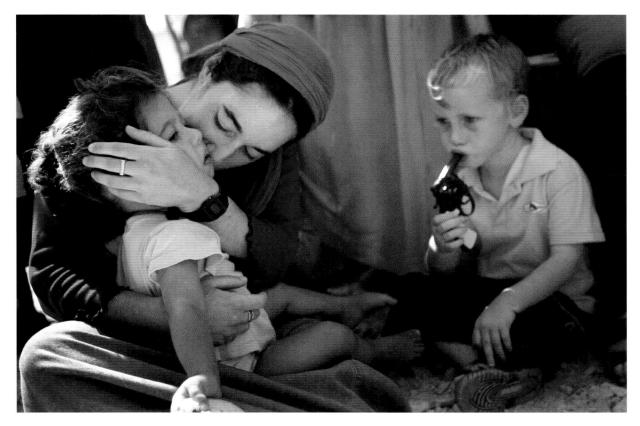

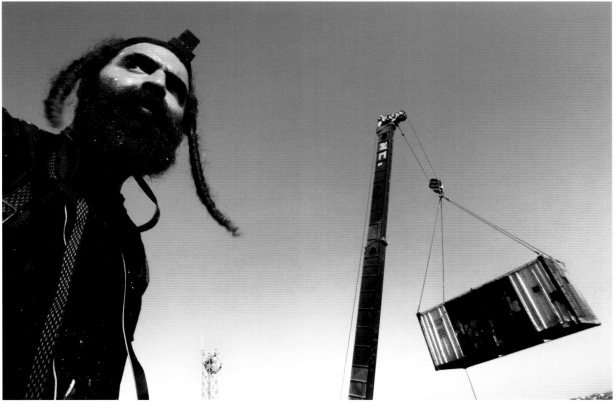

In August, Israel brought to an end its 38-year occupation of the Gaza Strip. Under Israeli prime minister Ariel Sharon's disengagement plan, some 8,500 settlers were withdrawn from land seized during the 1967 Six-Day War. About half the settlers left voluntarily. Those who remained were given until midnight on August 16 before facing forcible eviction by the Israeli army. The hard-liners were joined by supporters from Israel and the West Bank. Previous pages: Soldiers arrest a settler as activists try to prevent the entry of removal containers into Neve Dekalim, the largest settlement, on August 16. Facing page, top: Die-hard settlers wait on August 18 for Israeli soldiers to carry them off the roof of a synagogue in Kfar Darom, where they had positioned themselves in resistance to evacuation. Below: A settler confronts a soldier after hours of resistance on the Kfar Darom synagogue roof. This page, top: Israeli settlers block the road to Shirat Hayam to prevent the arrest of their leader Noam Livnat on July 12. Below: A settler waits for the army to break the blockade of the synagogue roof on August 18.

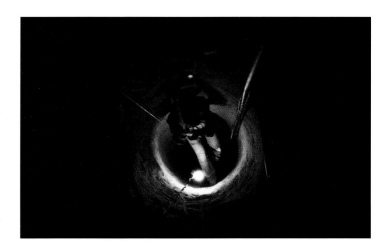
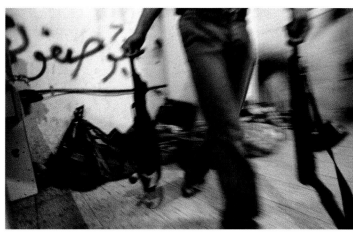
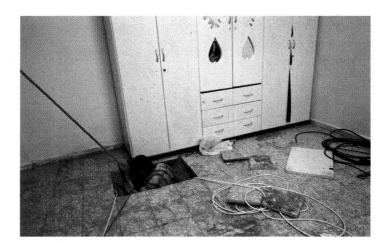
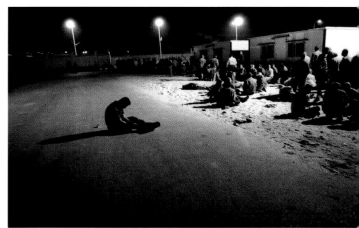

Seamus Murphy
Ireland, for The Sunday Times
Magazine
2nd Prize Stories

Palestinians used a system of tunnels
beneath the Gaza-Egyptian border for
travel and arms smuggling. Both the
Israeli defense force and the
Palestinian police moved to uncover
tunneling activity. Top left:
A Palestinian man lowers himself into
a 12-meter-long shaft leading to a
network of tunnels. Right: Al Aqsa
Martyrs Brigade fighters transport
weapons that have been brought into

Gaza through the tunnels. Below, left:
A man enters the 'eye' to a tunnel,
concealed beneath floor tiles and
covered by a carpet in a girl's
bedroom. Right: A man slumps
exhausted in the middle of the road
after arriving at the Erez checkpoint at
3am, in an attempt to find work in
Israel. Facing page: Boys look down a
shaft in Rafah leading to a tunnel
uncovered by Palestinian police.

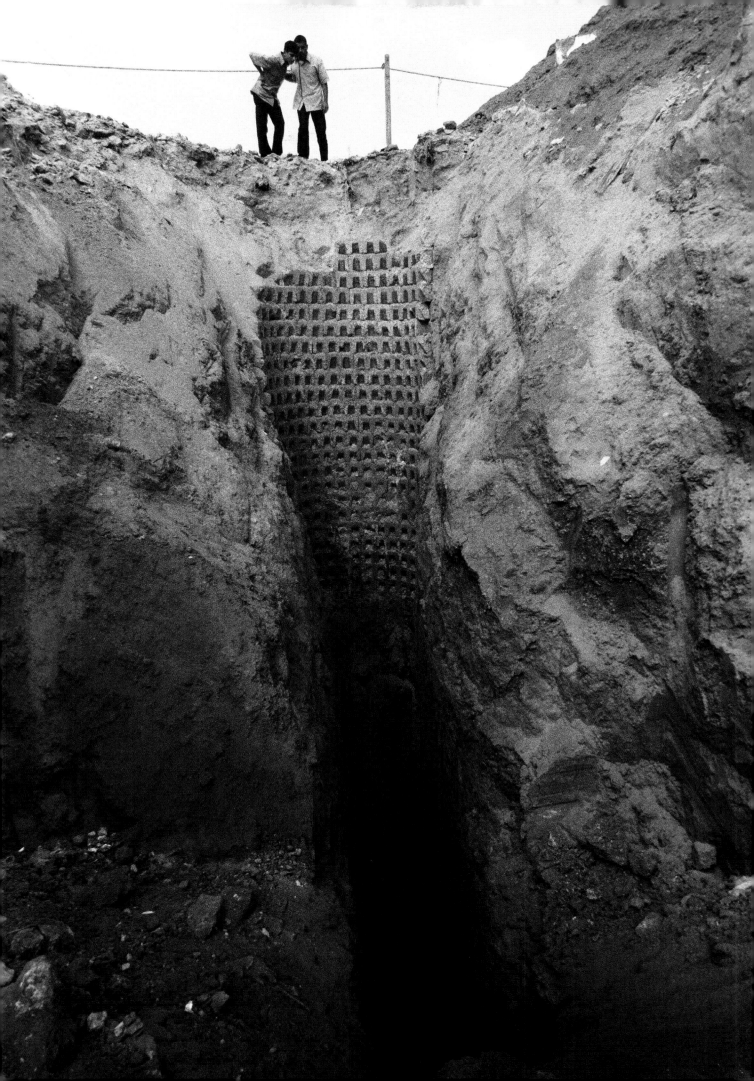

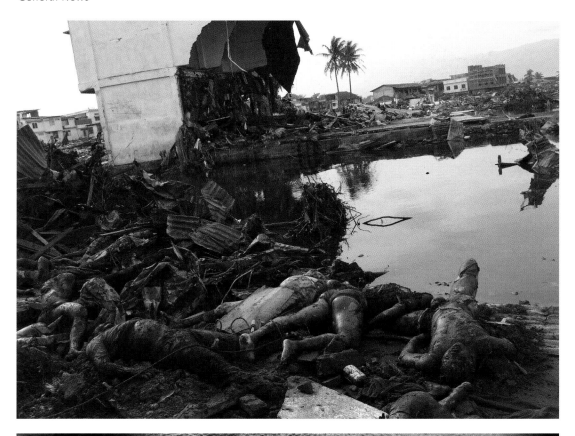

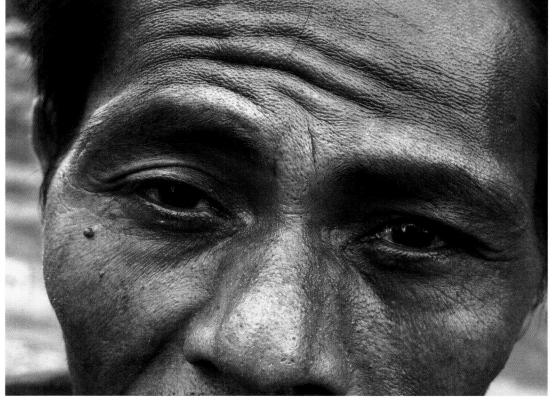

David Butow
USA, Redux Pictures for
US News & World Report
3rd Prize Stories

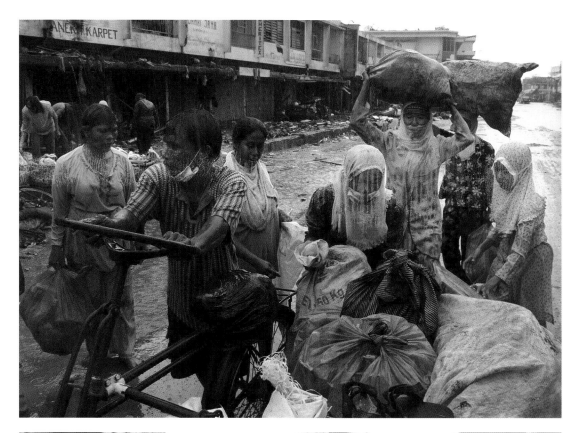

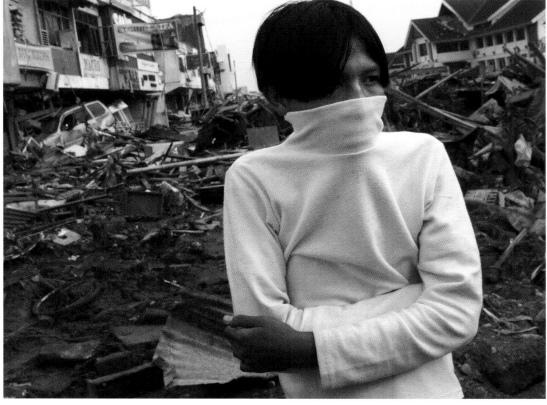

The Indonesian province of Aceh was one of the areas worst affected by the tsunami that followed a massive undersea earthquake in the Indian Ocean on December 26, 2004. Over 70 percent of the inhabitants of some coastal villages in Aceh lost their lives. In Indonesia as a whole more than 110,000 people were killed, and over 800,000 made homeless. Aid agencies faced almost insurmountable logistical problems in their efforts to reach those affected over washed-out roads and bridges. Facing page, top: Victims of the tsunami lie in the ruins of a shopping district in the regional capital Banda Aceh, on January 3. This page, top: A group of people make their way to a shelter after salvaging their belongings, in a commercial district of Banda Aceh on January 9. Below: A man uses his shirt to counteract the stench of rotting bodies over a week after the tsunami hit.

Spot News

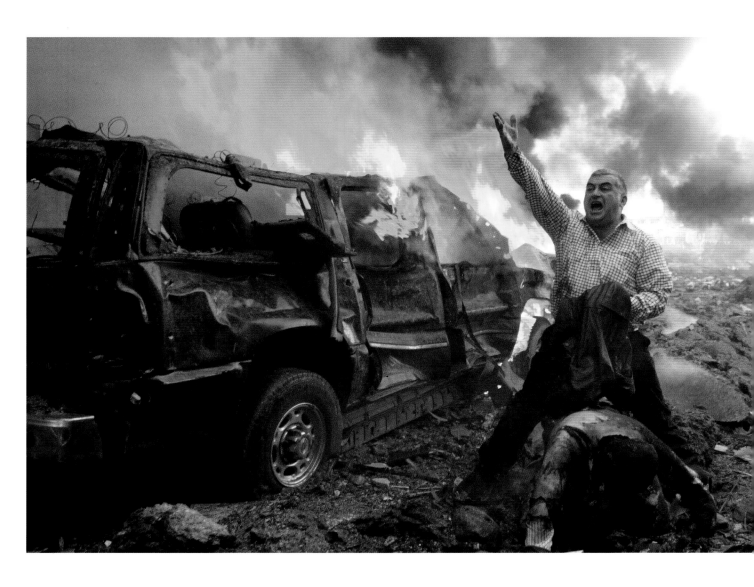

Mohamed Azakir
Lebanon, Reuters
1st Prize Singles

A man shouts for help at the scene of the truck-bomb explosion that killed former Lebanese prime minister Rafik Hariri in Beirut on February 14. Twenty other people were killed in the blast, which appeared aimed at the politician's motorcade. Hariri had resigned as premier to join the opposition four months earlier, and was aiming at making a comeback in May elections. Opposition leaders blamed the Lebanese and Syrian governments for the killing, calling for the government's resignation and the withdrawal of Syrian troops from Lebanon.

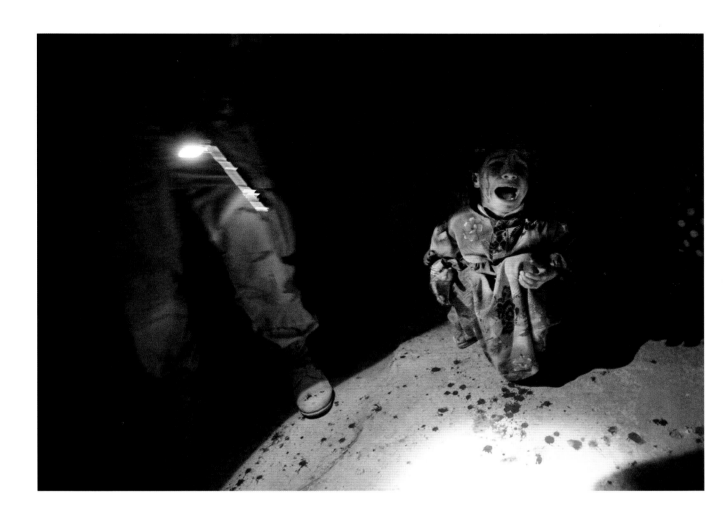

Chris Hondros
USA, Getty Images
2nd Prize Singles

Samar Hassan cries seconds after US troops shot and killed her parents in an incident in Tal Afar in northern Iraq in January. Soldiers opened fire after the car driven by Samar's father failed to stop as it approached their dusk patrol. A US military statement said troops trying to halt the car used hand signals and fired warning shots before firing directly at the car, killing the driver and front-seat passenger. The town had only days before been the scene of a gun battle between US forces and local insurgents. As a defense against car bombs in many cities in Iraq, it had become standard practice for foot patrols to stop oncoming vehicles, particularly after dark. Five of Samar's siblings were in the car with her. All six survived, although her brother Racan was seriously wounded. US soldiers gave the children first aid before taking them to a nearby hospital.

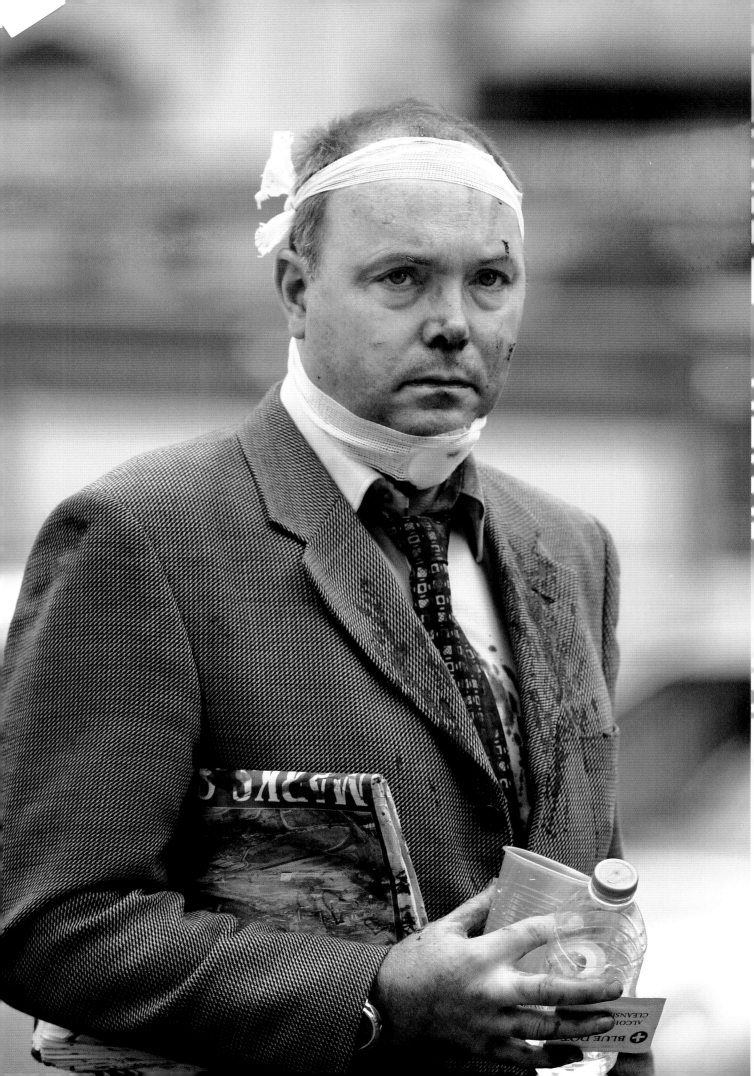

Edmond Terakopian
United Kingdom, Press Association
3rd Prize Singles

A commuter, still clutching his morning newspaper, leaves Edgware Road Underground Station in London after a suicide bombing on July 7. The bomber blew himself up on a train at the station, killing seven passengers. This was one of four coordinated attacks on the transport system during the morning rush hour. Three bombs exploded within 50 seconds of each other on London Underground trains, and a fourth blast occurred on a bus less than an hour later. The explosions resulted in some 700 injuries and 56 deaths, including those of the four bombers. Surveillance video footage showed that the four men had been working together, but the motivation for the bombings was at first unclear. By October investigators were still uncertain as to the background to the plot, though some believed the attacks had been planned by Islamist paramilitary organizations based in the United Kingdom. Later, intelligence services claimed links between the bombers and al-Qaeda.

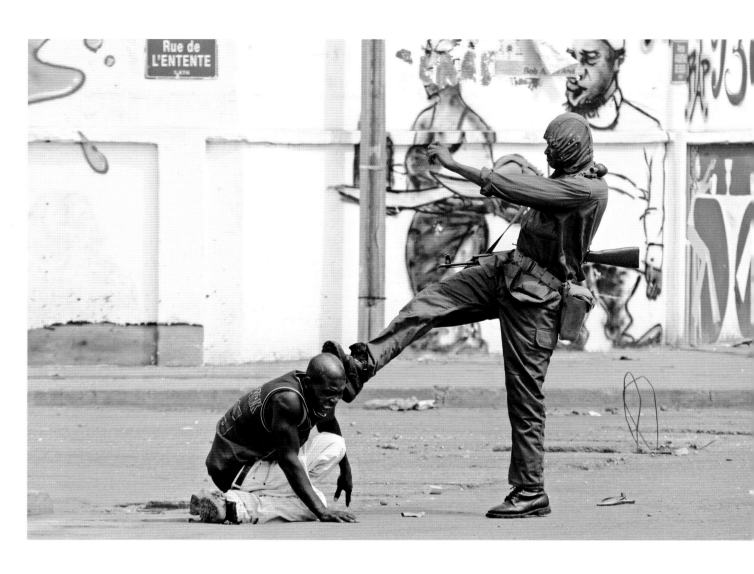

Ben Curtis
United Kingdom, The Associated Press
1st Prize Stories

Faure Gnassingbe, the son of Africa's longest-reigning dictator Gnassingbe Eyadema, was elected president of Togo in April. The military had installed Gnassingbe as president after his father's death in February, in a move described by the opposition and some other African leaders as a military coup. Under strong international pressure, Gnassingbe stepped down and called an election. Opposition members alleged the polls were rigged and organized protests. Within minutes of Gnassingbe being declared winner they rampaged through the streets of the capital Lome, burning barricades and clashing with security forces. This page: A soldier aims a kick to the head of a rioter suspected of looting. Facing page: The mother of a suspected looter wails on the ground while a soldier beats her son. (story continues)

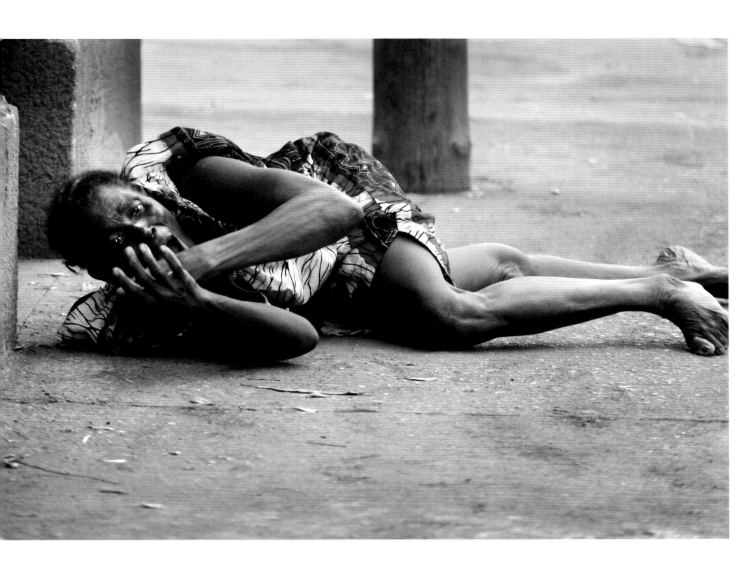

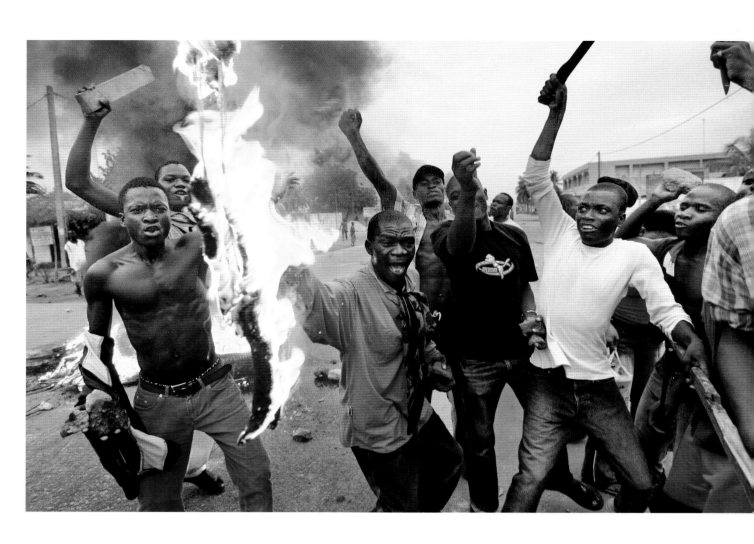

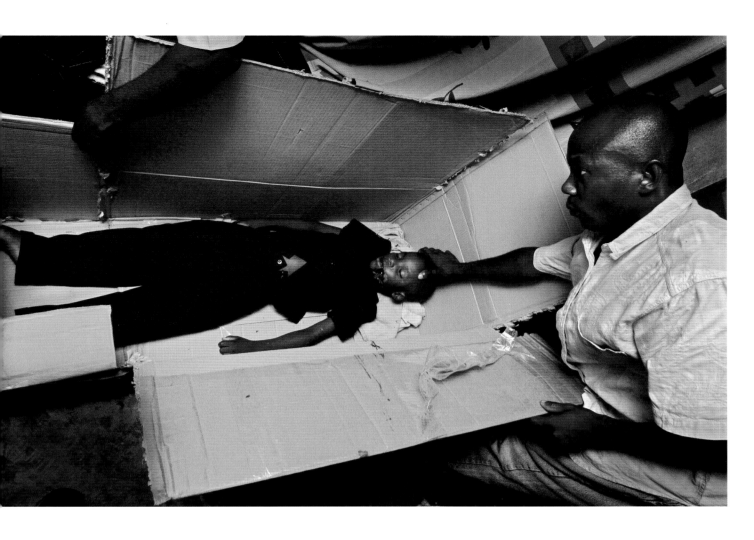

(continued) According to the United Nations, up to 500 people were killed and 40,000 Togolese fled to neighboring countries in violence surrounding the elections. Facing page: Men wielding machetes, sticks and rocks protest near a roadblock of burning tires in Bagida, 15 kilometers from the capital. This page: A man prepares the body of a six-year-old boy for burial in a cardboard coffin, in the mainly opposition Tokoin neighborhood of Lome. According to the boy's father, he was shot by gunmen wearing T-shirts bearing the face of Faure Gnassingbe after they broke into the house at night and began firing at random.

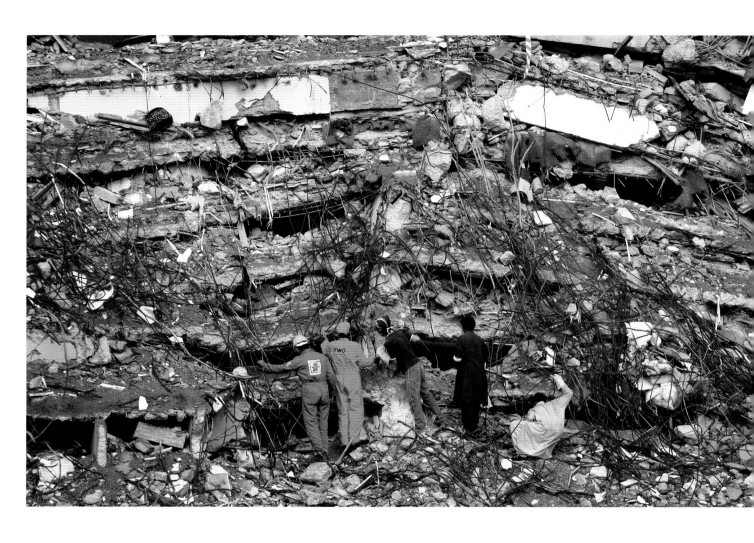

Tomás Munita
Chile, The Associated Press
2nd Prize Stories

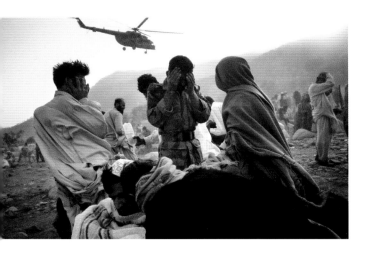

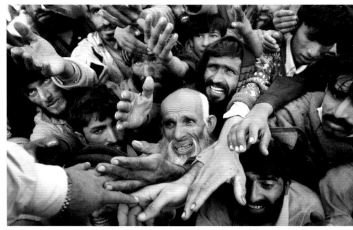

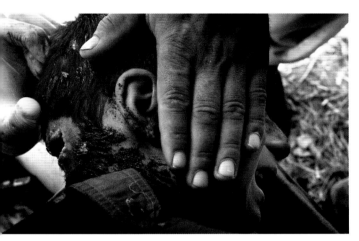

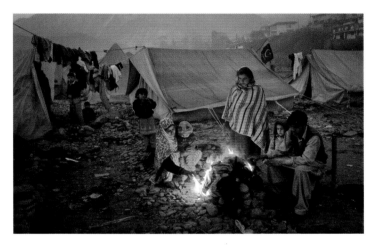

On October 8 an earthquake measuring 7.6 on the Richter scale struck in the Kashmir region of South Asia near the India-Pakistan border. Over 73,000 people in Pakistan were killed and around three million made homeless, with another 1,400 deaths in Indian-administered Kashmir. Many roads were so damaged by the quake that they were impassable for months. Accusations were leveled at both the Pakistani and the Indian governments for a disorganized early response to the disaster, and at Western nations for slowness in coming forward with financial aid. Eventually relief efforts did become more coordinated. International donors pledged some US$ 5.4 billion towards recovery, and India and Pakistan cooperated in unprecedented ways in territory that the two nations had long held in dispute. Facing page: Rescue workers look for survivors in the debris of the Margalla Towers in the Pakistani capital Islamabad. Two apartment blocks in the complex collapsed leaving more than 30 dead. This page, top left: Survivors wait for a helicopter to evacuate them from a field hospital in Balakot, Pakistan, at the epicenter of the quake. Helicopters played a crucial relief role in inaccessible areas, but struggled to keep up with the demand. Right: Earthquake survivors reach for blankets distributed by an NGO in Balakot. Below, left: Six-year-old Asad is treated in a field hospital in Balakot, after his school had collapsed killing around 30 pupils. Right: Kashmiri survivors burn cloth to keep warm in a refugee camp in Muzaffarabad, Pakistan, in December.

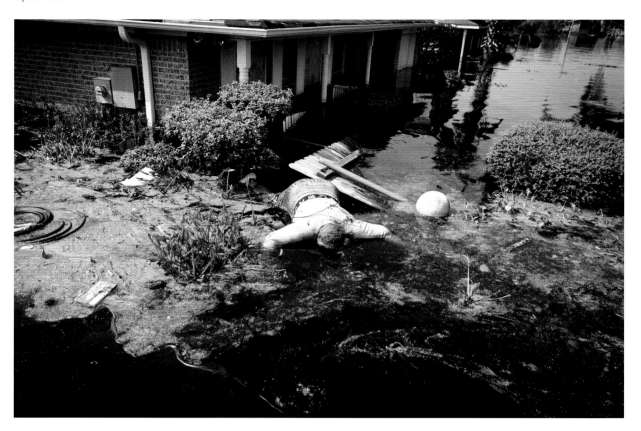

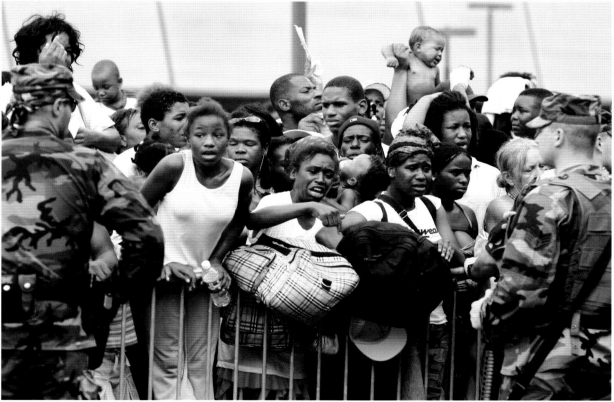

Michael Appleton
USA, New York Daily News
3rd Prize Stories

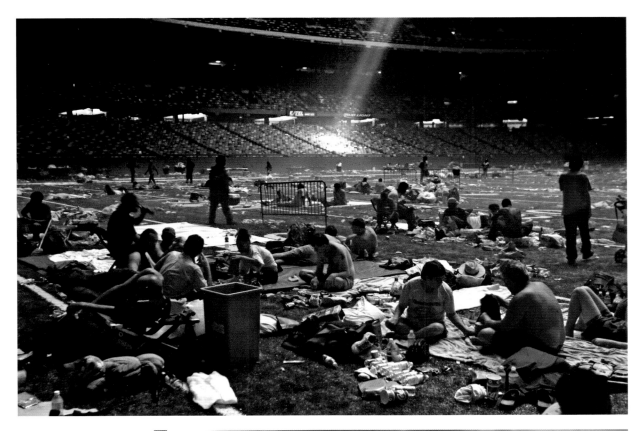

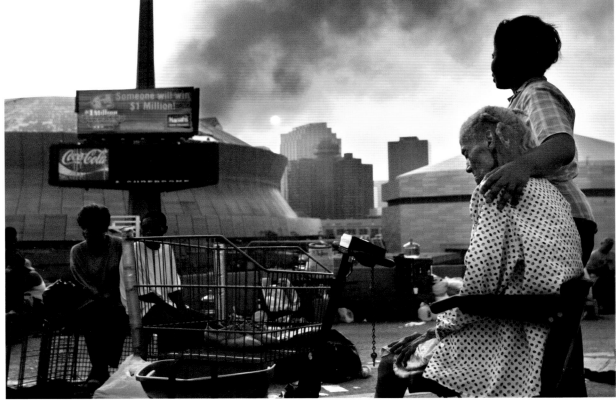

Hurricane Katrina, the sixth-strongest Atlantic hurricane ever recorded, hit the US Gulf Coast on August 29 causing severe destruction. Levees protecting New Orleans were breached, flooding 80 percent of the city. Rescue efforts were delayed and disorganized. One-fifth of the population remained trapped in the city without power, food or drinking water. Some 20,000 people made their way to the city's Superdome, which became increasingly uninhabitable. Facing page, top: The body of a woman floats in polluted floodwaters. Below: Tension mounts as people wait to be evacuated from the Superdome. This page, top: People were left for days in the Superdome, with the final evacuation not fully complete until September 4. Below: Hundreds of residents were stranded on a downtown overpass despite dry passageway out of the city. Following pages: A man watches as fire rages through an affluent New Orleans suburb.

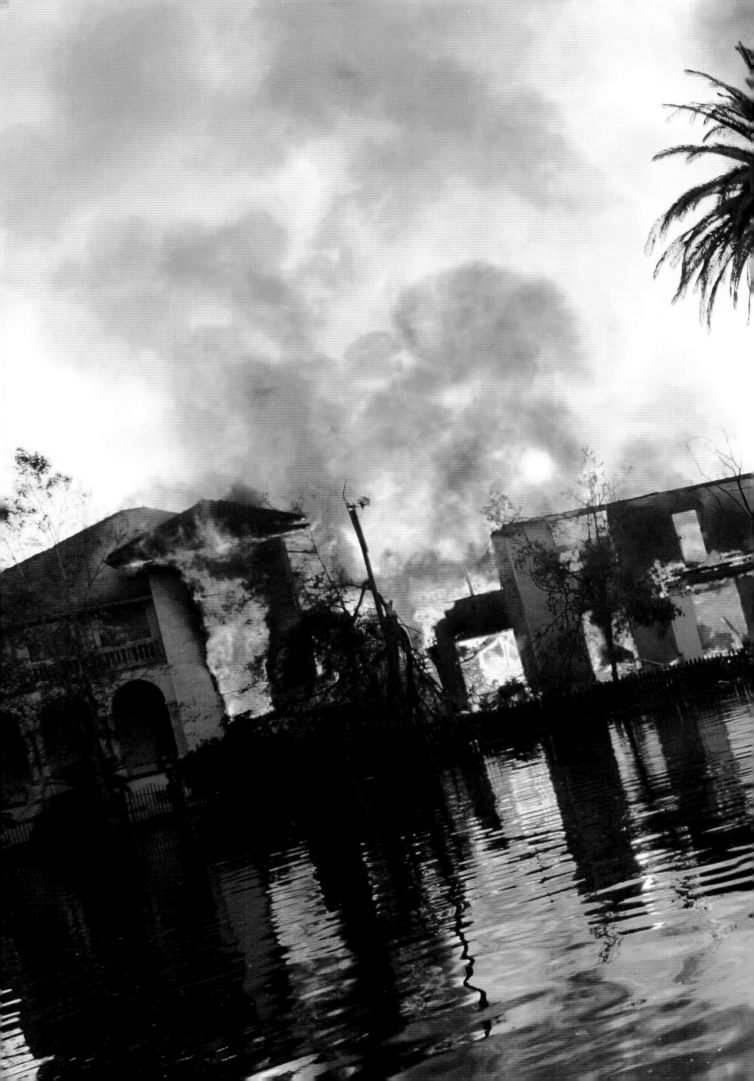

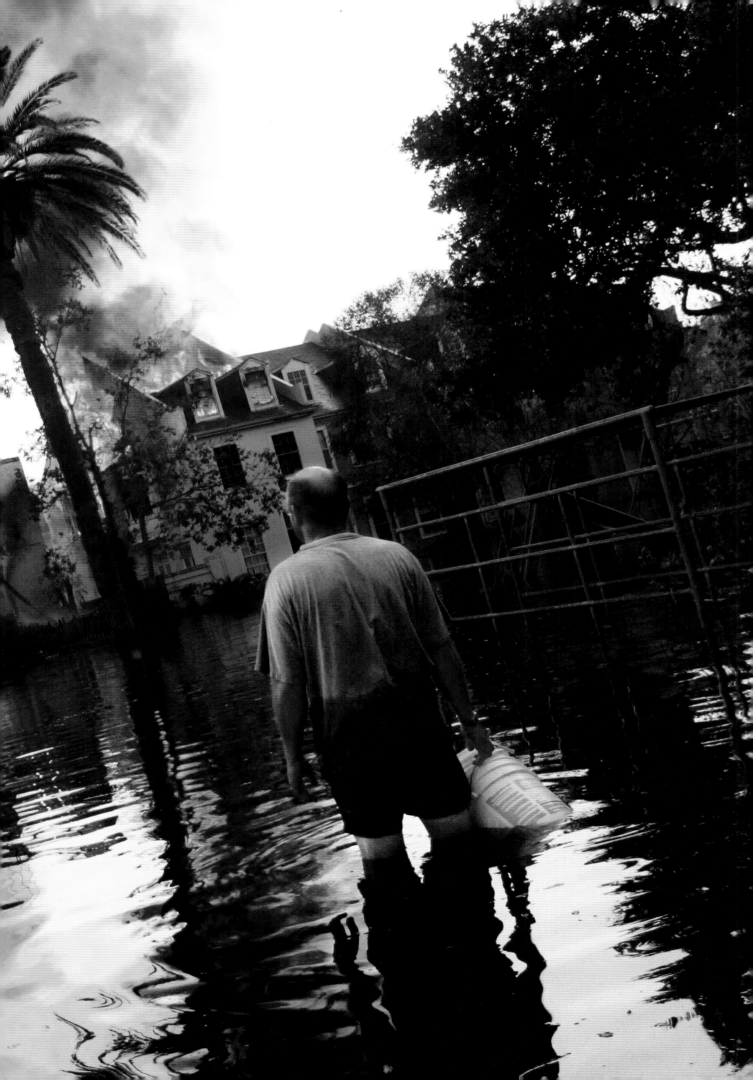

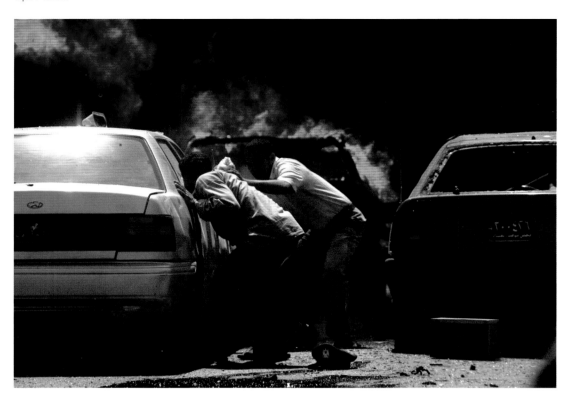

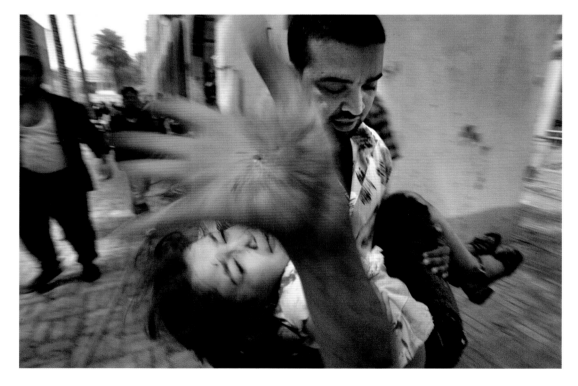

Scott Nelson
USA, for World Picture News
Honorable Mention Stories

On May 7 a suicide car bomb targeting a passing civilian contractor convoy exploded, killing 22 people and wounding more than 35 in a crowded Tahrir Square in central Baghdad. January elections in Iraq did not stem countrywide insurgency, which became increasingly sectarian.

Predominantly Sunni insurgents targeted Shiite and Kurdish civilians in suicide bombings. A Pentagon report said that nearly 26,000 Iraqis had been killed or wounded in attacks by insurgents by October 2005. Facing page, top: Bystanders take cover from the blast and try to push unaffected cars away from the flames. Below: An injured schoolgirl is evacuated from Aqida girls' school near the scene of the blast. This page, top: Five pupils from Aqida girls' school were injured as they were boarding a minibus when the bomb went off. Below: An Iraqi police officer consoles a colleague shortly after the explosion.

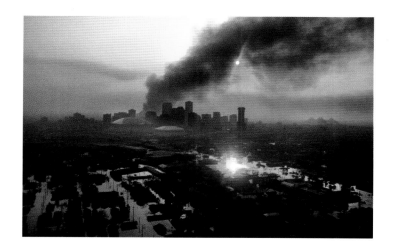

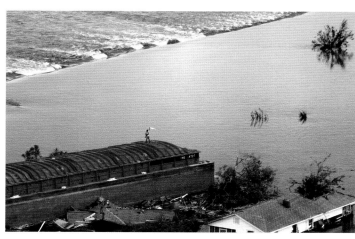

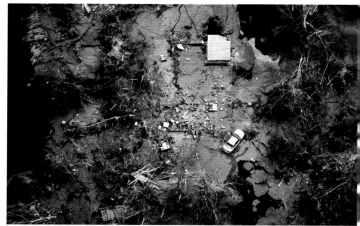

Vincent Laforet
USA, The New York Times
Honorable Mention Stories

When hurricane Katrina made landfall on the US Gulf Coast in August it took 1,417 lives and caused over US$ 75 billion damage, making it the deadliest hurricane for nearly a century and the most expensive natural disaster in US history. More than 1.5 million people were displaced in what became an humanitarian crisis on a scale not experienced in the US since the Great Depression in 1930s. Katrina also caused a political storm, as the chaotic reaction to the catastrophe highlighted a lack of planning and an absence of cooperation between local, state and federal bodies. President Bush, the Federal Emergency Management Agency (FEMA), the Department of Homeland Security, Louisiana's governor, as well as the New Orleans police force and mayor's office all came in for considerable criticism. This page, top left: Smoke rises over downtown New Orleans five days after the hurricane. Right: A hurricane survivor waves a white flag from the roof of a building near the main break of a breached levee. Below, left: Fuel floats on the surface of water flooding a car dealership in New Orleans. Facing page: An empty shopping-center parking lot in Jefferson County.

Nature

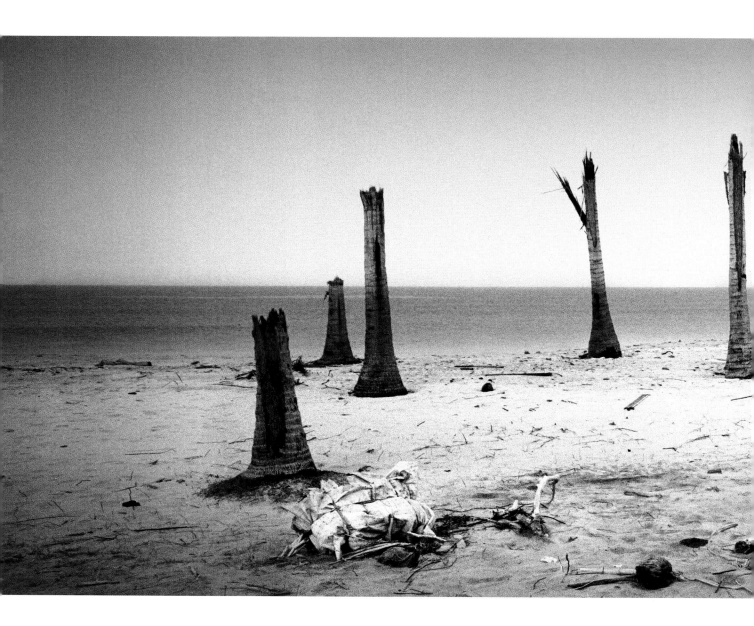

Massimo Mastrorillo
Italy
1st Prize Singles

Destroyed palm trees line Lhoknga Beach near Banda Aceh in Indonesia in February, two months after the massive tsunami that swept over the area. It is estimated that the height of the wave exceeded 15 meters when it hit the shore. Almost all buildings, trees and vegetation around Lhoknga were washed away. Low-lying agricultural land behind the town remained under salt water for four days after the tsunami, with severe consequences for farmers. In places nearly all of the sand on the beach was removed by the wave.

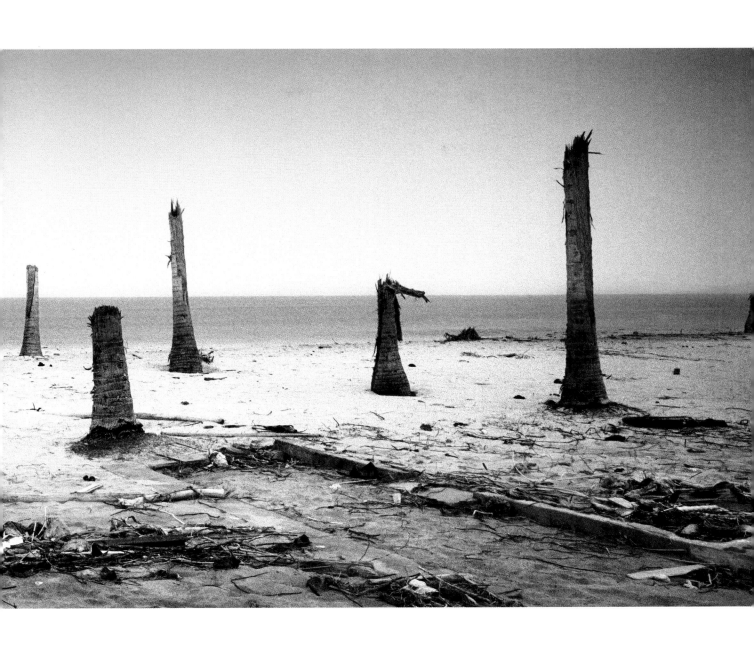

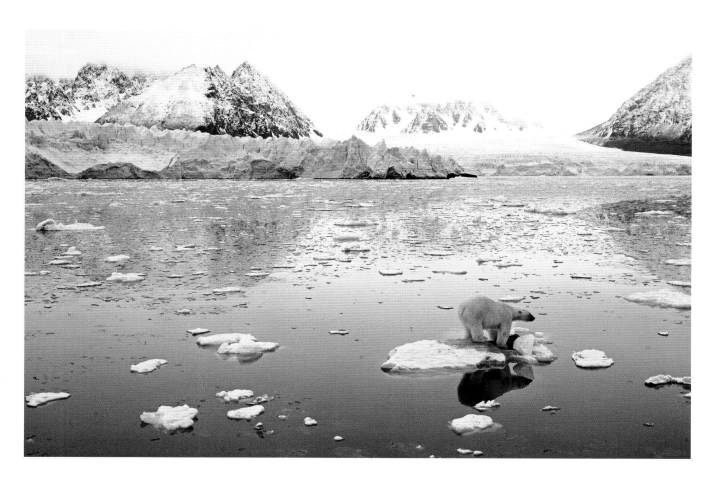

Pål Hermansen
Norway, for Orion Forlag/Getty
Images
2nd Prize Singles

A polar bear eats a seal on an ice flow
near the Monaco glacier on the
northwest coast of Svalbard
(Spitsbergen) in Norway. Polar bears
feed primarily on seals, in the summer
months hunting those basking on ice
flows as they depend on a frozen
platform from which to tackle their
prey. In the summer of 2005 there was
very little ice in the area north of
Svalbard, and the bears congregated
in areas where glaciers reached open
water. Polar bears are a potentially
threatened species. They have been
protected by severe restrictions on
hunting throughout the Arctic since
1973, and the population in Svalbard
has grown from a low of 1,000 to
around 3,000. However, scientists are
now worried about the effects of
pollution and global warming on the
animals' feeding patterns.

Halden Krog
South Africa, Beeld
3rd Prize Singles

A fishing boat lies in the middle of a rice paddy some six kilometers from the coast, near Banda Aceh in Indonesia, weeks after the tsunami struck the region in December 2004. Fishing was an important part of local economies throughout the affected region, and many had their means of livelihood destroyed. Not only were boats wrecked, but marine fish stocks were depleted. Millions of fish were swept ashore by the wave, and others were unable to survive in an ocean where the ecosystem had been severely disrupted.

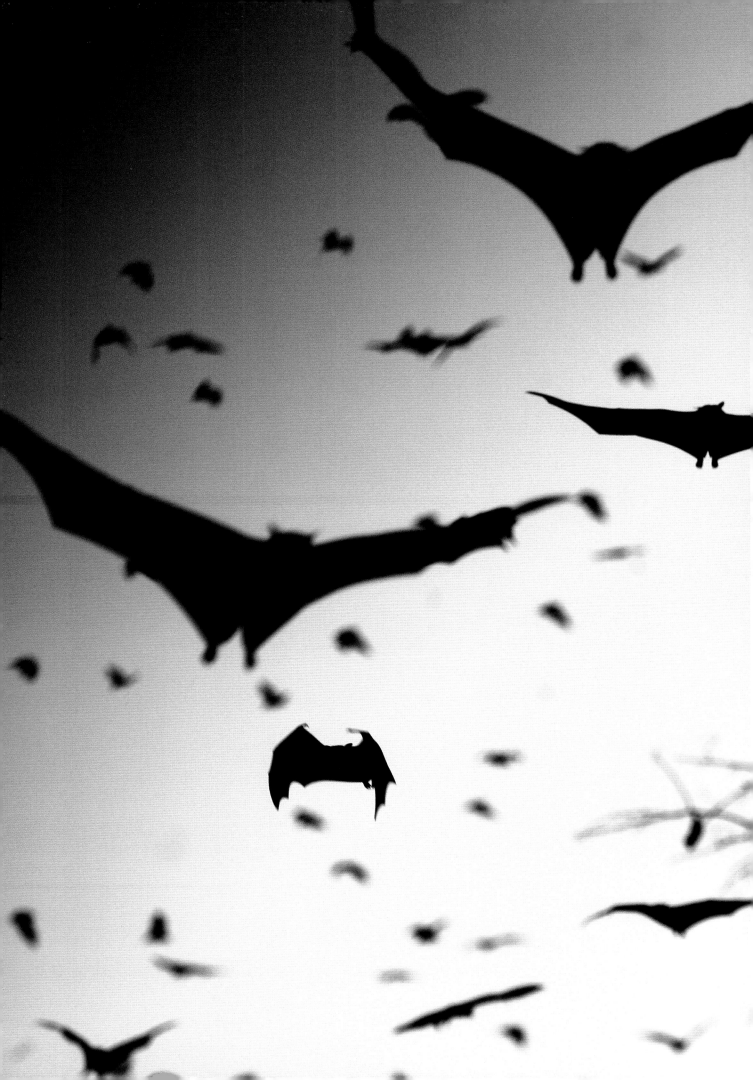

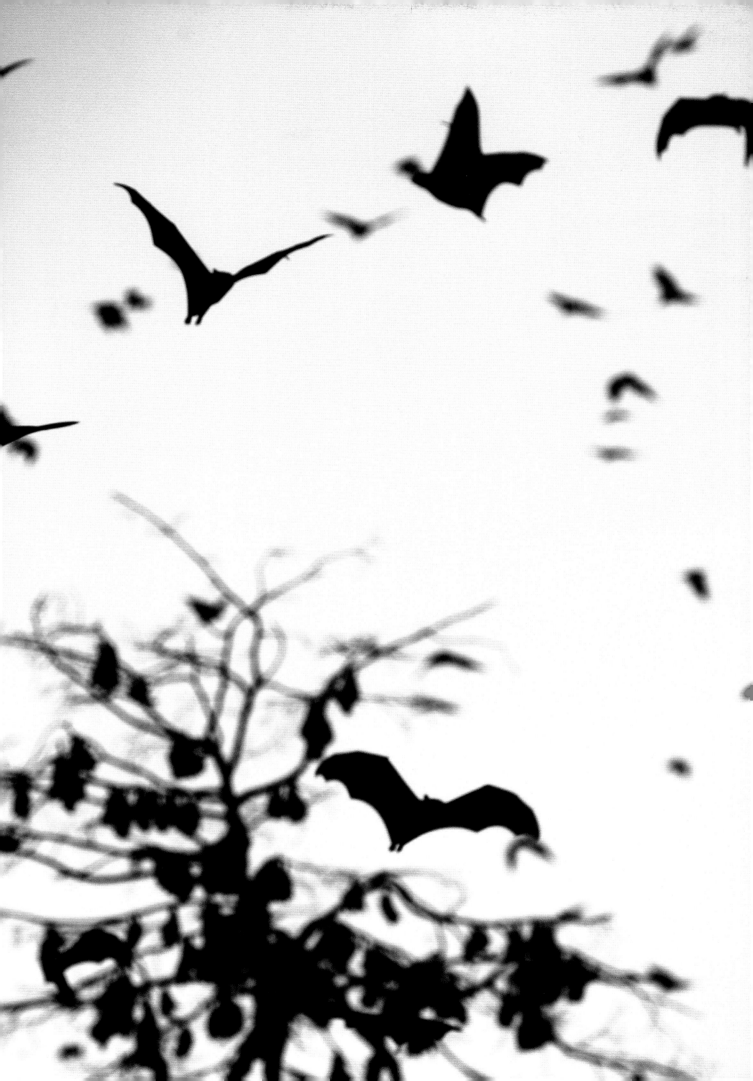

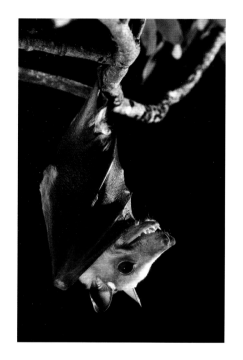

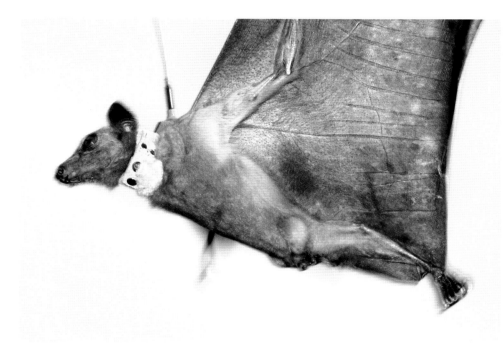

Kieran Dodds
United Kingdom, Evening Times/
The Herald
1st Prize Stories

Every year an estimated eight million straw-colored fruit bats (*Eidolon helvum*) are among the seven different bat species that arrive in the abundant Kasanka National Park in Zambia in October. Despite the scale of the migration little is known about where the bats come from or where they go. Satellite transmitters have been placed on four animals to trace their movements. Early data show that they travel thousands of kilometers after departing Zambia, in search of food. Previous pages: Bats return to roost after a nightly forage, in which they can fly over 100 kilometers and consume twice their body weight in fruit. This page, left: An epauletted fruit bat (*Epomophorus species*) hangs on a branch after being netted by researchers trying to ascertain the bat varieties at Kasanka. Right: Bat "Mercury" flies off after having a transmitter attached. Facing page, top: A branch collapses under the weight of sleeping bats. Bats who together weigh the equivalent of 500 elephants gather in just 15 hectares of land. Below: Thousands of bats swarm above the forest just after sunset. The dispersal takes half an hour each evening.

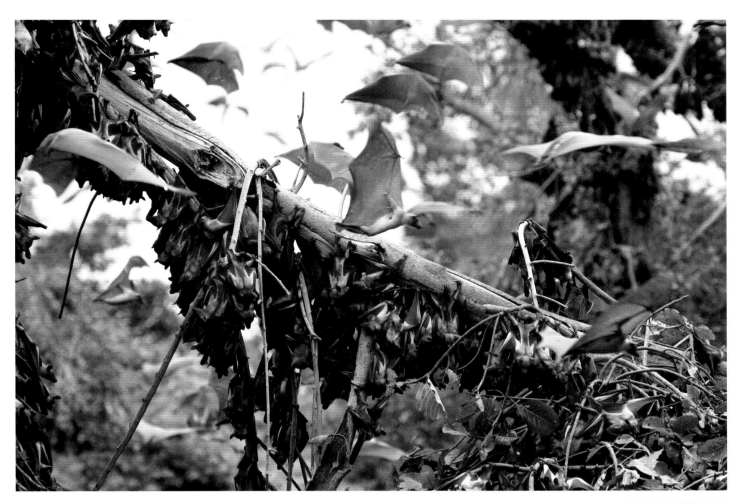

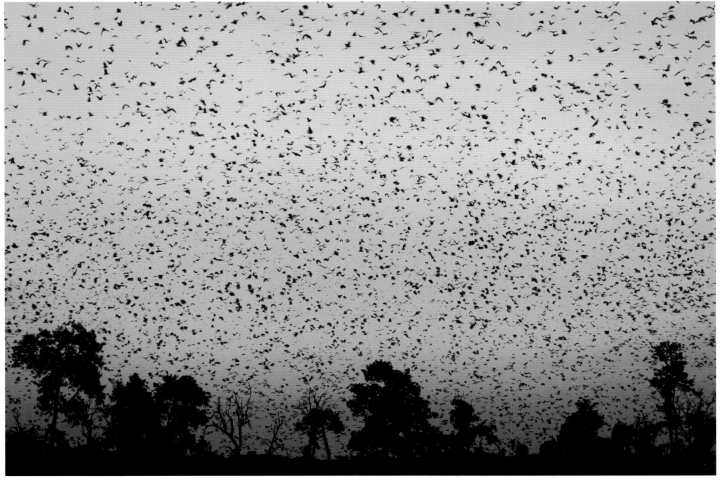

Palani Mohan
Australia, Getty Images
2nd Prize Stories

In contrast to its thriving African cousin, the Asian elephant is imperiled – even in those countries where it is revered to the point of worship.
As the human population spreads, the elephants' natural habitat is destroyed. They are forced onto farmland where they cause damage to crops, and so

are attacked by villagers. Elephants are also captured and put to work in the logging and tourist industries. In Thailand alone, the wild population has declined from 100,000 at the turn of last century to fewer than 1,500 today. This page: A three-year-old elephant in Thailand is led away by his

mahout. Facing page, top left: Wild elephants in Sri Lanka at sunset. Right: Mahouts take their elephants across a river to feed in Thailand. Below, left: An elephant is taken to work on the back of a truck, in Sri Lanka. Right: An elephant peers through the trees in the forests of Nepal.

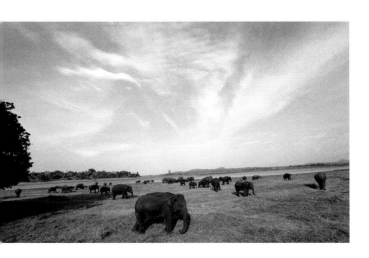

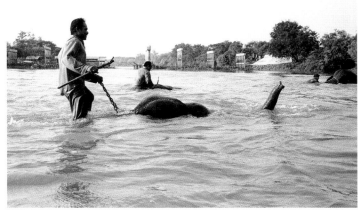

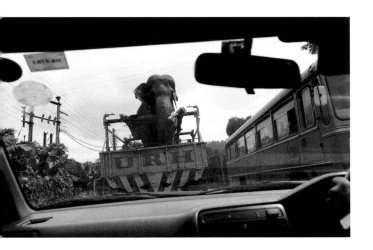

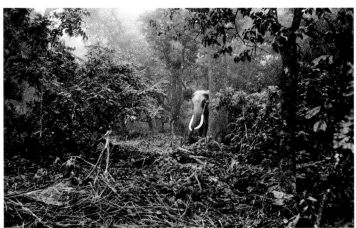

49

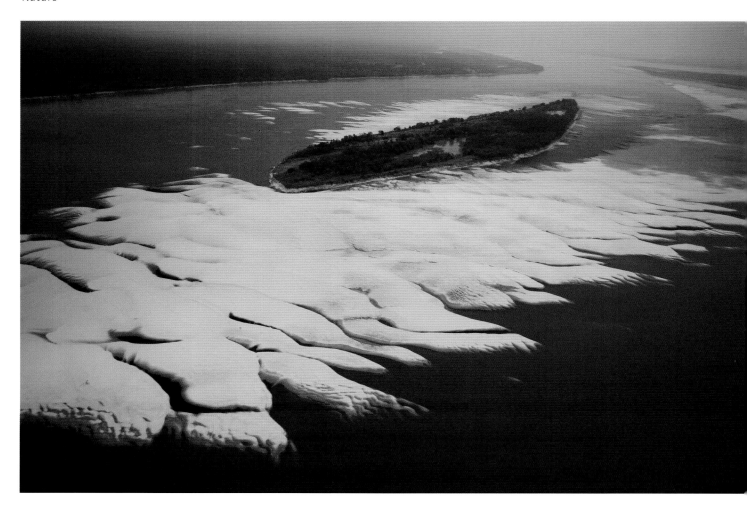

Daniel Beltrá
Spain, for Greenpeace
3rd Prize Stories

The Amazon region experienced its worst drought in many decades. Low water levels stranded river-life and boats. Those communities who relied on river transport were isolated and had to depend on airlifts for supplies. Greenpeace blamed the drought on global warming and deforestation, claiming that forest burning had raised temperatures in the Amazon and prevented cloud formation. Brazilian government meteorologists said the dry weather had been caused by unusually high temperatures in the Atlantic Ocean, and also linked it to the year's devastating hurricanes. This page: Vast sandbanks surround Trindade Island in the Amazon River. Facing page, top: Lake Curuai, part of the Amazon River system, dried up almost completely. Below: A fishing boat is stranded near Manaus, in the central Amazon region.

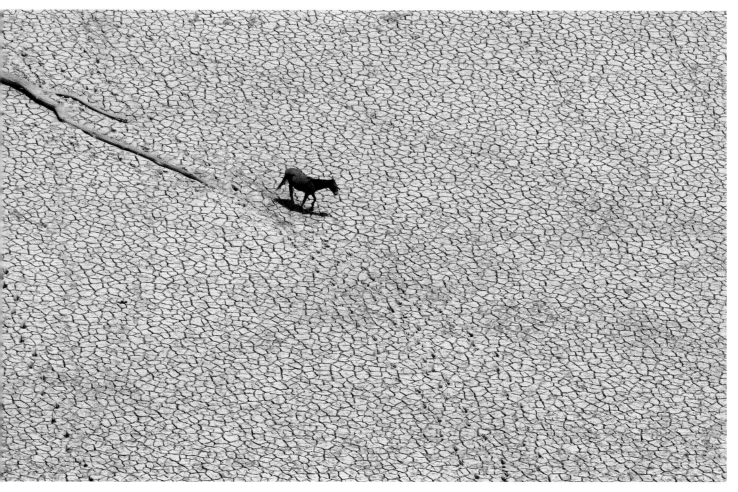

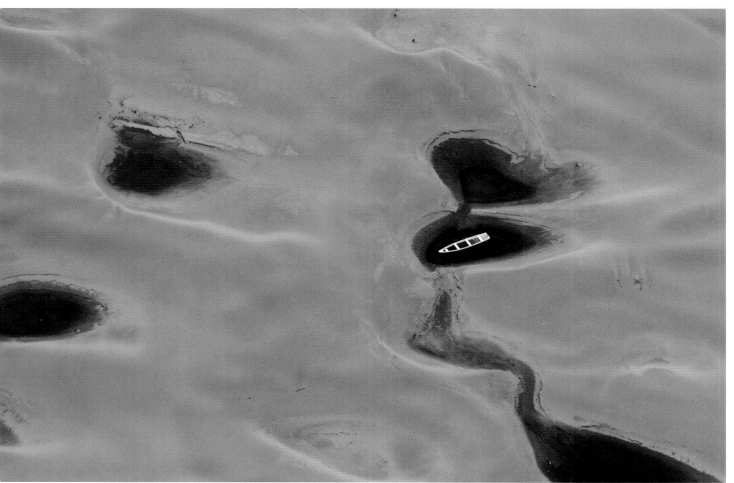

Sports Features

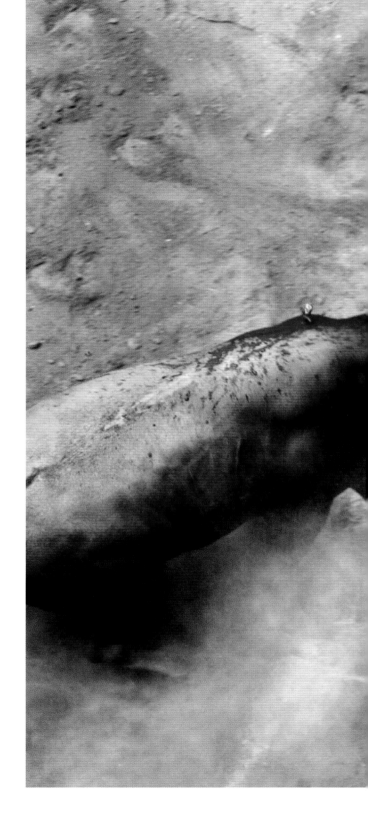

Henry Agudelo
Colombia, El Colombiano
1st Prize Singles

A bull attacks a horse during a
corrida at La Macarena bullring in
the city of Medellín in western
Colombia. Picadors mounted on
horses play a role early on in a
bullfight, stabbing the bull with
lances to weaken it through loss of
blood before its final confrontation
with the torero. The bull weighed
around 500 kilograms. The horse
received a blow to one of its legs,
but was not gored and was taken
from the ring.

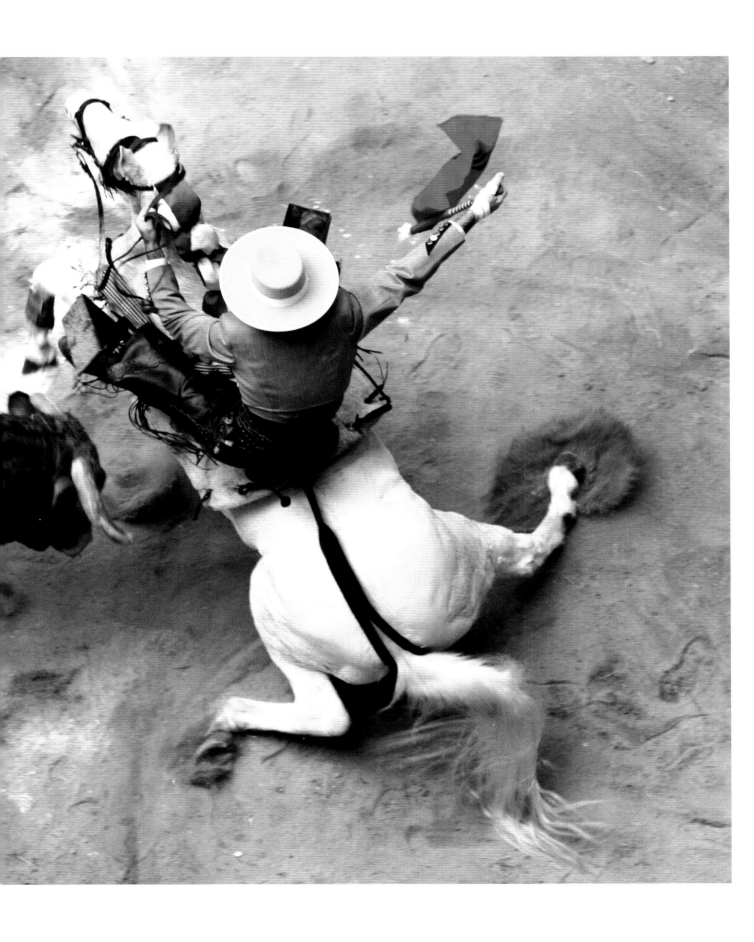

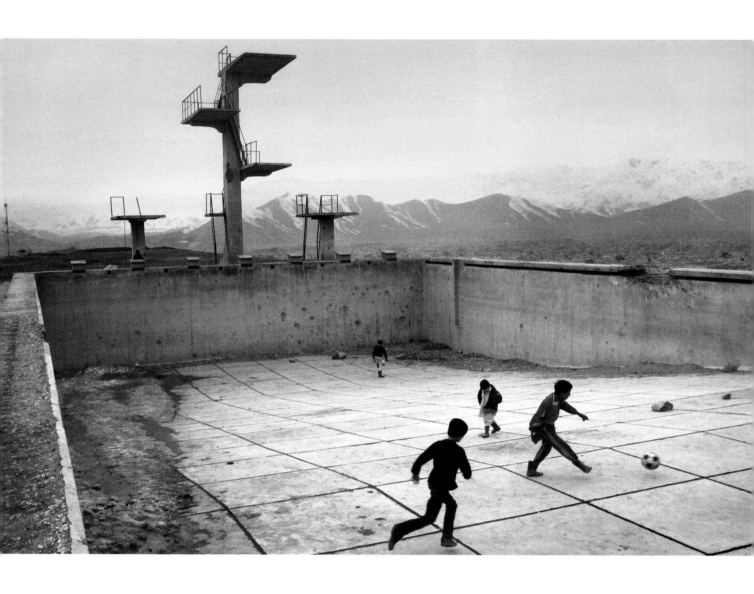

David Guttenfelder
USA, The Associated Press
2nd Prize Singles

Afghan boys play soccer inside an
empty swimming pool dating from
the Soviet occupation. The pool, on a
hilltop in Kabul, was damaged by
shelling during the country's civil war
and is now a favorite place for youth
to congregate and play games.

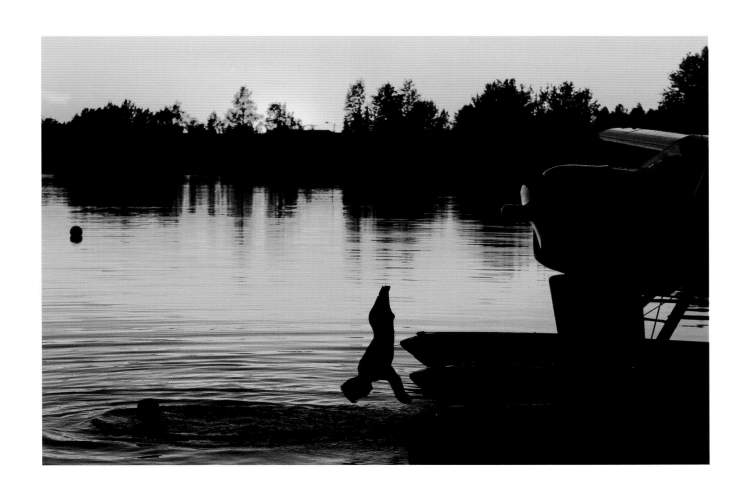

Ezra Shaw
USA, Getty Images
3rd Prize Singles

James Lilly (in water) and Alejandro Albor (diving) go for a swim in Lake Hood after the Sadler's Ultra Challenge, a six-day wheelchair race that covers the 440 kilometers between Fairbanks and Anchorage in Alaska.

The competition is the longest wheelchair and handcycle race in the world, attracting athletes from around the globe. James finished third in the wheelchair division, and Alejandro second in the handcycle C division.

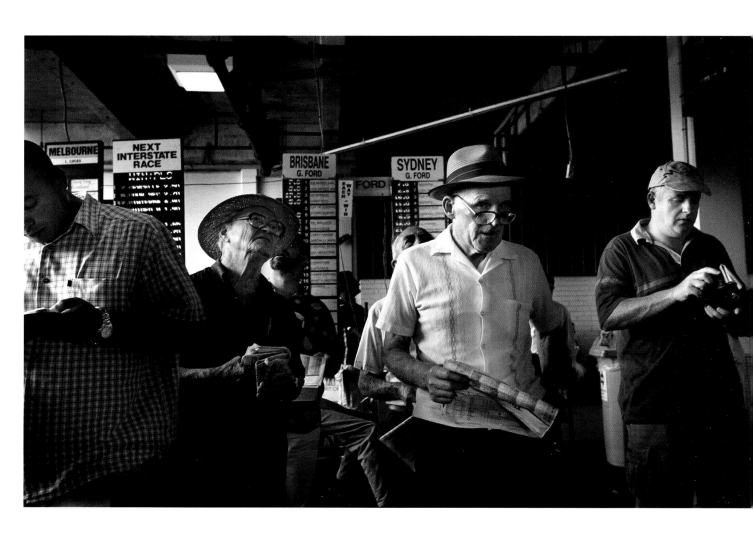

Mark & Jenny Evans
Australia
1st Prize Stories

Horse-racing is an important part of
the Australian sports scene. It is the
third most attended spectator sport
in the country after Australian Rules
football and rugby league. This page:
Punters check the odds before
placing their bets, in the betting ring
of Warwick Farm racecourse in
Sydney, Australia. Facing page: The
gate attendant, a familiar figure at
Warwick Farm, is reflected in the
jockey scales. (story continues)

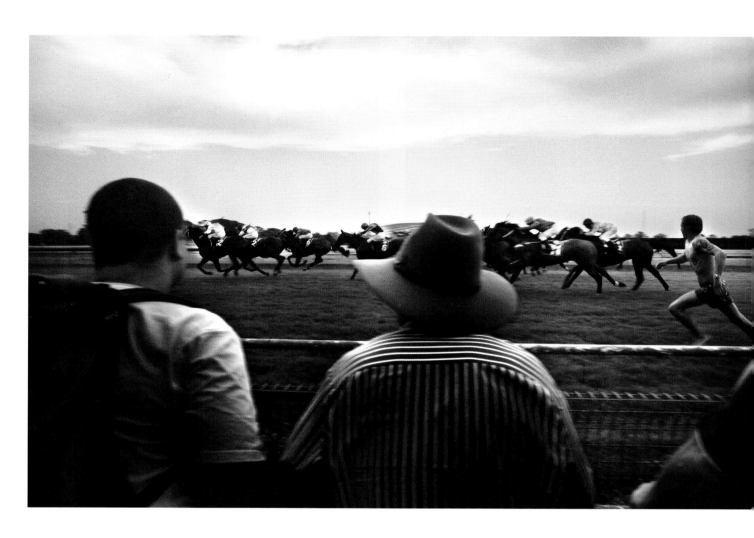

(continued) Racing carries an appeal that crosses age and class barriers. It attracts both professional punters and those out to gamble just a few dollars. This page: A drunken man runs on to the course as horses near the finishing line. Facing page: Members of the elite Australian Jockey Club join the public dancing to a live band after races at Warwick Farm.

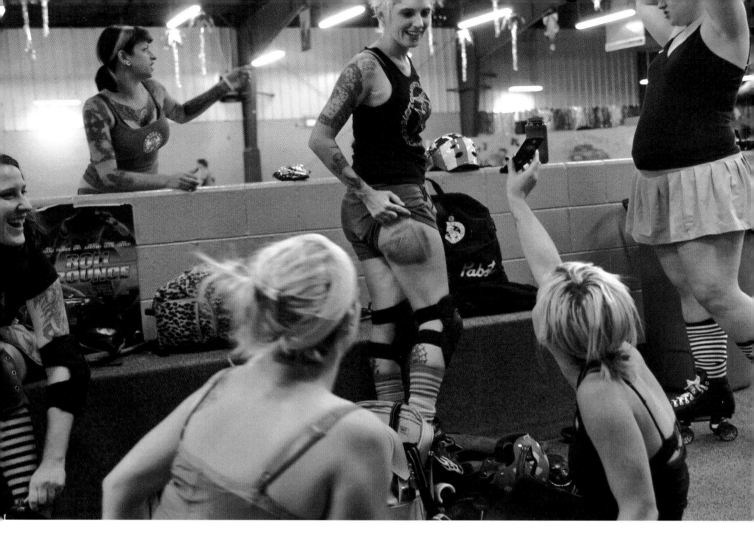

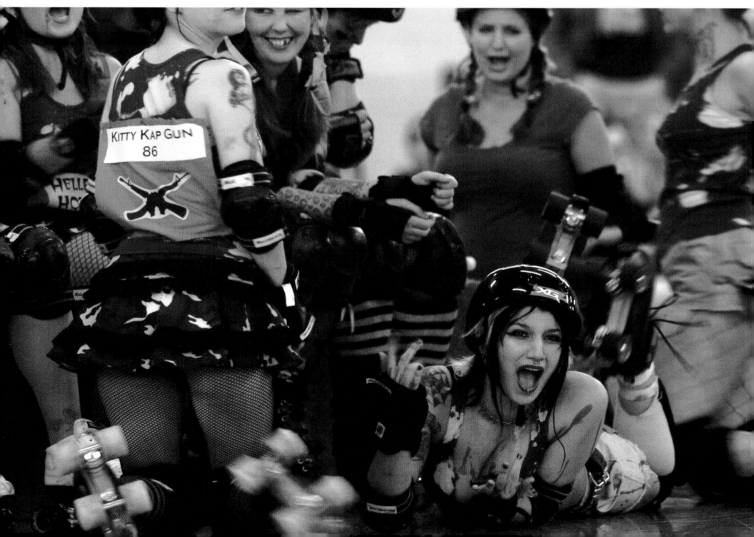

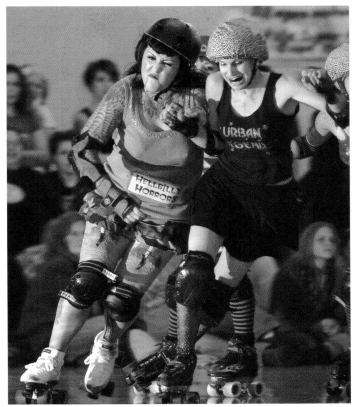

David Maialetti
USA, Philadelphia Daily News
2nd Prize Stories

The Philly Roller Girls formed their all-
girl, skater-owned and operated, roller
derby league in March. Their Premier
Exhibition in November brought roller
derby back to Philadelphia for the first
time in 30 years. Roller derby is a team
sports entertainment based on
formation roller-skating around a track.
It is very much a contact sport, as team
members crash into walls and get into
fights. The girls flaunt their tattoos and
bruises, and have names like Darth
Hater and Violet Temper. Facing page,
top: Deidre 'Jersey Diabla' Vaughn
shows off a large bruise on her leg to
teammates before practice. Below:
Members of the Philly Roller Girls cheer
teammates as they prepare to start
their first exhibition. This page, left:
Jillian 'Honey St Claire' Zito is a
founding member of the all-girl league.
Right: Honey St Claire battles with Mo
Pain in a Premier Exhibition bout.

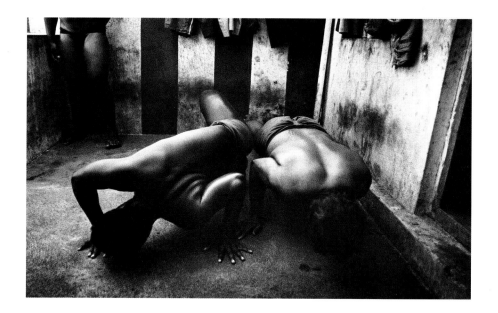

**Tomasz Gudzowaty &
Judit Berekai**
Poland/Hungary, Yours Gallery/
Focus for Pozytyw
3rd Prize Stories

Nada kusti is a traditional form of
Indian wrestling that goes back
thousands of years, employing
methods used to train ancient
warriors. Wrestlers attend twice daily
practice sessions at a traditional
garadi (gym). Contests take place in
an arena covered with a red clay dust,
which coats the wrestlers and is
thought to have curative properties.
This page, left: Wrestlers practice a
form of calisthenics to develop their
strength and stamina. Right: The
'wrestler's pillar' is kusti's most
characteristic piece of training
equipment and is used to develop
strength in the legs, arms and upper
body. Facing page, top: Heavy Indian
clubs are also used for muscle
development. Below: Wrestlers face
each other in a training bout.

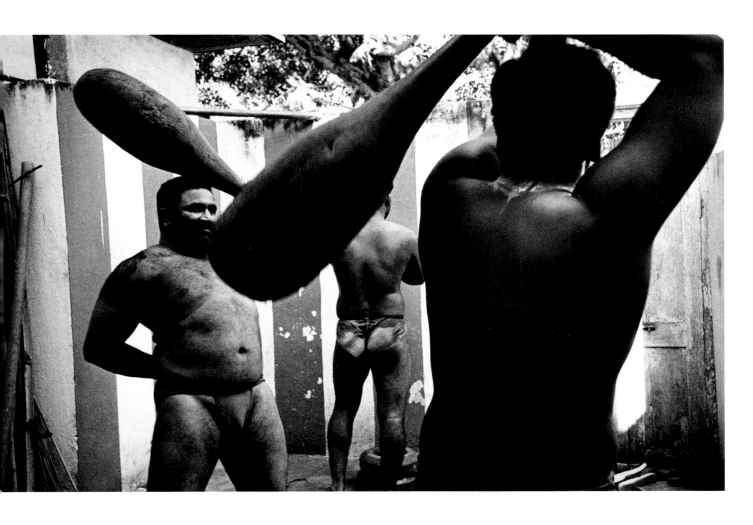

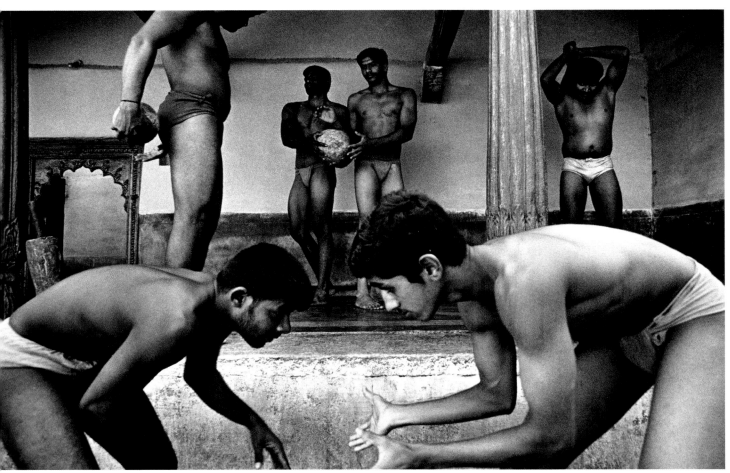

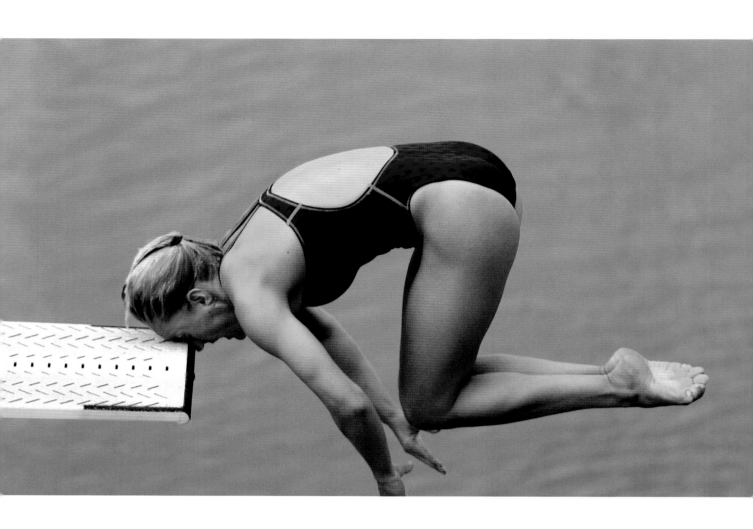

John G. Mabanglo
USA, European Pressphoto Agency
1st Prize Singles

Chelsea Davis of the USA strikes her face on the diving board while attempting an inward two-and-a-half somersault in the preliminary round of the women's three-meter springboard competition, at the FINA World Championships in Montreal, Canada, in July. She required three stitches but otherwise sustained no serious injury. The championships showcase five disciplines: water polo, open water swimming, diving, swimming and synchronized swimming.

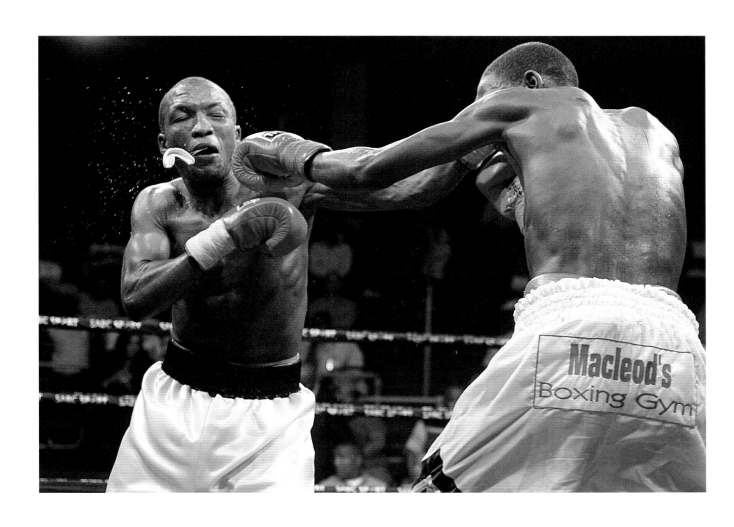

Sydney Seshibedi
South Africa, Sunday Times
2nd Prize Singles

Sello Hanong's gumguard goes
flying following a punch from Sidney
Maluleka during a featherweight
match at the Expo Centre at Nasrec,
southwest of Johannesburg in South
Africa in September. Maluleka went
on to win the fight on points over
six rounds.

Ryan Pierse
Australia, Getty Images
3rd Prize Singles

Andy Roddick of the USA hits a
backhand during a quarter-final
match against Nikolay Davydenko
of Russia at the Australian Open at
Melbourne Park in January. Roddick
went on to the semi-finals after
Davydenko was forced to retire
with breathing problems. He was
then beaten by home favorite
Lleyton Hewitt.

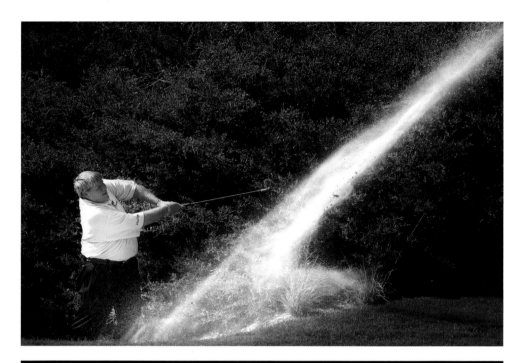

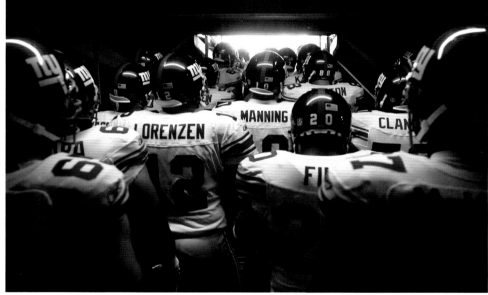

Donald Miralle, Jr.
USA, Getty Images
1st Prize Stories

Sports portfolio. This page, top: John Daly hits out of the bunker on the second fairway during a golf exhibition at Rancho Santa Fe in California. Daly and his partner Tiger Woods lost to Retief Goosen and Phil Mickelson. Below: Quarterback Eli Manning and his fellow New York Giants enter the stadium through a tunnel at the start of their National Football League game against the San Diego Chargers in September. Manning was originally drafted by the Chargers, but controversially opted to play for the Giants in his first season. Facing page, top: World-record holder Aaron Peirsol streamlines off the wall after the 200-meter backstroke preliminary heats during the Santa Clara Grand Prix in California in June. Peirsol did not qualify for the finals, but went on to break his own record two weeks later at the World Championships. Below: Pilot Grayson Fertig and brakeman Lorenzo Hill of the USA in the qualifying run of the two-man bobsled event during the Bobsled & Skeleton World Cup at Lake Placid, New York in February.

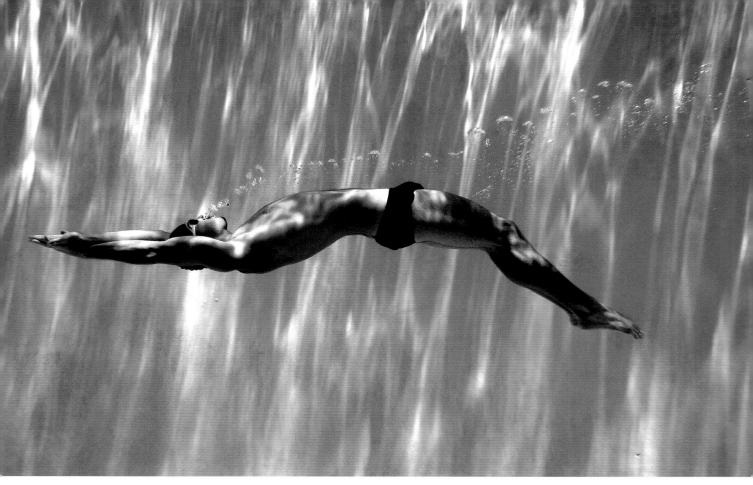

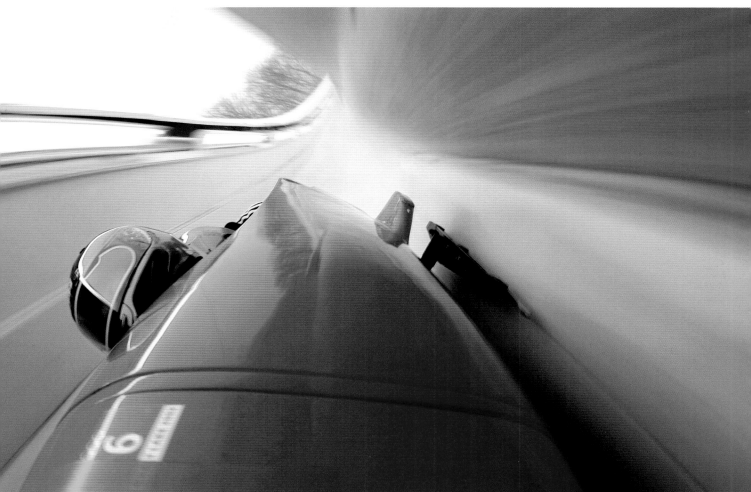

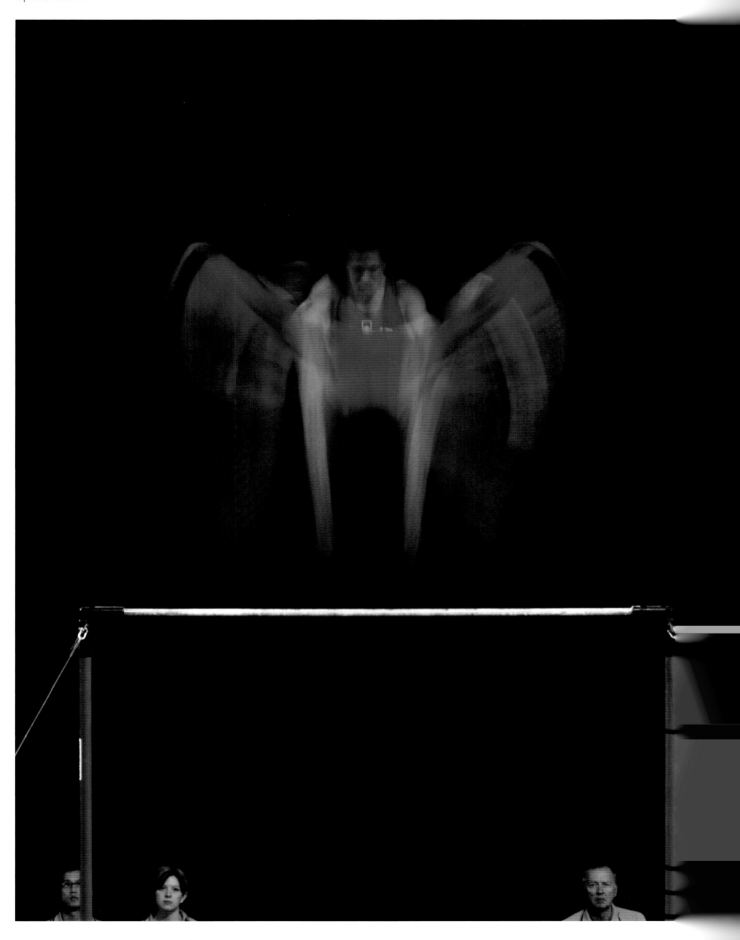

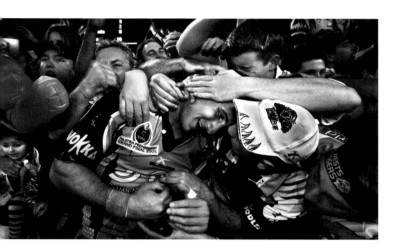

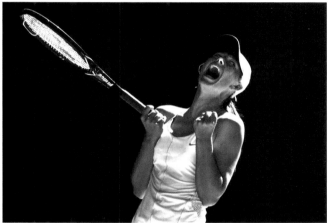

Adam Pretty
Australia, Getty Images
2nd Prize Stories

Sports portfolio. Facing page: Aljaz Pegan of Slovenia on his way to a gold medal on the horizontal bar, during the apparatus finals of the World Gymnastics Championship in Melbourne in November. This page, left: Robby Farah of the Wests Tigers is mobbed by fans after victory in the National Rugby League Grand Final in Sydney, Australia. Wests Tigers beat the North Queensland Cowboys 30-16. Right: Maria Sharapova of Russia celebrates a point against Silvia Farina Elia in a quarter-final match at the Australian Open in Melbourne in January. She reached the semi-finals, where she was beaten by Serena Williams, who went on to win the championship.

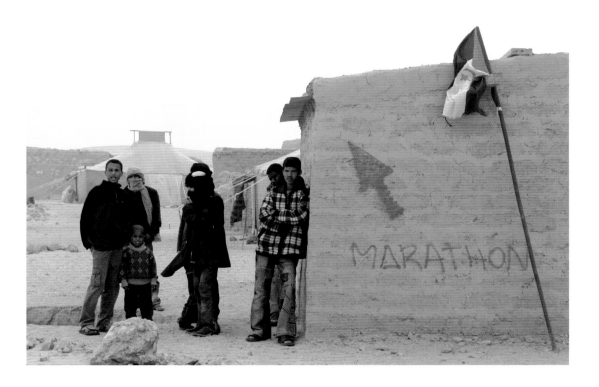

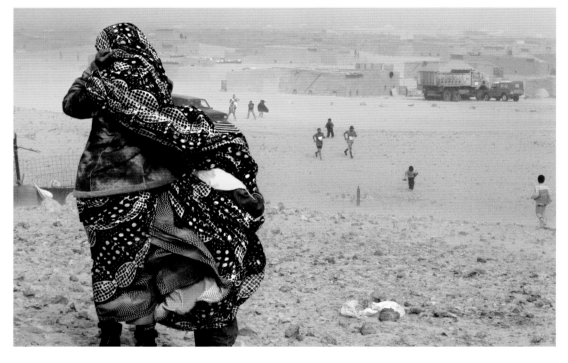

Benito Pajares
Spain, El Mundo/SaharaMarathon
3rd Prize Stories

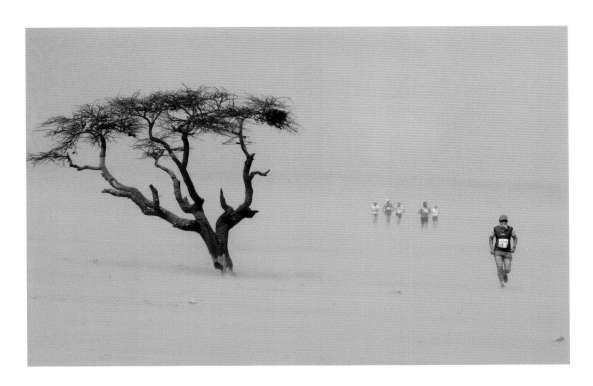

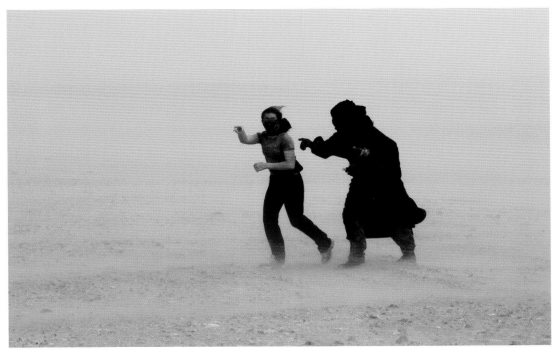

The Sahara Marathon is an international sports event organized to show support and raise funds for the Sahrawi people. The Sahrawis have been living in refugee camps in southwestern Algeria for 30 years, following post-colonial conflict in the region. The marathon has been run annually since 2000 along a route between three of the camps, and attracts hundreds of participants from all over the world. In addition to a standard-distance marathon there are shorter races and one for children. Runners sometimes have to battle against sandstorms of up to 120 kilometers per hour, and at times cannot easily see where they are going. Facing page, top: Spectators await the arrival of runners beneath a Sahrawi flag. Below: A mother uses her shawl to shield her daughter's face from sand as the runners come by. This page, top: Participants run past the sole tree to be found along the many kilometers of their route. Below: A runner who is lost is given directions by one of the organizers.

Arts and Entertainment

Shayne Robinson
South Africa, PhotoWire Africa
for The Globe and Mail
1st Prize Singles

A young dancer exercises at the barre during a ballet class in Alexandra township outside Johannesburg, South Africa. Dance mistress Penny Thloloe runs classes not only for the children's enjoyment, but also in the hope that ballet might provide a ticket out of the township for some of her students, as it did once for her. In the apartheid years Penny got the chance to study ballet at a semi-private school, won a scholarship to London and was later a founder dancer in the Ballet Theatre Afrikan. Alexandra has over 60 percent unemployment and many of its children orphaned by Aids. Penny had to go to some lengths to explain that classes were entirely free of charge, and that some students might go on to earn money by dancing. Over 1,000 children came to her first audition, of which 37 were selected to begin classes in January.

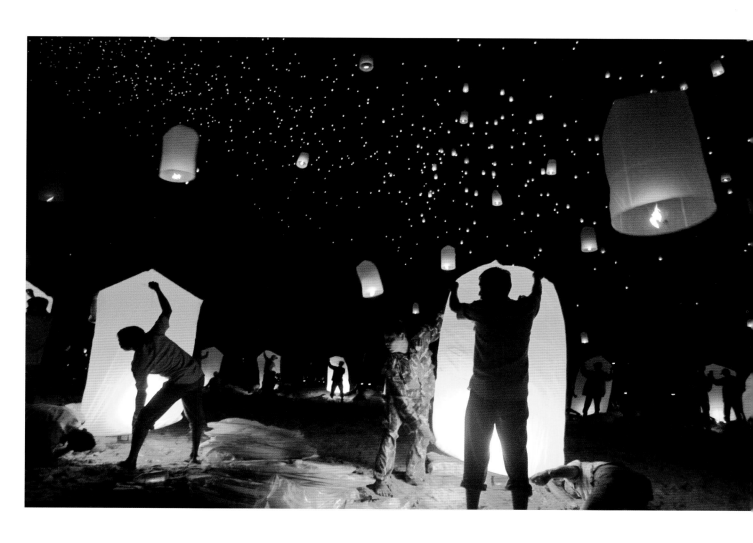

Xin Zhou
People's Republic of China,
Guangzhou Daily
2nd Prize Singles

Five thousand *kong ming* lamps are released into the sky at Bang Niang Beach, in Khao Lak, Thailand in a commemoration ceremony one year after the December 2004 tsunami. The lamps symbolized people killed in Thailand in the disaster. They are part of an ancient local tradition in which the lanterns are not only a memorial for the souls of the dead, but help give them passage to heaven. Khao Lak was the area of Thailand worst hit by the tsunami, which in twelve countries around the Indian Ocean caused well over 200,000 deaths and displaced millions of people. Memorial events reflecting the different cultures affected by the disaster were held throughout the region.

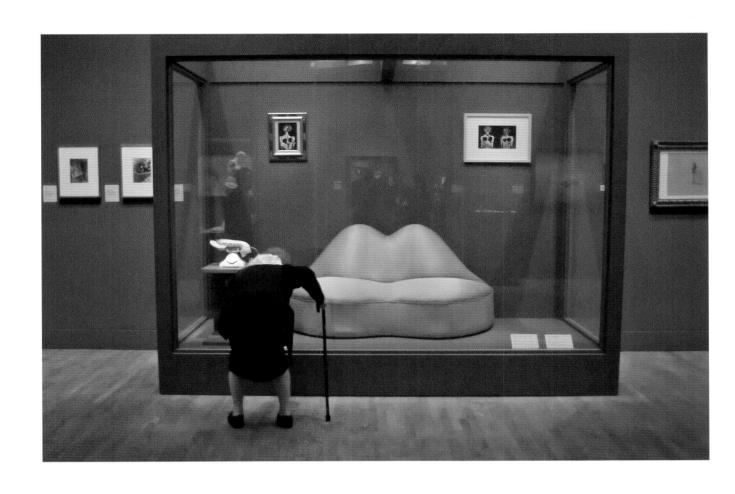

Michael Wirtz
USA, The Philadelphia Inquirer
3rd Prize Singles

An elderly woman takes a closer look at a 'Mae West Lips Sofa' and a 'Lobster Telephone' at the Salvador Dalí exhibition at the Philadelphia Museum of Art in the USA in February. The exhibition had its first outing at the Palazzo Grassi in Venice in 2004 to mark the centenary of the artist's birth. It was the first major retrospective of Dalí's work since his death in 1989. Dalí's creative life as a painter, writer, object-maker, designer of ballets and exhibitions, filmmaker, theorist and publicist spanned seven decades, though he is perhaps best-known for the surrealist paintings and objects made largely in the 1920s and 1930s.

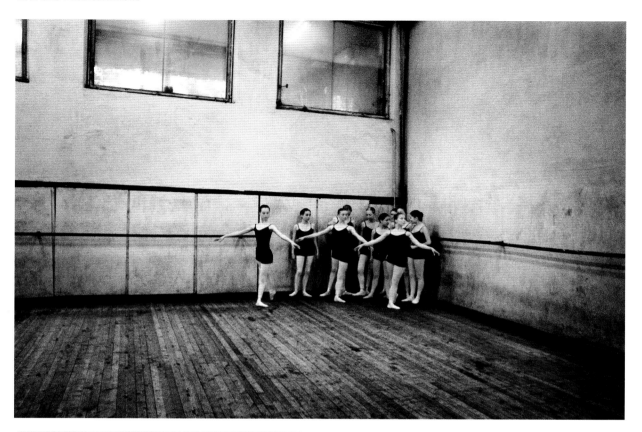

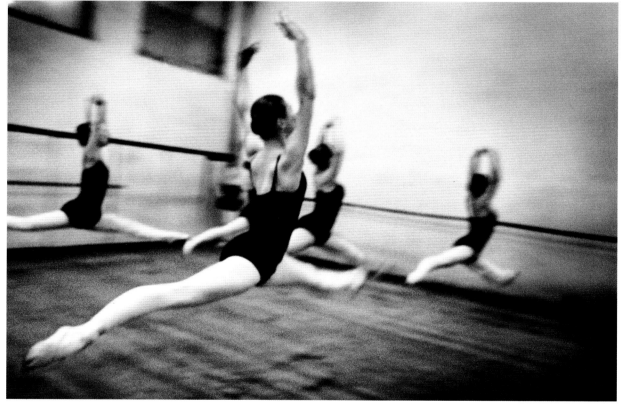

Åsa Sjöström
Sweden
1st Prize Stories

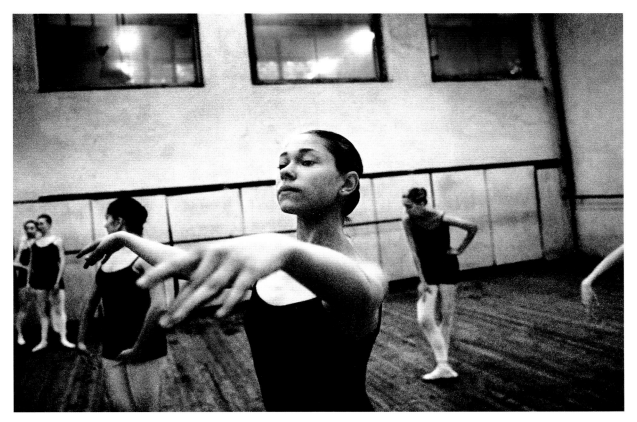

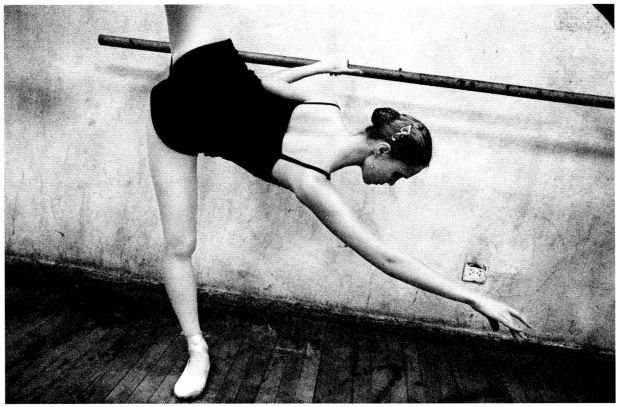

Sixteen-year-old dance students go through their exercises at the Theater of Opera and Ballet School in Chisinau, the capital of Moldova. The school is a scene of fierce competition. Moldova is one of the poorest countries in Europe, and many young people see ballet as a means to wealth and foreign travel. Twelve boys and twelve girls aged around eight are accepted into a ballet class every year. They stay for nine years, training a minimum of five hours a day in addition to normal lessons. Each year numbers in the class diminish, as those not considered talented enough are no longer allowed to continue.

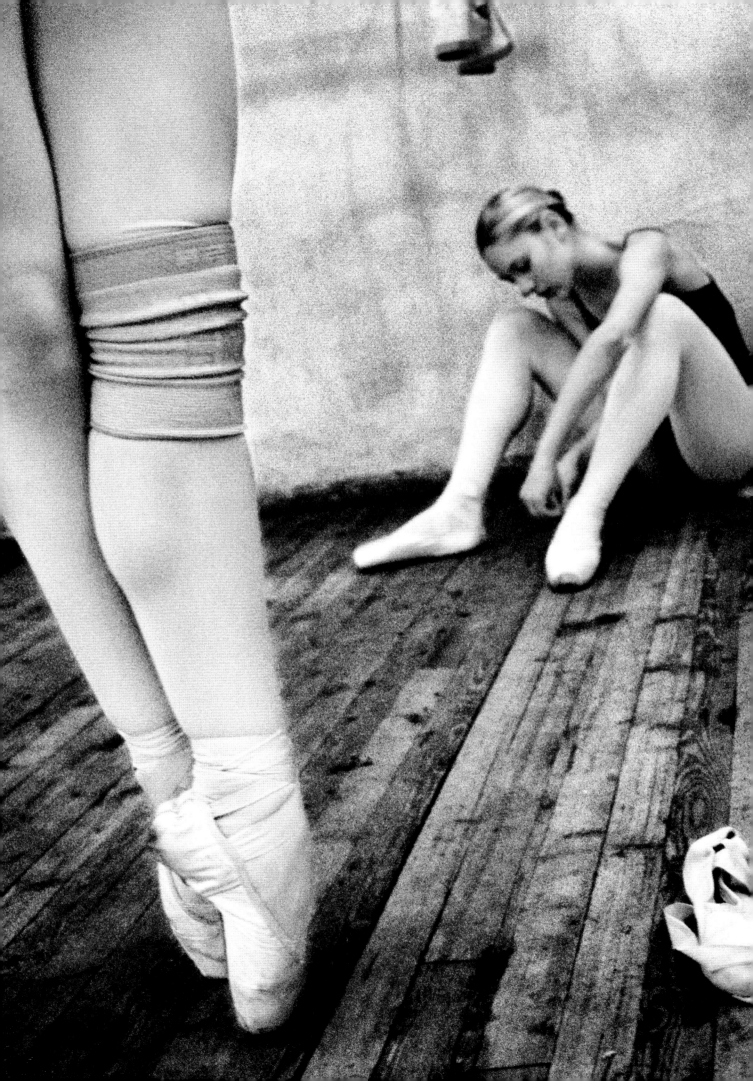

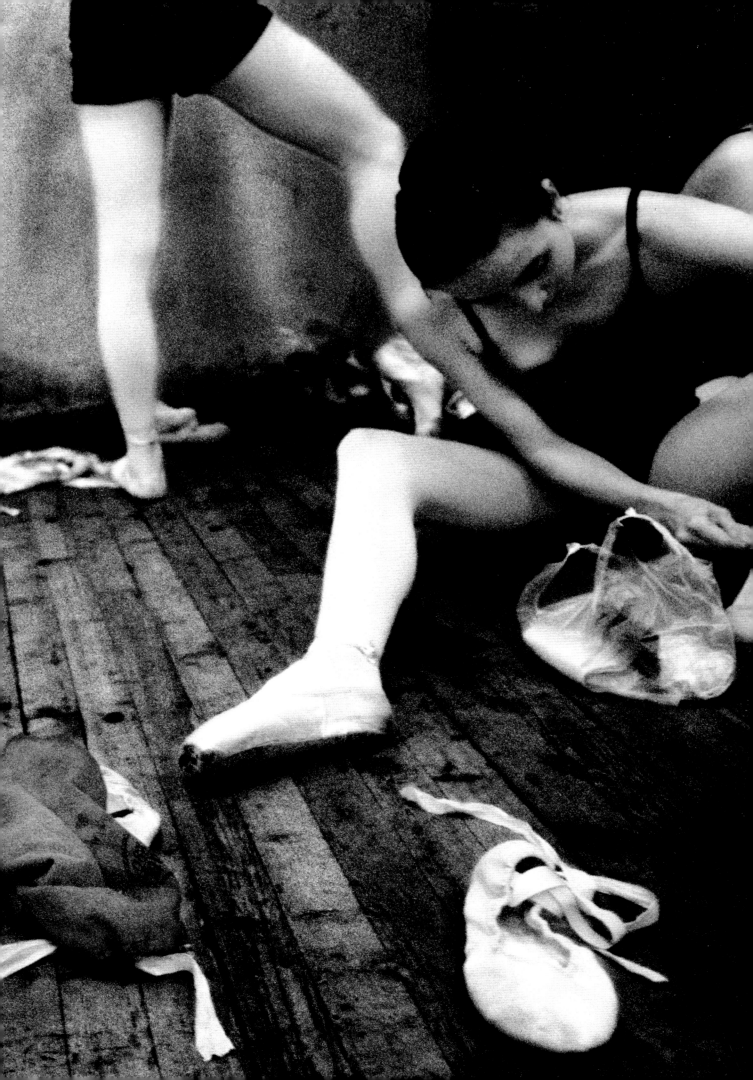

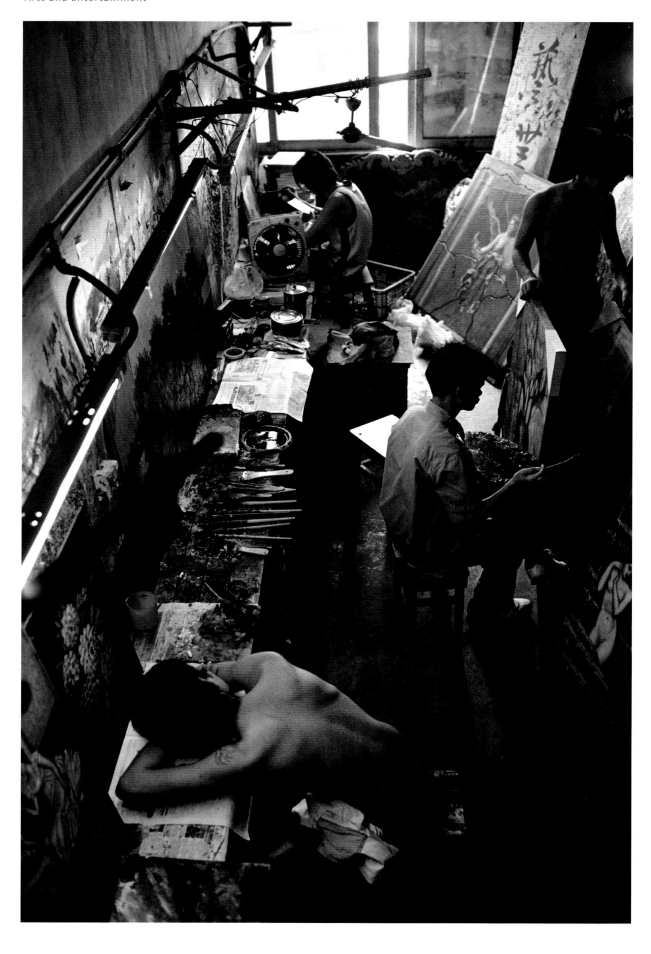

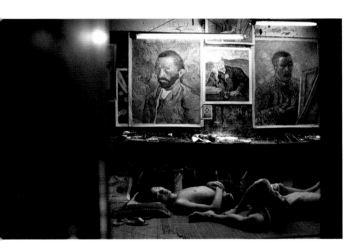

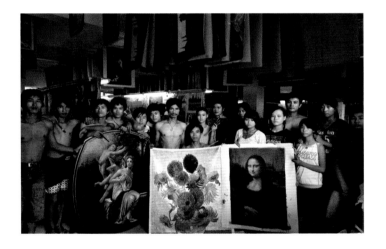

Haibo Yu
People's Republic of China,
Shenzhen Economic Daily
2nd Prize Stories

Dafen oil-painting village in Shenzhen, 30 kilometers north of Hong Kong, is the largest painting workshop in China. Over 8,000 artists produce some five million works a year for export, copying classical masterpieces by the likes of Van Gogh, Leonardo Da Vinci, Picasso and Rafael. The first painting factory in Dafen was started by a printer from Hong Kong in 1986. Favorable transport and communication links, as well as low labor costs, led to rapid international success, and there are now around 300 similar factories in the village. The painters come from regions all over China, many of them young peasants with ambitions to earn their living from art. Facing page: Painters have to work day and night to deliver goods on time. This page, top left: Though some painters specialize in the work of one artist, most have to adapt to a variety of Masters' styles. Right: Newly finished paintings are hung out to dry. Below, left: The studios often double as dormitories for the artists. Right: Painters from one of Dafen's studios display their work.

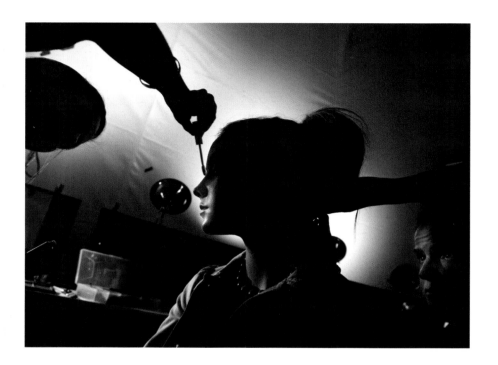

Paolo Pellegrin
Italy, Magnum Photos for Olympus
3rd Prize Stories

Backstage scenes from New York
Fashion Week in February. Twice
yearly, US and international
designers show off their new
collections in huge air-conditioned
marquees in New York's Bryant Park.
The event attracts not only top
models and designers, but the
invitation-only shows and parties
are also a lure to celebrities and
socialites.

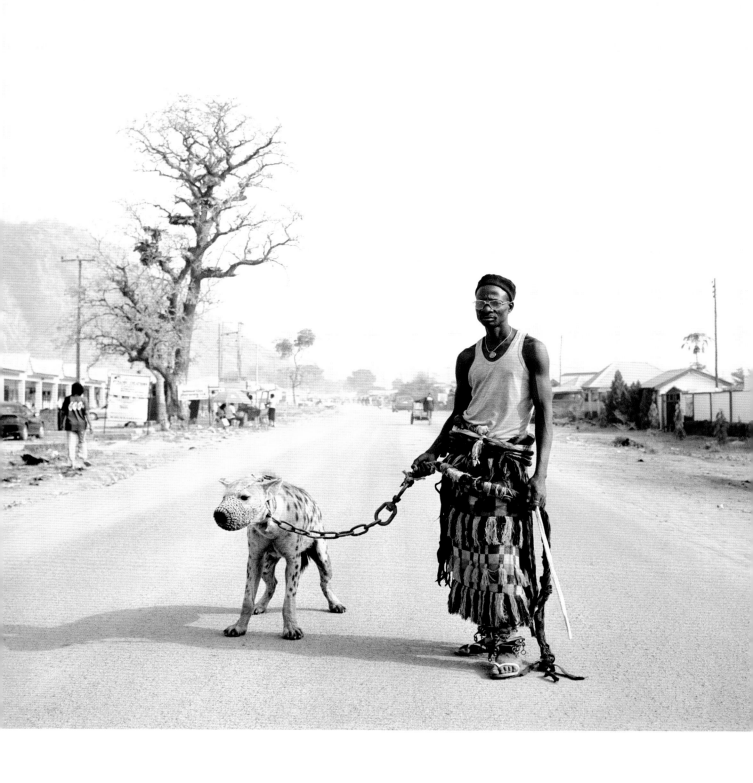

Pieter Hugo
South Africa, Corbis
1st Prize Singles

Mallam Galadima Ahamadu with the hyena Jamis on the streets of Abuja, Nigeria. Mallam is part of a troupe that travels around northern Nigeria with three hyenas, two rock pythons and four monkeys. They work as entertainers and sell the fetishes and herbal medicines that are much in demand in Nigeria. The hyenas are trained to mock-attack, which draws the crowds. The handlers capture the hyenas from caves in the wild, subduing them with traditional potions, then subjecting them to up to two months training. The creatures are then taught to interact with humans and other animals without attacking them. Mallam and his colleagues feed the hyenas a goat every three days or so, which also helps to keep them calm, and sprinkle water on them as they dislike excessive heat.

David Høgsholt
Denmark
2nd Prize Singles

Mia (26) stands behind Copenhagen's central station, the area that houses the city's red-light district. She is a drug addict and a sex worker. Mia has lost her boyfriend to an overdose, her own addiction is worsening, and she seldom sees her six-year-old daughter, who is in foster care. Despite these difficulties Mia tries to lead as decent a life as possible.

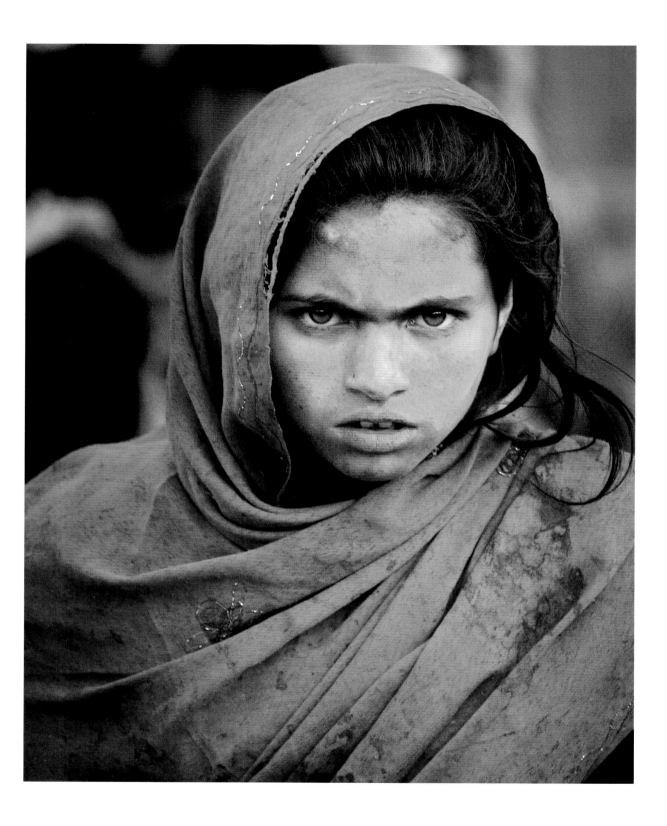

Tomás Munita
Chile, The Associated Press
3rd Prize Singles

A displaced girl in the shattered town of Balakot in Pakistan, some three weeks after the earthquake that racked the Kashmir region on October 8. She leads a mule carrying her belongings. Balakot was one of the towns hardest hit by the quake. Barely a building was left standing in what had once been a popular tourist destination. The city was renowned for the beauty of its situation at the entrance to the steep, thickly forested Kaghan Valley. It was also an object of pilgrimage as it was the location of the mausoleums of two Muslim martyrs.

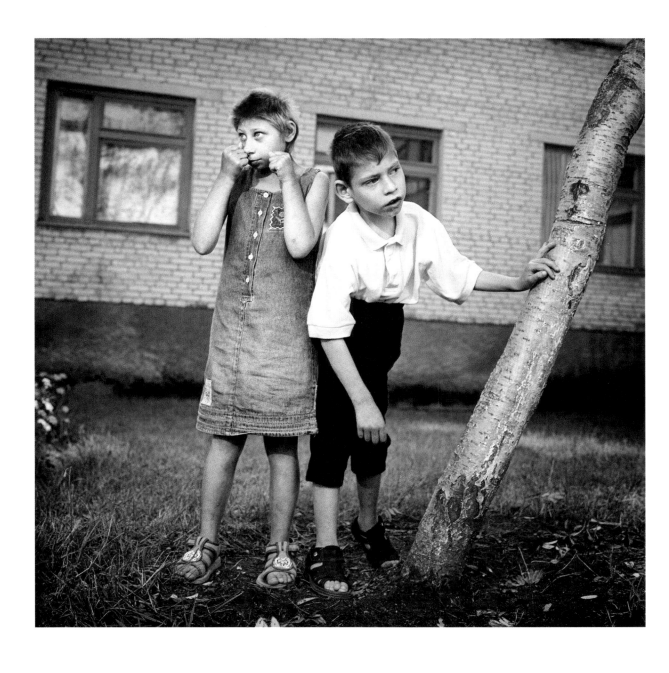

Robert Knoth
The Netherlands, TCS/Contrasto for
Greenpeace International
Honorable Mention Singles

Natasha Popova (12) and Vadim
Kuleshov (8) live in the Vesnova
orphanage southeast of Minsk in
Belarus. Natasha was born with
microcephaly (her head is
abnormally small); Vadim has a
bone disease and is mentally
retarded. It is not known for certain
whether exposure to radiation can
be linked to such conditions, but

the Belarus government estimates a
250 percent increase in birth defects
after the 1986 nuclear disaster at
Chernobyl, just across the border in
Ukraine. Some 30 high-dependency
people, ranging in age from five to
25 and all branded 'mentally unfit'
live in the institution at Vesnova.
Conditions are badly affected by
the lack of funds.

Paolo Pellegrin
Italy, Magnum Photos for Newsweek
1st Prize Stories

On the night of April 2 Pope John
Paul II died at the age of 84 after a
long illness. When a Vatican official
announced the Pope's passing, many
who had gathered in St Peter's
Square in Rome during his last days
simply continued to gaze up at the
window of his apartment. (story
continues)

(continued) When the Polish Karol
Wojtyla was elected Pope in 1978 he
became the first non-Italian to hold
the post in four-and-a-half centuries.
His election is seen by historians as a
factor in the subsequent collapse of
communism in Eastern Europe. As
John Paul II he became the most
widely traveled pope in history, and
was instantly recognizable around
the globe.

Martin Roemers
The Netherlands, Hollandse Hoogte/
Laif Photos & Reportagen
2nd Prize Stories

The year saw the 60th anniversary of the end of World War II. Veterans joined commemoration ceremonies across Europe. This page, top left: Henk Paulus (87) was born in Indonesia, and as a prisoner-of-war endured forced labor on the Burma railroad. Right: Gerhard Hiller (83) joined the German army when he was 19 and was taken prisoner by the Allies during the invasion of Normandy. Below, left: Frederick Lennart Bentley (80) was blinded by a German grenade while on a night patrol in Normandy. He had to feel his way back behind Allied lines. Right: Edward Hamilton (87) was commander of a battalion in the US Army and despised cowardice. If he suspected one of his men had inflicted self-injury in order to be sent home, he made sure the soldier was sentenced to hard labor. Facing page: Leen Jonker (88) was a gunner with a Dutch squadron of the Royal Air Force. When he was injured by German anti-aircraft fire his friends were not allowed to visit him in hospital. The authorities were concerned that if they saw him, they would not want to fly again.

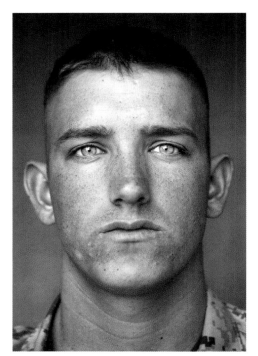 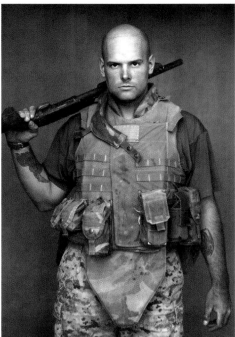

Lucian Read
USA, World Picture News
3rd Prize Stories

The Pentagon boosted the number of US troops in Iraq to 150,000 in the run up to Iraqi national elections in January, the highest level since the US-led occupation began. Most of the increase in troop count came from extended deployment of units already on the ground. These men are from Kilo Company, 3rd Battalion, 1st Marines – an infantry company in the Marine Corps that was serving its third deployment in Iraq. This page, from left: Stephen Parker (20) from Athens, Texas; Travis Musselman (22) from Ligonier, Indiana; Jeremy Newman (19) from Long Beach, California. Facing page, from left: Chaucer Rideaux III (25) from Woodland Hills, California; Justin Boswood (22) from Kalkaska, Michigan; Joshua Cisneros (21) from Lubbock, Texas.

 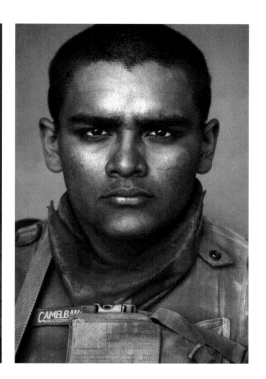

Daily Life

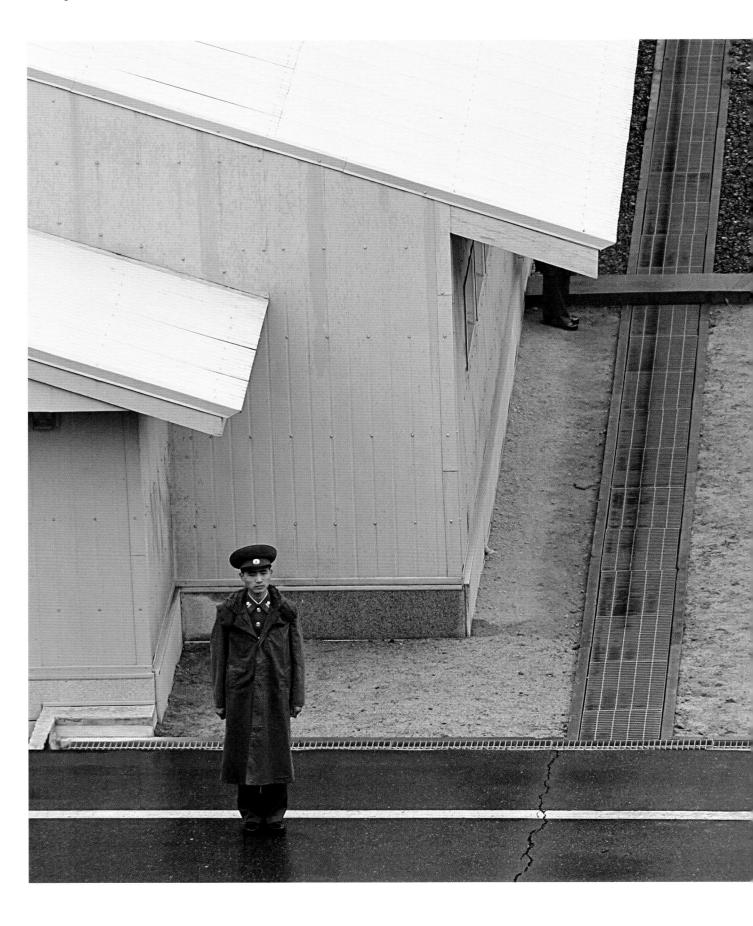

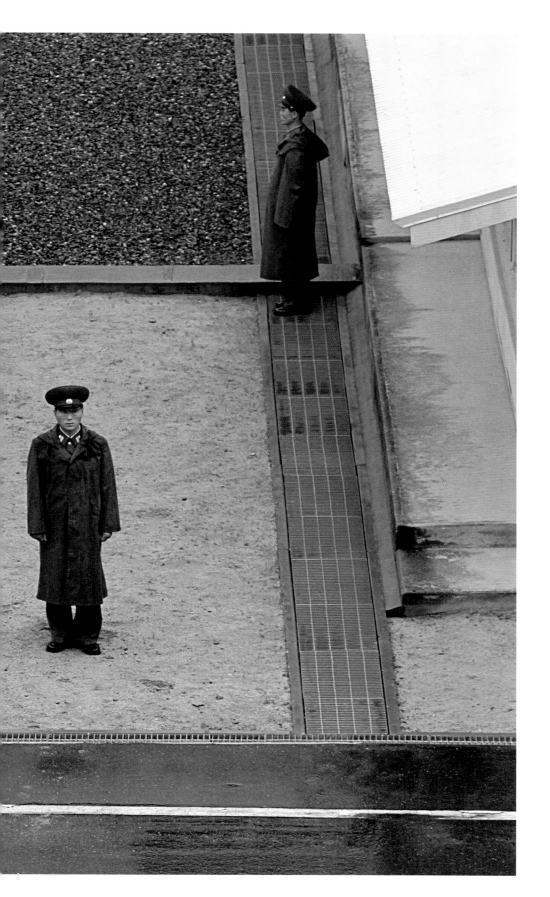

Sergey Maximishin
Russia, Focus Photo und Presseagentur
for Newsweek Russia
1st Prize Singles

North Korean border guards stand
watch at Panmunjeom, at the
frontier between North and South
Korea. The concrete Military
Demarcation Line, separating sand
from asphalt areas, marks the divide
between the two countries. The
blue buildings straddling the line
were the scene of discussions that
lead to the 1953 armistice, ending
the Korean War. Relations between
capitalist South Korea and
communist North Korea, one of the
most secretive nations on earth,
remain tense — but in 2005 the
countries jointly celebrated the
60th anniversary of their
independence from Japan.
A four-day inter-Korean festival in
August included a football match
and cultural events, and the
countries linked fiber-optic cables
to allow families separated for
decades to take part in video
reunions. In a White Paper on
defense earlier in the year, South
Korea had dropped its reference to
North Korea as its "main enemy".

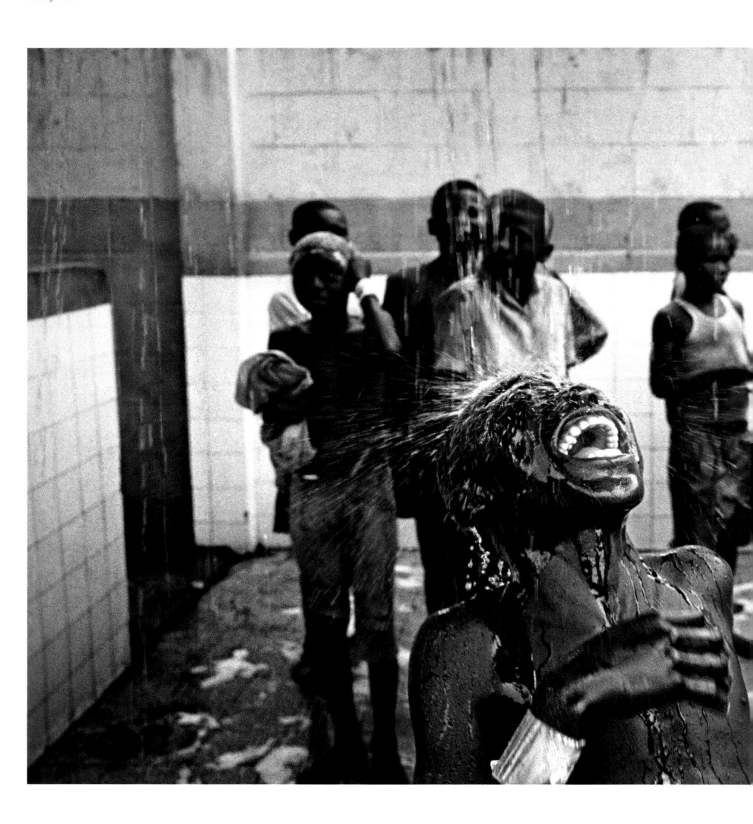

Marcus Bleasdale
Ireland, for Human Rights Watch
2nd Prize Singles

Street children enjoy a shower in a
care center in Kinshasa, in the
Democratic Republic of Congo.
Food and lodging, as well as basic
schooling, are offered to the children
in exchange for light labor. Conflict,
internal displacement, HIV/Aids and
poverty contribute to the rising
number of children who live and
work on the streets. An estimated
30,000 street children live in
Kinshasa, with tens of thousands
more in other urban areas around
the country. Many of them have been
cast out of home by their parents,
having been accused of witchcraft.
They are blamed for the family's
economic ills or the death of a
relative from an Aids-related illness.
Once in the streets, children face
physical and sexual abuse from older
children, adults and sometimes also
from police and the military.

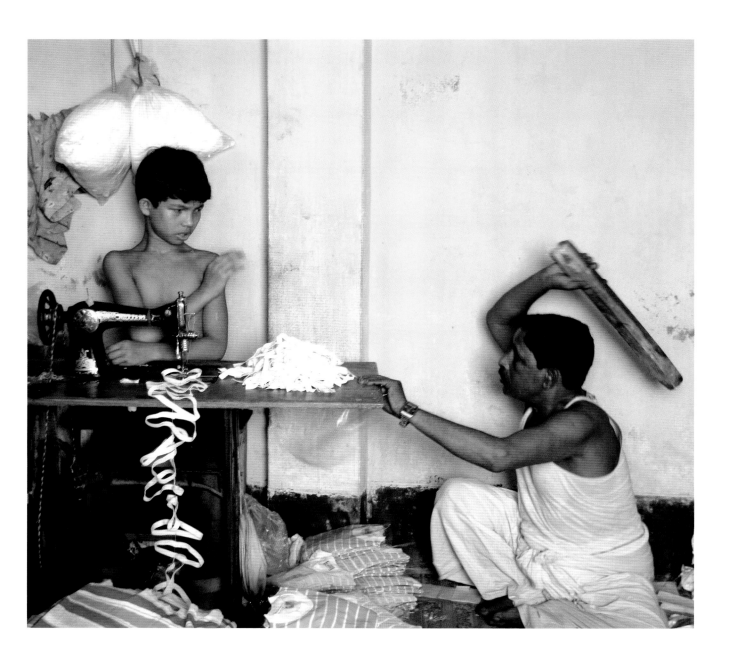

G.M.B. Akash
Bangladesh
3rd Prize Singles

A child worker in Bangladesh is punished for not completing his work on time. UNICEF estimates that some 3.3 million children, one-fifth of the country's labor force, are employed in Bangladesh. This is despite efforts in the 1990s to curb child labor in the garment industry. Many children are forced into hazardous occupations in painting or engineering workshops, or in tanneries that use dangerous chemicals. On average a child laborer gets 60 taka (less than US$ 1) a day, about one third of the adult rate. In addition, factory owners prefer child workers because they are able to keep the workplace free from trade unionism. Early employment also deprives the children of opportunity for education, thus preventing them from finding a way out of low-paid occupations.

Donald Weber
Canada, Polaris Images
Honorable Mention Singles

Viktor Popovichenko, a 32-year-old
hard drinker from Orane, Ukraine,
takes a tumble after one too many
shots of *samegun*, a homemade
vodka that sells for US$ 1 a liter.
Viktor drinks a bottle a day. Orane is
a nearly deserted village just 30
kilometers from Chernobyl, scene of
the nuclear disaster of 1986. With no
work and few other activities to keep
them busy, many residents of Orane
resort to alcohol to pass the time.
A recent World Mental Health survey
in Ukraine found that 38.7 percent
of men were heavy alcohol users.

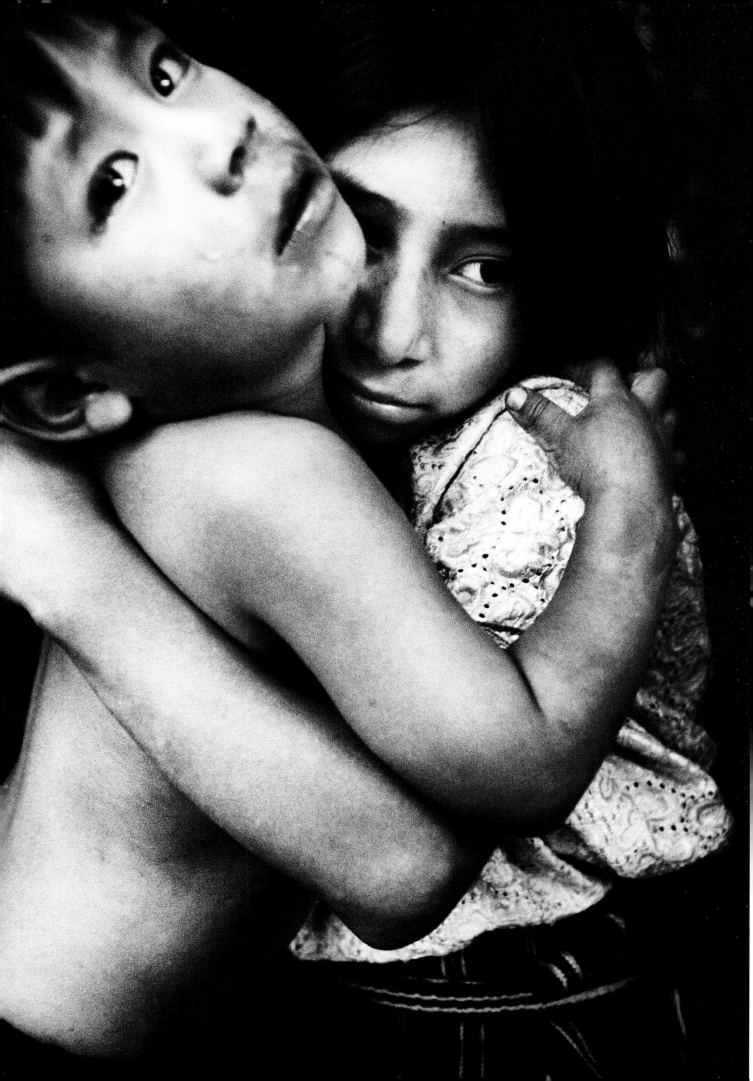

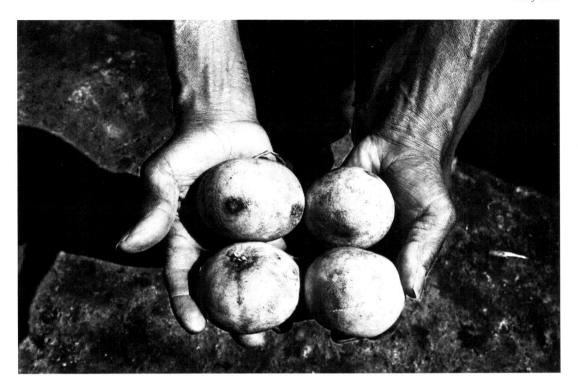

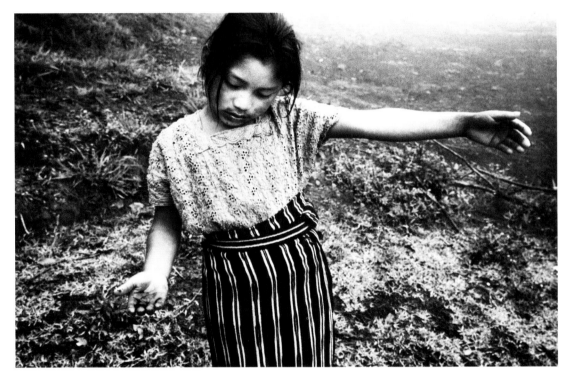

Jacob Aue Sobol
Denmark
1st Prize Stories

The Gomez Brito family are Ixil Mayans, and live near the village of Nebaj in a remote mountain region of southwestern Guatemala. As a result of their isolation, the Ixil Mayans long maintained their traditional beliefs and way of dress, but in the late 1970s and 1980s many indigenous people were displaced by civil war. When peace returned in the 1990s the family, like many others, were able to return to their traditional ways. Facing page: Twelve-year-old Elisabeth hugs her youngest brother Roberto (3). This page, top: The family have a single lemon tree on their land. Below: Maria (7) takes a rest after picking blueberries. (story continues)

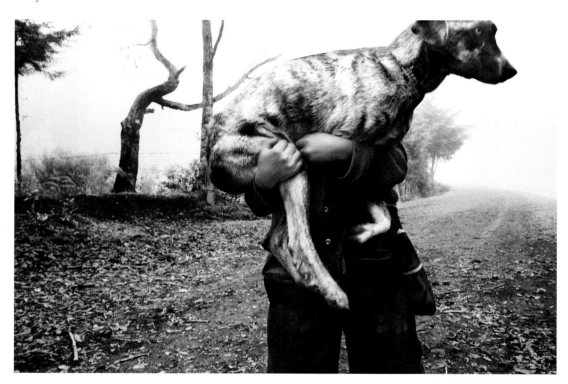

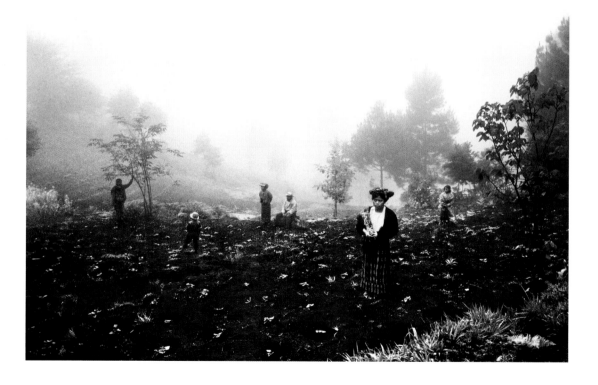

(continued) Mother Juanita and father Andrés live with their nine children. They work on small plots of land that have belonged to their family for generations. From sunrise to sunset the family collect fruit and berries, cultivate corn and beans, and tend their animals. This page, top: Eliseo (10) carries the family dog. The dog follows him each morning on the long walk to the other side of the mountain to look after the horses. Below: Women of the family help with sowing beans. Usually, they stay at home working on household chores, but help in the fields at busy times. Facing page: In April the family burn back their cornfield to prepare for the next season.

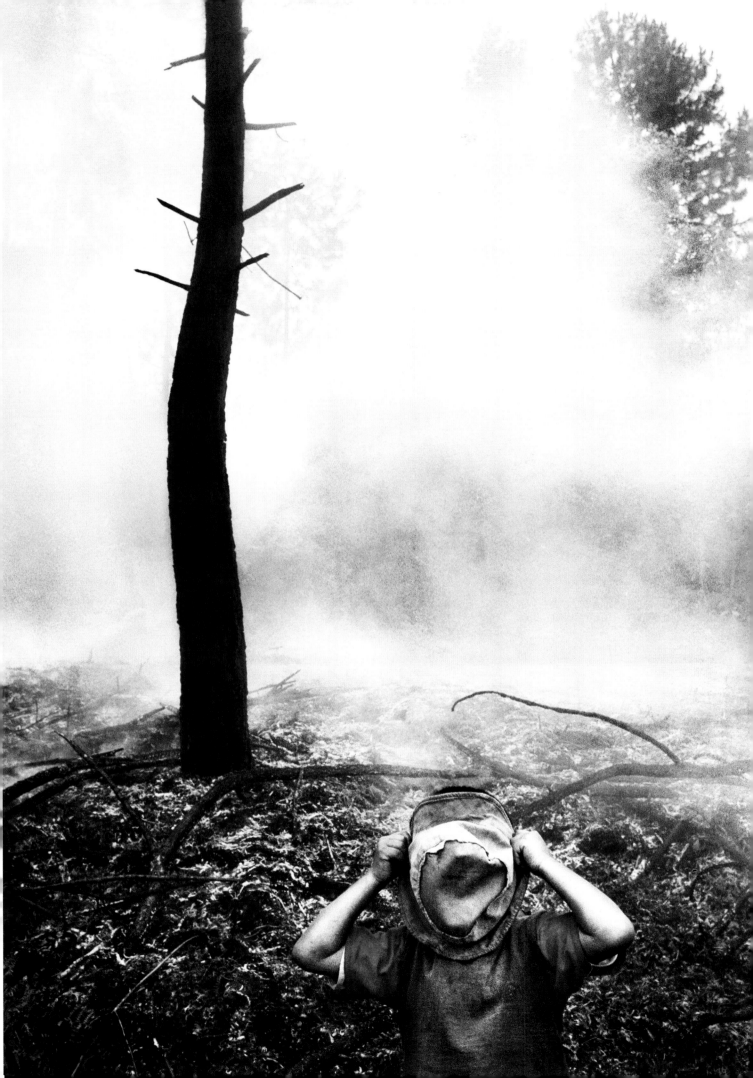

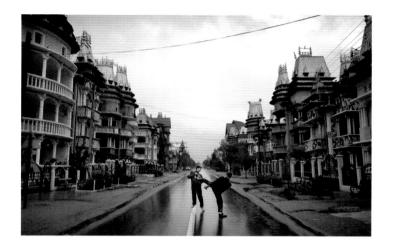

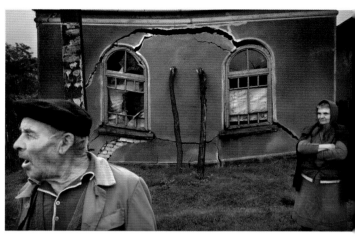

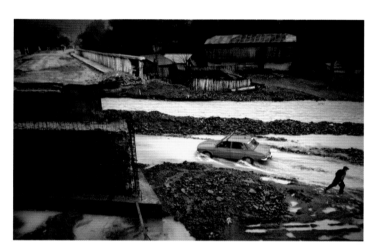

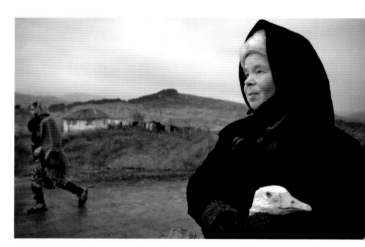

Tamas Dezso
Hungary, for Geo Hungary
2nd Prize Stories

Dictatorship and nationalism isolated Romania from Western Europe for decades. Romania missed the first round of European Union expansion into Eastern Europe in 2004, as it had failed to implement sufficient democratic and market reforms. The European Commission later noted an improvement but wanted to see tighter controls on standards of food hygiene and a rooting out of corruption. The country faced natural disasters as well as economic hardship, as it was struck by avian flu and by floods that affected some two-thirds of the country. This page, top left: Boys kick-boxing on the main street of Buzescu, a village in southern Romania where rich gypsies build grand houses simply to display their wealth, often to leave them standing empty. Right: An elderly couple stand in front of their home, made uninhabitable by flooding, in the village of Nanov, on the Vedea river in southern Romania. Below, left: A car approaches a village in the east of the country along a riverbed, after floods had washed away the bridge on the only access road. Right: A woman returns home with a goose under her arm. Facing page: Villagers in Calvini in central Romania join in a feast celebrating St Nicholas, a major patron saint of the Orthodox church.

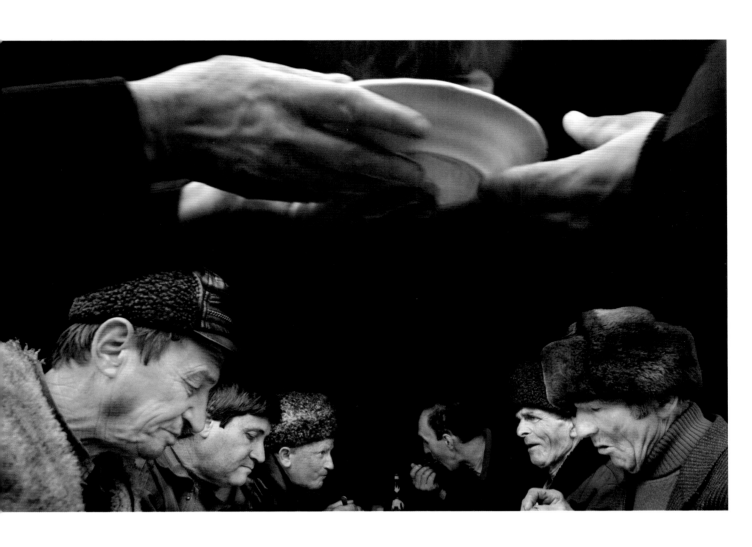

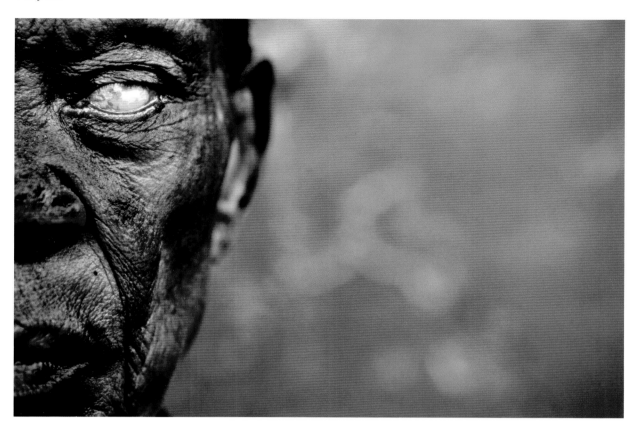

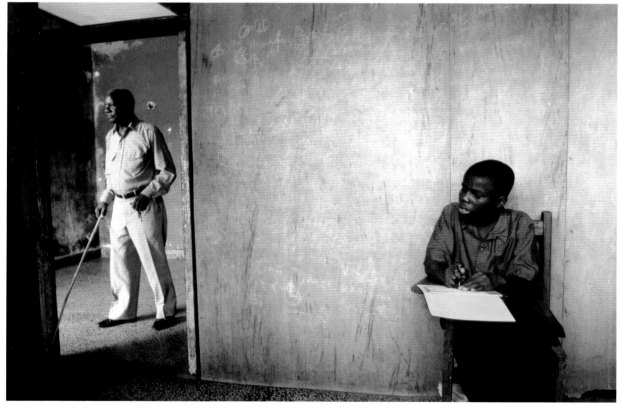

Michal Novotny
Czech Republic, Lidové Noviny
3rd Prize Stories

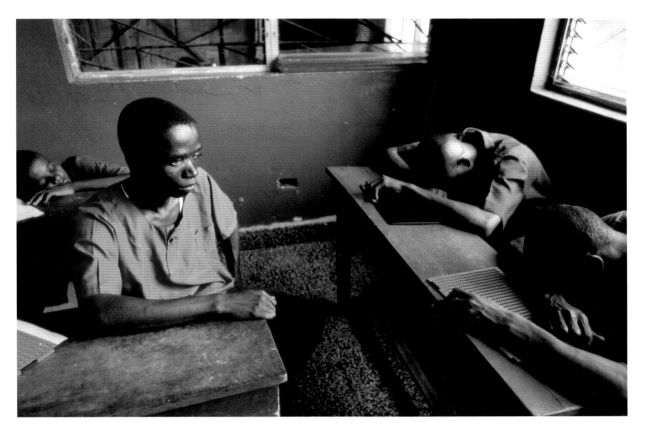

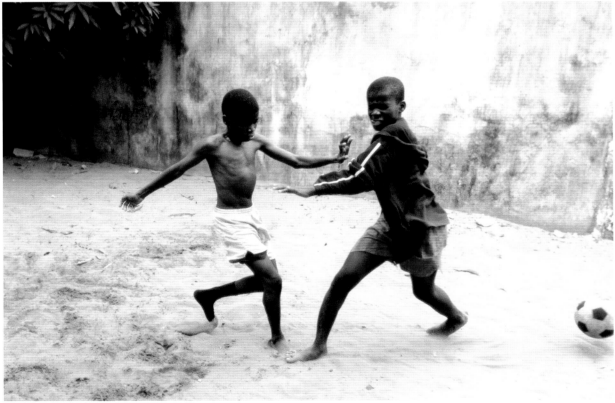

Liberia's long-running civil war and subsequent political turmoil finally gave way to elections and relative stability in 2005. In the aftermath of the conflict, disabled people comprised some 16 percent of the population. There are an estimated 77,000 blind people in Liberia, many of whom have lost their sight as a consequence of malnutrition, or through conditions that might easily not have led to blindness if tackled in time. Local attitudes are changing from the traditional perception of blindness being seen as the result of sorcery. Facing page, top: The chief of a lepers' community in eastern Liberia. Below: A student writes in Braille in his classroom at a school for the blind in the capital Monrovia. This page, top: A student waits for lessons to begin, while others take a nap. Below: Blind students play football with a ball that contains a rattle.

Contemporary Issues

Yannis Kontos
Greece, Polaris Images
1st Prize Singles

Young Abu (7) buttons his father's collar in their shelter in a camp for amputees near Freetown in Sierra Leone. Abu Bakarr Kargbo had both arms cut off by rebels of the Revolutionary United Front when they attacked Freetown in 1999. Some 50,000 people were killed and thousands more had their bodies mutilated in a civil war between government and rebel forces that lasted from 1991 to 2002. Hacking off hands or arms of civilians was a rebel trademark, designed to sow terror among their enemies. In 2004 a peaceful settlement was finally reached and a war crimes tribunal opened. Former combatants from both sides benefited from social reintegration programs, but little was directed at amputees.

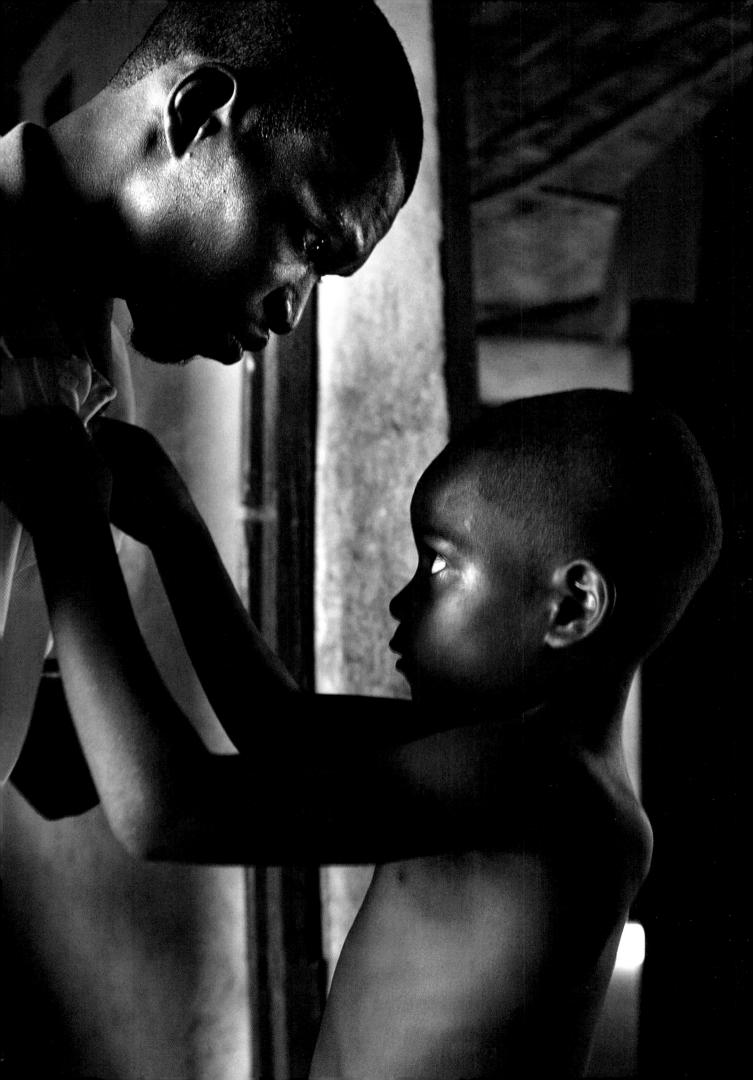

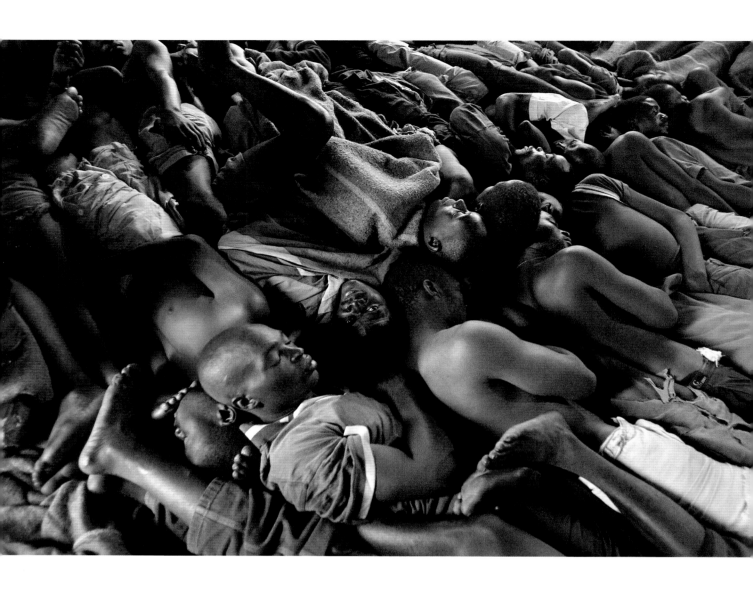

Joao Silva
South Africa, The New York Times
2nd Prize Singles

Inmates of the Maula Prison in Lilongwe, Malawi sleep on the floor. They are so tightly packed that they turn over only when a designated prisoner wakes them to do so en masse. Malawi prisons do not have a bad human rights record, but are overcrowded as many of those incarcerated have been on remand for several years as a result of a lack of financial and legal resources. Malawi's 12 million citizens have 28 legal-aid attorneys and eight prosecutors with law degrees among them. The situation is repeated across the continent in countries where judicial systems are underfinanced and understaffed.

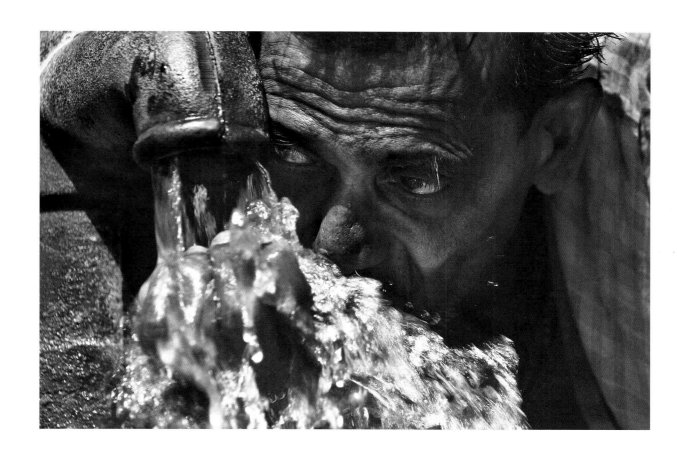

Sucheta Das
India
3rd Prize Singles

An elderly man drinks water from a tubewell contaminated by arsenic, in the village of Gutri in West Bengal, India. Arsenic occurs naturally in the environment in varying degrees. Although it is not certain where the contamination in West Bengal originates, it is thought that the arsenic seeps from rocks into underground water supplies. Levels of the chemical are particularly high in West Bengal and Bangladesh, where as many as 40 million people are believed to be at risk. Long-term consumption of even small amounts of arsenic can be fatal, and studies have linked prolonged exposure with cancer, diabetes and liver disease. Deep tubewells are particularly affected. From the 1970s onwards both the United Nations and the World Bank advocated the digging of such wells as an alternative to surface water bodies that had become polluted by industrial effluents and sewerage.

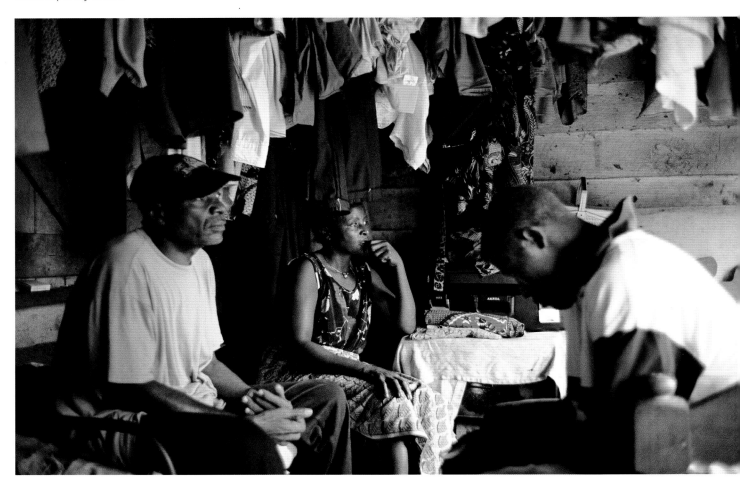

Olivier Jobard
France, Sipa Press for Paris Match
1st Prize Stories

The short distance across the sea from northern Africa to mainland Spain or the Canary Islands is a popular route for clandestine immigrants looking for a better life in Europe. Kingsley, a 22-year-old Cameroonian, was one who attempted the passage. This page: Kingsley tells his parents of his decision to leave for Europe. Facing page, top: Kingsley and some compatriots observe the Spanish enclave of Melilla from a garbage dump on the outskirts. Smugglers demand large sums to help immigrants cross the barbed-wire barriers around Melilla. This means of entry is also dangerous, as people are shot and killed in the process. Below: The boat that smugglers provided to make a crossing to the Canaries capsized 300 meters from the coast. Few could swim and two men were drowned. (story continues)

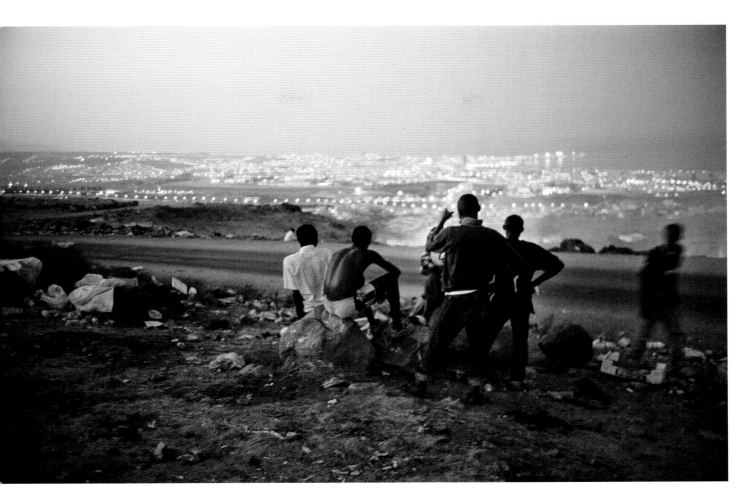

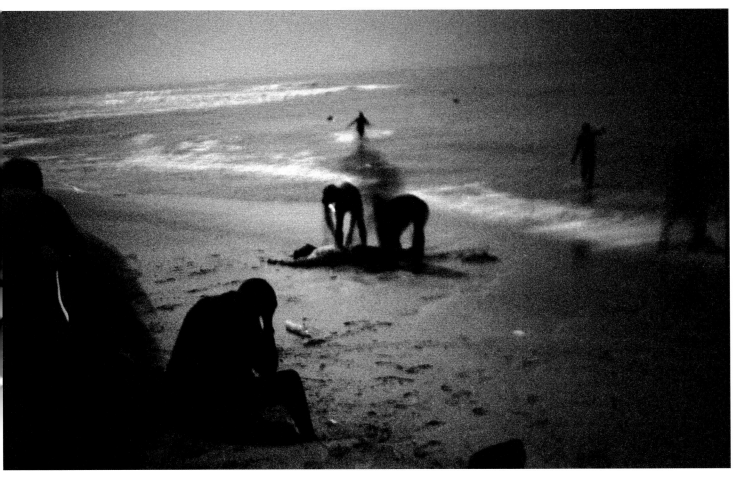

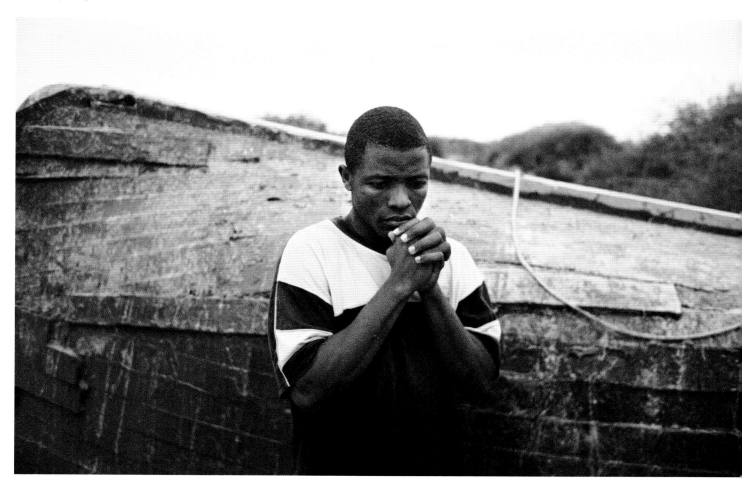

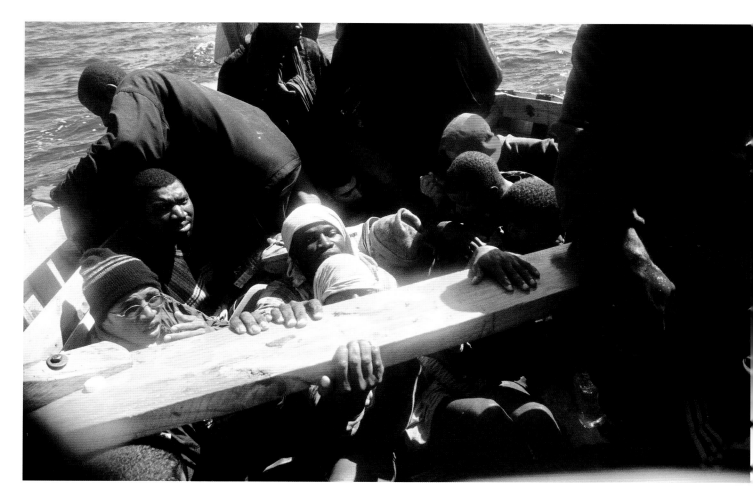

(continued) In his hometown, Kingsley earned just US$ 30 a month as a lifeguard at a hotel. He had already tried to reach Europe once before, in 2002, but turned back in Nigeria having run out of funds. On his second attempt he managed to raise the more than US$ 1,000 required to pay for the trip, for smuggler fees, and to finance his first weeks in Europe. Facing page, top: The would-be immigrants repaired the boat, but were anxious about using it again. Below: They made their second attempt a day after the first, but had to bail out water continuously. They were picked up by coastguards and taken to a detention center. Three weeks later, Moroccan nationals were sent back. Others who had not revealed their nationalities were freed by the Spanish government as officials could not state indisputably to which country repatriation should take place. Kingsley was flown to Malaga on the Spanish mainland. This page: In his new life in Val d'Oise near Paris Kingsley works twelve hours a day as a warehouseman and has a three-hour commute to work.

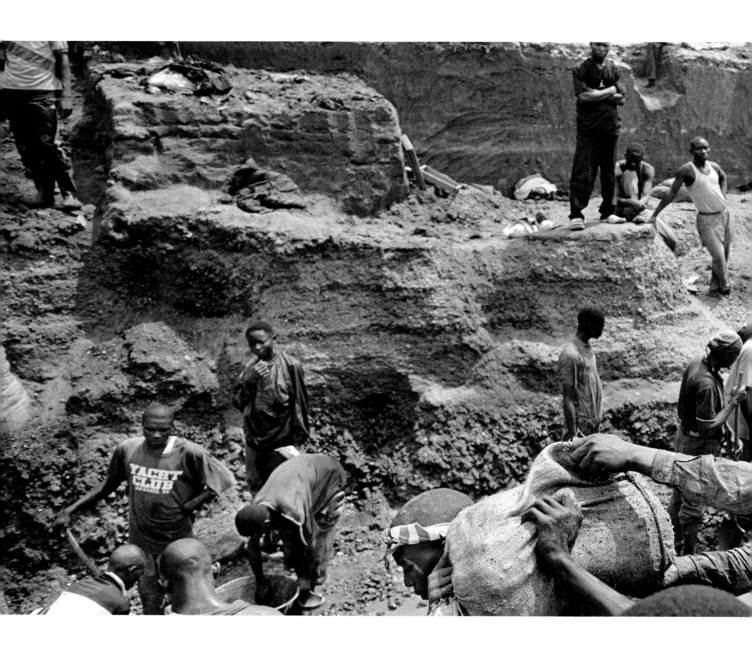

Kadir van Lohuizen
The Netherlands, Agence Vu
for NIZA/Vrij Nederland
2nd Prize Stories

The diamond industry draws its materials from some of the poorest and most troubled regions in the world. In the past, warlords and rebel groups in countries including Angola, the Democratic Republic of Congo, Liberia and Sierra Leone have used profits from the mines they control to buy arms and fund wars. The industry has attempted to prevent the spread of these 'conflict diamonds' by setting up the Kimberly Process to document and certify all exports. But conflict diamonds persist, smuggled out of strife-torn areas to neighboring countries and then sold on the black market or mixed with certified stones. Above: Men work in an open-pit mine at Bakwa Bowa in the Democratic Republic of Congo. They are watched over by armed guards. Production runs for 24 hours a day, in two twelve-hour shifts. (story continues)

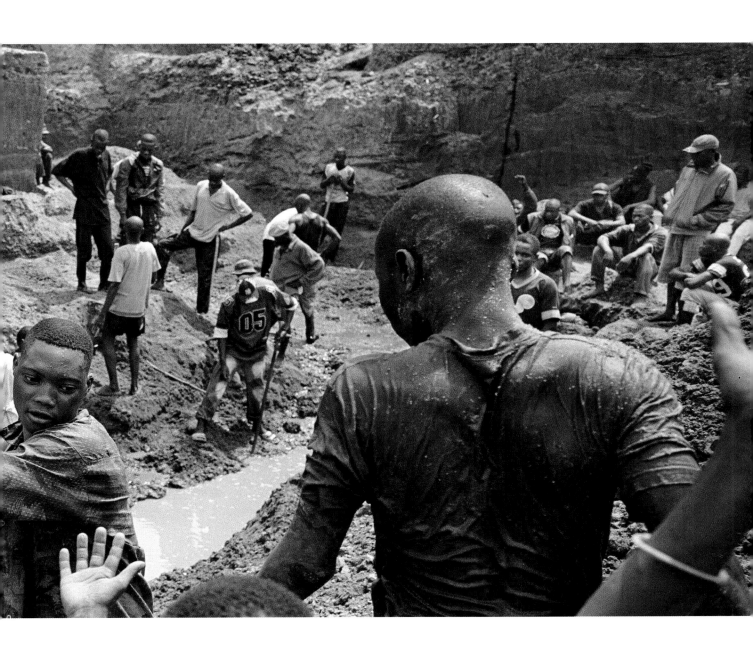

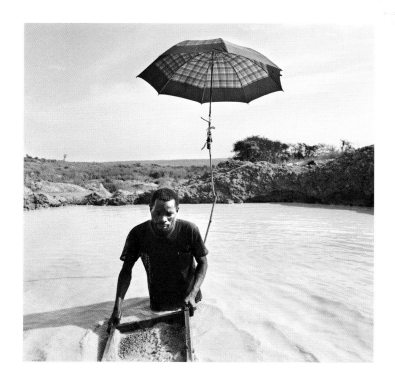

(continued) For the purposes of a Kimberly certificate dealers buying from freelance prospectors and smaller mines are supposed to draw up papers at the end of each day registering what has been bought. This page, left: Alluvial mining by an age-old method continues in many countries, such as here in Angola.

Right: A diamond dealer in Mbuji Mayi, the main diamond-trading town of DR Congo. He and many of his colleagues double as clergymen, buying diamonds from their loyal congregations. Facing page, top: A high-class jeweler's on Fifth Avenue in New York. Below: A society party in London.

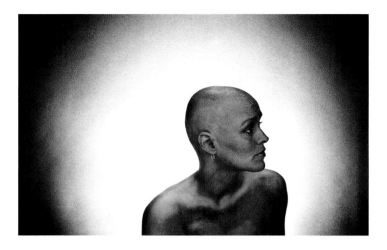 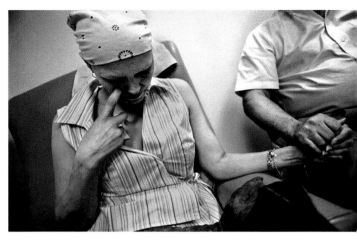

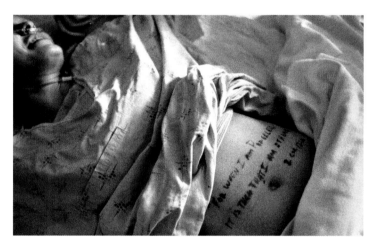 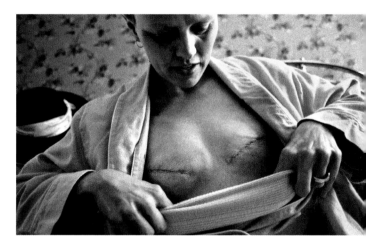

Christopher J. Capozziello
USA, for Time
3rd Prize Stories

Breast cancer is the most common cancer among women and the second leading cause of cancer death in women. In 2005 over 41,000 died from the disease in the US alone, but earlier diagnosis and improved treatment would appear to be driving death rates down. Mary Ann Nilan was diagnosed with breast cancer at the age of 39. She had chemotherapy, then a double mastectomy followed by reconstruction with implants, and

asked a photographer to record the process. This page, top left: Mary Ann shaved her head on her 40th birthday, before chemotherapy as she didn't want to lose her hair bit by bit. Right: A priest holds her hand as she awaits the last of eight chemo treatments. Below, left: Mary Ann wrote a verse from St Paul on her stomach to be read by doctors performing the mastectomy: "For when I am weak, it is then that I am strong". Right: After

surgery she was less upset by the damage than she had expected. Facing page, top left: Mary Ann examines her breasts after a painful injection of saline into tissue expanders that will stretch her skin to make way for implants. Right: A nurse locates a port for a saline injection. Below, left: Mary (12) performs the daily ritual of measuring her mother's hair growth. Right: Mary Ann's hair grew back completely.

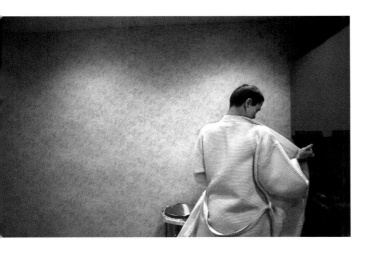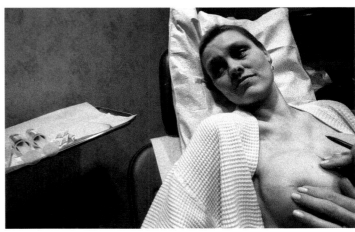
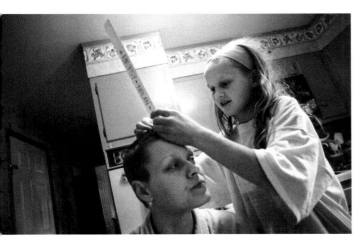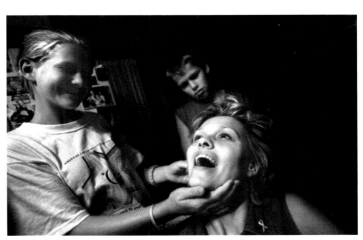

People in the News

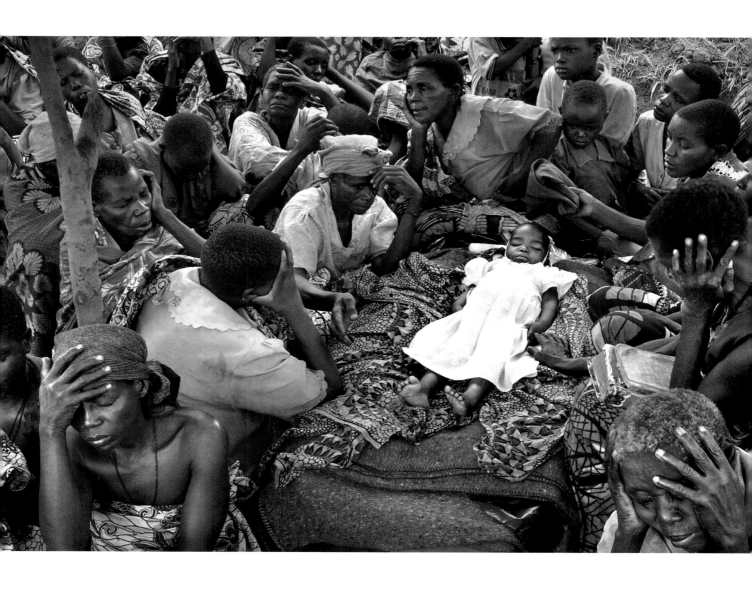

Sven Torfinn
The Netherlands, Panos Pictures
1st Prize Singles

Grieving relatives surround the corpse of five-year-old Vani Vamuliya, who died of dysentery in March. Vani's last days were spent in a camp for internally displaced persons (IDPs) in Tche, in the northeast of the Democratic Republic of Congo. Nearly four million people are believed to have perished over six years of violence in DR Congo, in one of the bloodiest conflicts since World War II.

Government forces, supported by Angola, Namibia and Zimbabwe were pitted against rebels supported by Uganda and Rwanda. Most of the casualties were women and children, and most died from starvation or disease. Although a peace deal was signed in 2003, militia violence continued, especially in the east of the country. In the weeks before Vani died, some 13,000 IDPs sought refuge in the camp at Tche.

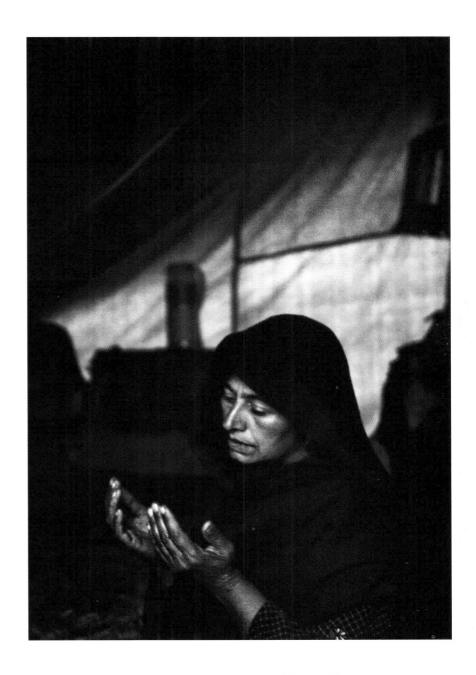

Jakob Dall
Denmark, for Danish Red Cross
3rd Prize Singles

Sameena Qureshi mourns the death
of her 16-year-old son Naseem in the
earthquake that devastated the
Kashmir region in October. Naseem
was one of 300 pupils who were killed
when their school building collapsed.
Three weeks later Sameena, who was
living in a camp just 30 meters away
from her former home, collected food
from different humanitarian
organizations for a memorial meal
she could share with neighbors.
In the moments before her guests
arrived, she prayed for her son.

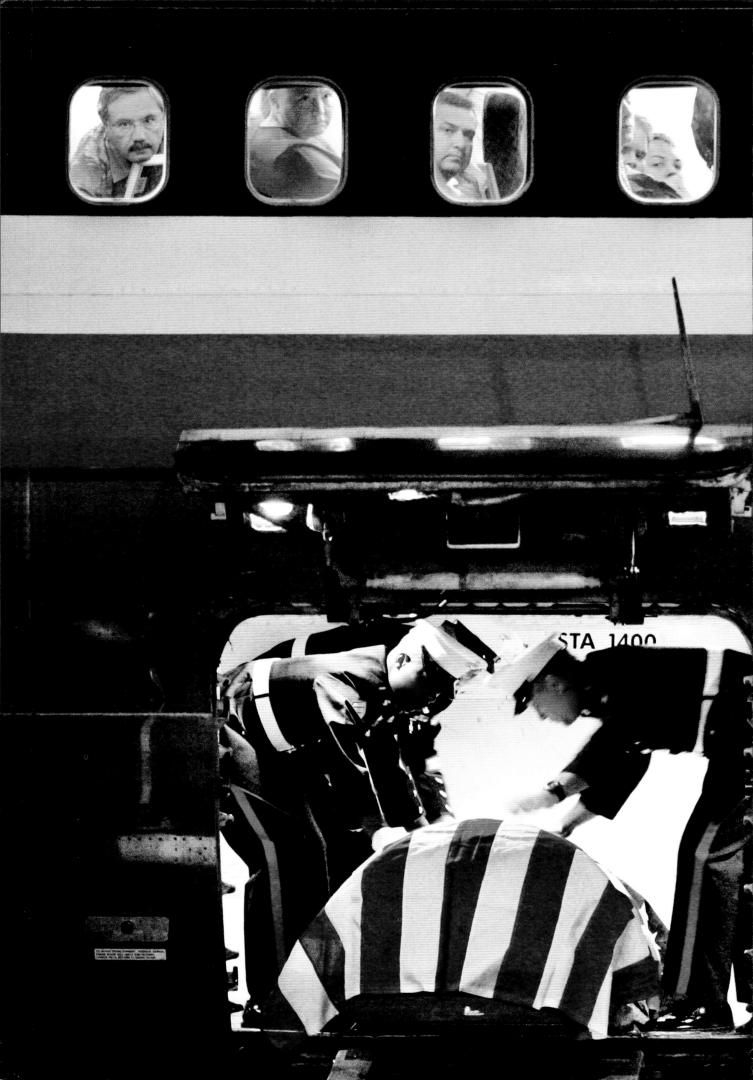

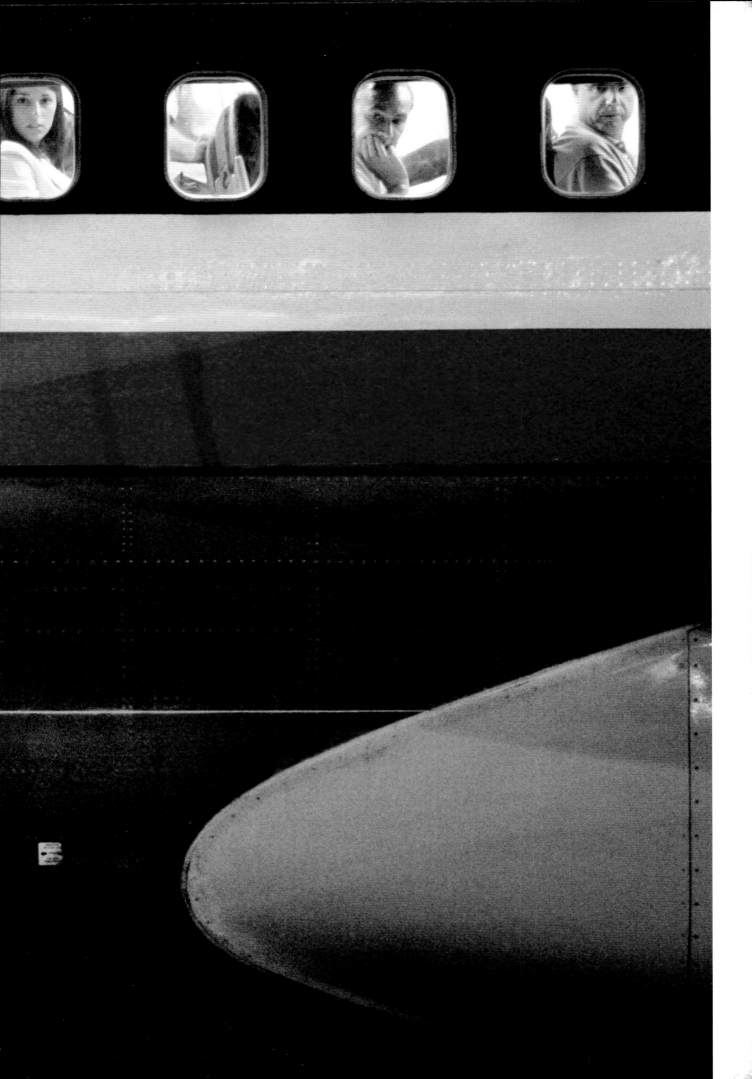

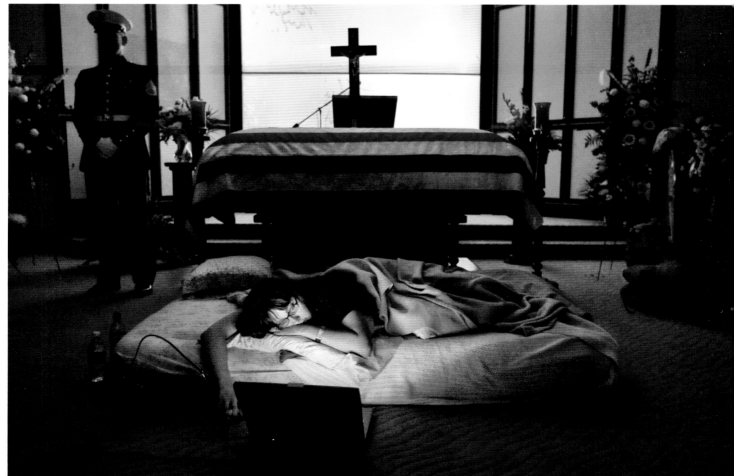

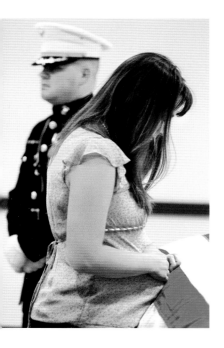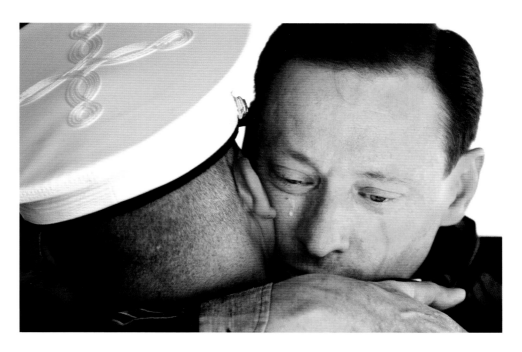

Todd Heisler
USA, Rocky Mountain News/
Polaris Images
1st Prize Stories

Since the start of the Iraq War, Marines based at Buckley Air Force base in Colorado, USA, have honored the memory of 16 fallen comrades, and had the difficult duty of helping the families to bear their loss. Second Lieutenant James Jeffrey Cathey was one of the fallen returned from Iraq for burial. Previous pages: Fellow marines drape a flag over Cathey's casket, as passengers on the plane that carried the body to his hometown of Reno, Nevada, watch his family and colleagues gather on the tarmac. Facing page, top: Major Steve Beck and another marine approach the Cathey home in order to escort his family to the airport. Below: On the night before the burial, Cathey's wife Katherine refused to leave the body, and played songs on her laptop that reminded her of her husband. This page, left: Katherine presses her pregnant belly to her husband's casket. She knows the child is to be a boy, and will name him James Jeffrey Junior. Right: Cathey's father is comforted by a marine from 23rd Squadron.

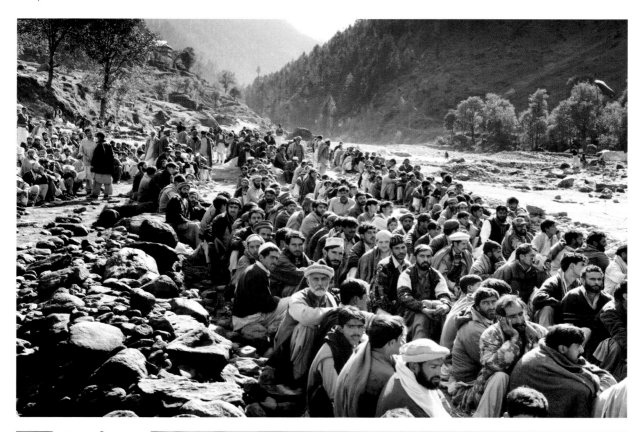

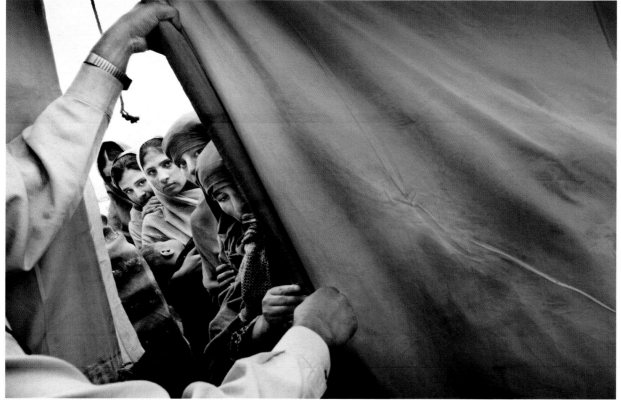

Jan Grarup
Denmark, Politiken/Rapho
2nd Prize Stories

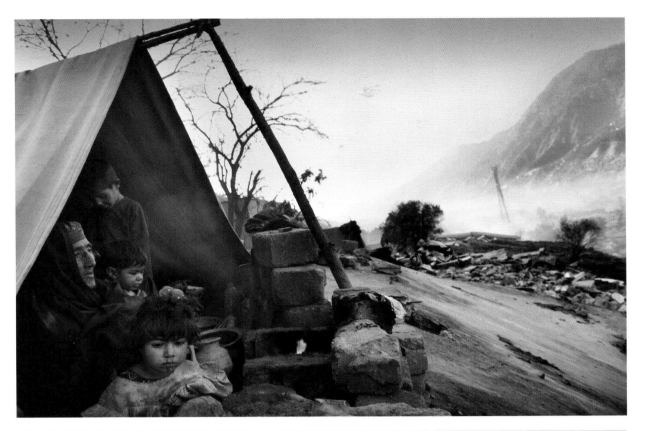

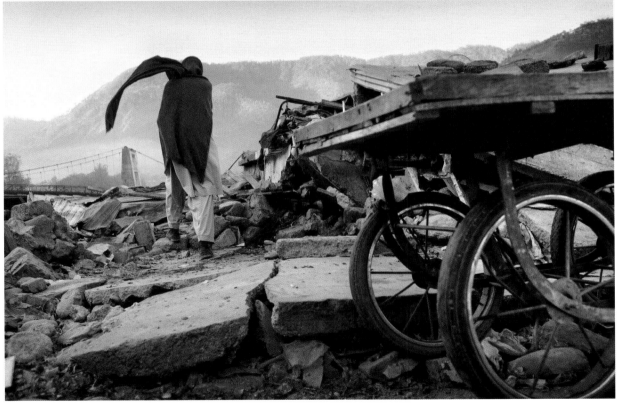

The massive October earthquake in Kashmir affected one of the highest and most remote regions on earth. Difficult terrain slowed relief work, and later snow would disrupt efforts even further. Over three million people were left homeless by the quake. By December the harsh Himalayan winter was closing in. Most tents distributed by aid workers were not designed to cope with the extreme cold. Facing page, top: Men wait for help in the Naran valley in Pakistan, some 60 kilometers from the epicenter, in December. After walking for days in the mountains, they reached the helipad only to find that supplies of tents and blankets had run out. Below: Women await help at a health clinic. This page, top: An old woman takes care of her grandchildren in a ruined house in the town of Balakot. Below: A survivor walks through the devastated market place at Balakot. Following pages: People cross a damaged footbridge in Patikka, Pakistan.

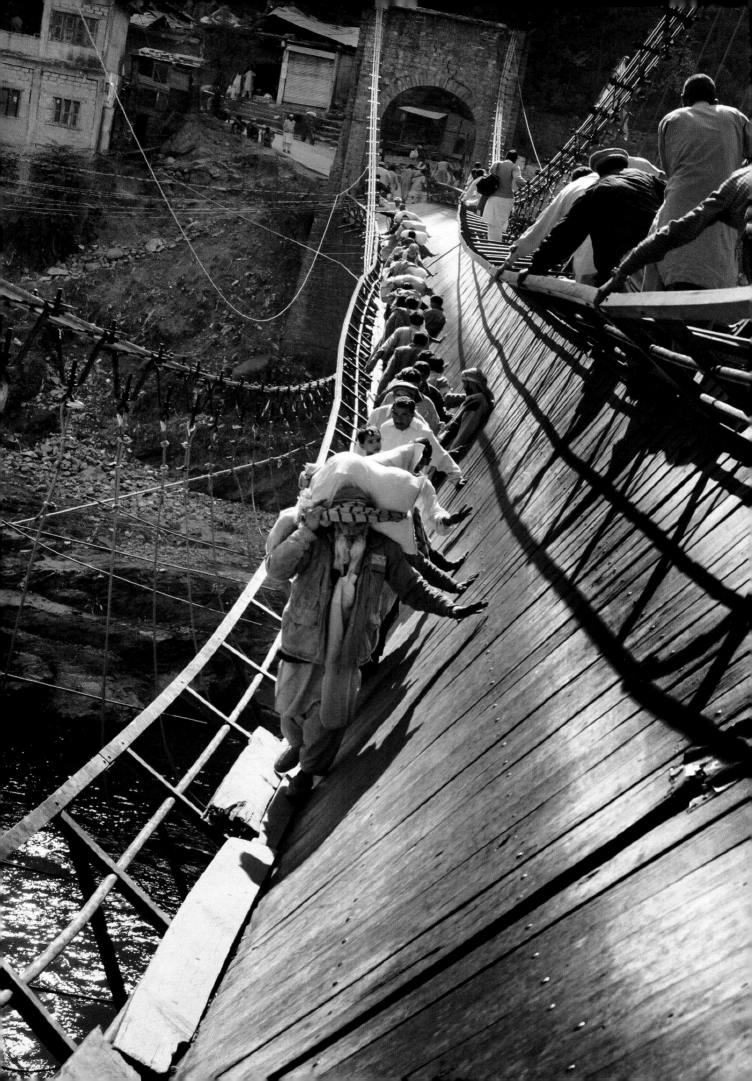

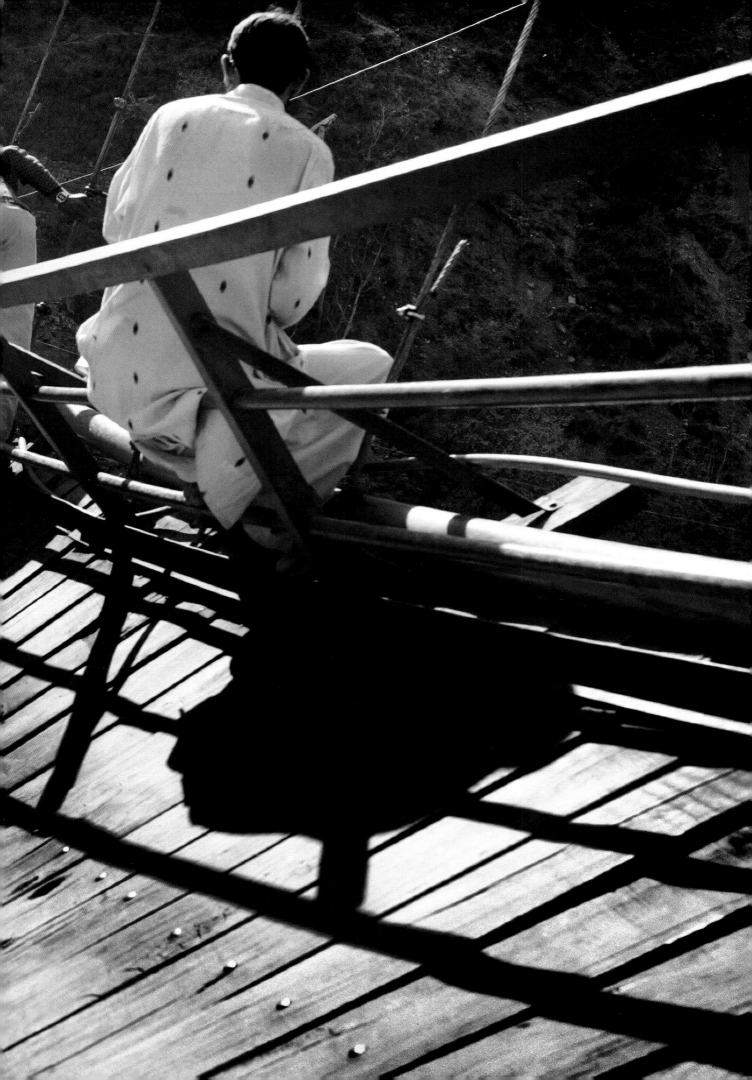

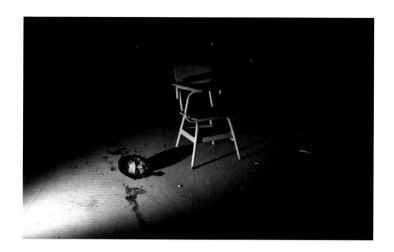

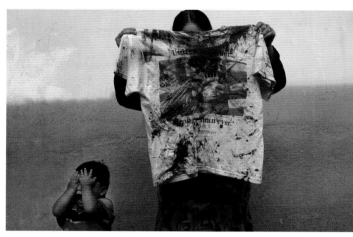

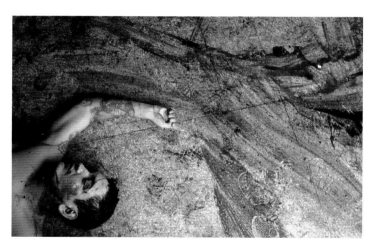

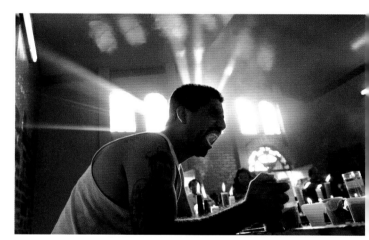

Rodrigo Abd
Argentina, The Associated Press
3rd Prize Stories

Youth gangs (known as *maras*) in Guatemala City were originally formed by the children of indigenous farmers, who fled the countryside in the 1980s during ongoing civil war and squatted on the outskirts of the capital. The youths imitated the style of Guatemalans deported from the USA for gang activity, and soon became involved in organized crime, murder, extortion and drug trafficking. Gang violence has now become part of everyday life in Guatemala. In August, gang rivalries erupted in a coordinated series of battles in four prisons across the country, leaving at least 30 prisoners dead and dozens more injured. This page, top left: The severed head of a gang member lies in the exercise ground after a prison riot in Guatemala City in September. Right: Ingrid Liliana Castro holds up the bloodied T-shirt of her husband Mario Roberto Diaz, a member of Mara 18, who disappeared in August after being wounded by unidentified assailants. Below, left: A dead inmate, a member of Mara 18, lies on the local morgue floor in Escuintla, 60 kilometers south of Guatemala City, after the August prison battles. Right: A member of Mara Salvatrucha eats a candle as part of a ritual to honor Maximón, a Mayan deity taken up by Guatemalan Catholics. Maximón is believed to give protection to thieves, prostitutes and outlaws. Facing page: A member of Mara 18, best known as 'El Criminal', poses for the press after being captured by the police during a weapons seizure in September.

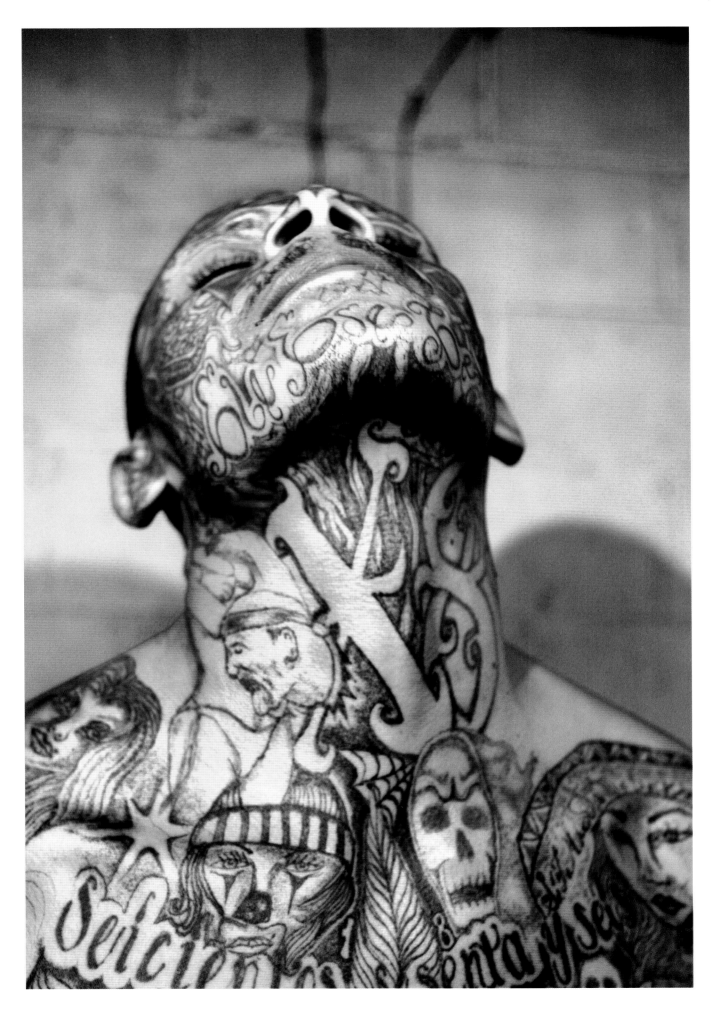

Prizewinners 2006

World Press Photo of the Year 2005
Finbarr O'Reilly, Canada, Reuters
Mother and child at emergency feeding center, Tahoua, Niger, 1 August

Page 4

The World Press Photo of the Year 2005 Award honors the photographer whose photograph, selected from all entries, represents an event, situation or issue of great journalistic importance in that year, and demonstrates an outstanding level of visual perception and creativity.

General News Singles
1 David Guttenfelder, USA, The Associated Press
Father and son in field hospital, Muzaffarabad, Pakistan, 30 October

Page 10

2 Andrew Testa, UK, Panos Pictures for The New York Times
Reburial of Srebrenica massacre victims' bodies, Potocari, Bosnia, 11 July

Page 12

3 Rafiq Maqbool, India, The Associated Press
Earthquake survivor waits for medical help, Kashmir, India, 9 October

Page 13

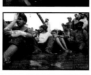

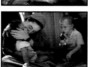

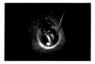
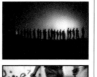

General News Stories
1 Uriel Sinai, Israel, for Getty Images
Evacuation of Jewish settlements, 12-18 August

Page 14

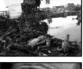
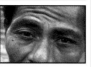
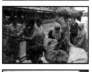

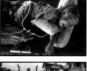
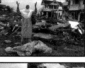
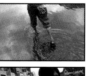
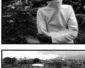
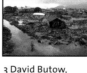

2 Seamus Murphy, Ireland, for The Sunday Times Magazine
Tunnel trade of Gaza, May

Page 18

3 David Butow, USA, Redux Pictures for US News & World Report
Tsunami aftermath, 3-10 January

Page 20

Spot News Singles
1 Mohamed Azakir, Lebanon, Reuters
Car bomb explosion, Beirut, Lebanon, 14 February

Page 22

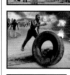

2 Chris Hondros, USA, Getty Images
Grieving girl moments after US patrol killed her parents in an accidental shooting, Tal Afar, Iraq, 18 January

Page 23

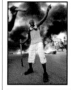

3 Edmond Terakopian, United Kingdom, Press Association
London underground bomb attack survivor, London, 7 July

Page 24

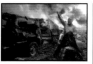
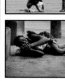
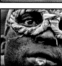
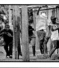

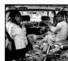

Spot News Stories
1 Ben Curtis, United Kingdom, The Associated Press
Street violence during presidential elections, Togo, 22-27 April

Page 26

**Honorable Mention
Scott Nelson, USA,
for World Picture
News**
Car bomb
explosion at Tahrir
Square, Baghdad,
Iraq, 7 May

Page 36

**3 Michael Appleton,
USA, New York
Daily News**
Hurricane Katrina
aftermath, New
Orleans, 30 August–
5 September

Page 32

...ás Munita,
, The
ciated Press
mir
quake
math,
ber–December

30

WE
NE ED
FO

**Honorable Mention
Vincent Laforet,
USA, The New York
Times**
Hurricane Katrina
aftermath,
30 August–
3 December

Page 38

Nature Singles
**1 Massimo
Mastrorillo, Italy**
Lhoknga: beach
with palm trees
after tsunami,
Banda Aceh,
Indonesia

Page 40

**2 Pål Hermansen,
Norway, for Orion
Forlag/Getty
Images**
Polar bear, Svalbard

Page 42

**3 Halden Krog,
South Africa, Beeld**
Stranded fishing
boat after tsunami,
Banda Aceh,
Indonesia,
12 January

Page 43

Nature Stories
**1 Kieran Dodds,
United Kingdom,
Evening Times/
The Herald**
Fruit bats, Kasanka
National Park,
Zambia

Page 44

**2 Palani Mohan,
Australia, Getty
Images**
Asian elephant

Page 48

**3 Daniel Beltrá,
Spain, for
Greenpeace**
Amazon drought

Page 50

139

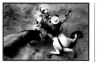

Sports Features Singles
1 Henry Agudelo, Colombia, El Colombiano
Bullfighter, Medellín

Page 52

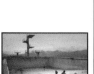

2 David Guttenfelder, USA, The Associated Press
Boys play football, Kabul, Afghanistan

Page 54

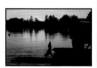

3 Ezra Shaw, USA, Getty Images
Wheelchair athletes relax after race, Alaska

Page 55

Sports Features Stories
1 Mark & Jenny Evans, Australia
Horse racing, Australia

Page 56

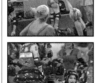

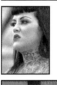
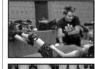

2 David Maialetti, USA, Philadelphia Daily News
The Philly Roller Girls

Page 60

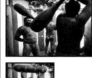
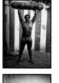
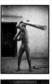
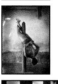

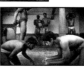

3 Tomasz Gudzowaty & Judit Berekai, Poland/Hungary, Yours Gallery/Focus for Pozytyw
Traditional Indian wrestling

Page 62

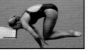
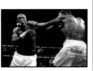

Sports Action Singles
1 John G. Mabanglo, USA, European Pressphoto Agency
Diver Chelsea Davis at FINA World Championships, Montreal, 22 July

Page 64

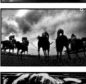

2 Sydney Seshibedi, South Africa, Sunday Times
Sidney Maluleka fights with Sello Hanong, Johannesburg, 16 September

Page 65

3 Ryan Pierse, Australia, Getty Images
Andy Roddick at Australian Open Tennis Championships, Melbourne, 26 January

Page 66

Sports Action Stories
1 Donald Miralle, Jr., USA, Getty Images
Sports portfolio

Page 68

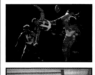

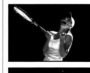
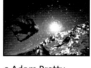

2 Adam Pretty, Australia, Getty Images
Sports portfolio

Page 70

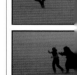

3 Benito Pajare, Spain, El Mundo SaharaMarath
Sahara Marath

Page 72

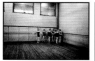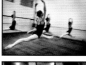

and
rtainment
les
ne Robinson,
Africa,
Wire Africa
e Globe and

class,
ndra
ship, South

4

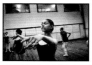

Zhou,
e's Republic
na,
gzhou Daily
mi victims
emoration
ony, Thailand

6

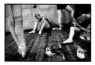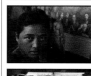

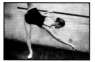

ael Wirtz,
he
elphia
er
vador Dalí
tion,
elphia

7

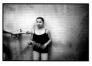

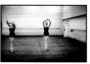

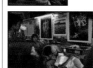

Arts and Entertainment Stories
1 Åsa Sjöström, Sweden
Ballet school, Moldova

Page 78

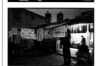

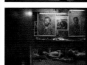

2 Haibo Yu, People's Republic of China, Shenzhen Economic Daily
Dafen oil painting village

Page 82

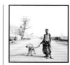

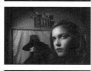

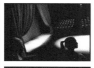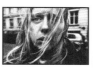

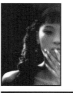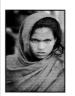

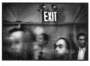

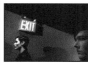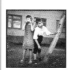

3 Paolo Pellegrin, Italy, Magnum Photos for Olympus
New York Fashion Week

Page 84

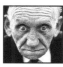

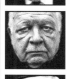

Portraits Singles
1 Pieter Hugo, South Africa, Corbis
Mallam Galadima Ahamadu with the hyena Jamis, Abuja, Nigeria

Page 86

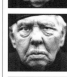

2 David Høgsholt, Denmark
Mia, drug addict and prostitute

Page 87

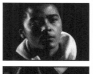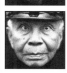

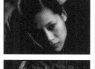

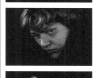

3 Tomás Munita, Chile, The Associated Press
Kashmir earthquake survivor, Balakot, Pakistan

Page 88

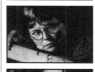

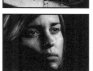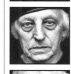

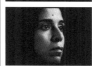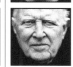

Honorable Mention
Robert Knoth, the Netherlands, TCS/Contrasto for Greenpeace International
Chernobyl children Natasha and Vadim

Page 89

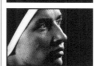

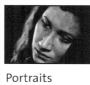

Portraits Stories
1 Paolo Pellegrin, Italy, Magnum Photos for Newsweek,
Vigil at St. Peter's Square, Rome, 2 April

Page 90

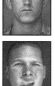

2 Martin Roemers, the Netherlands, Hollandse Hoogte/Laif Photos & Reportagen
World War II veterans

Page 94

3 Lucian Read, USA, World Picture News
Page 96

141

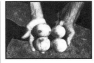
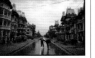
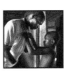
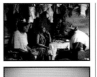

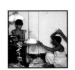

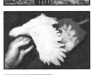
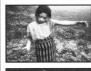
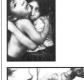
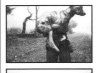
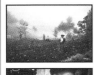

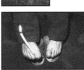
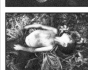

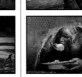
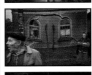
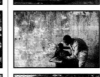
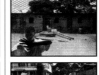
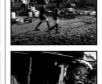
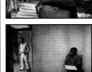
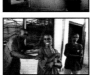
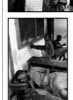
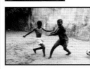
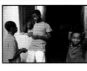
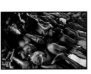
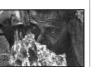

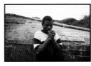

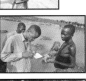

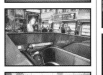
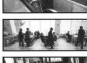
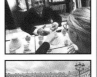
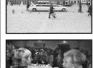
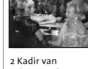

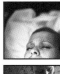

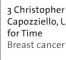

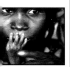

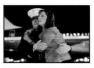

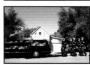

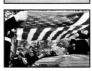

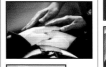

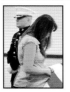

People in the News Stories

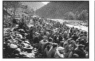

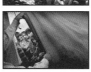

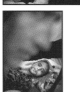

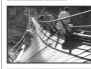

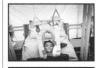

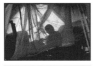

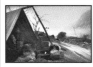

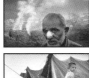

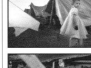

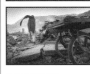

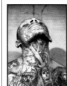

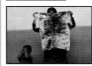

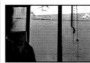

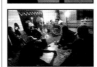

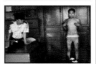

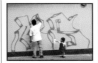

143

Participants 2006 Contest

In 2006, 4,448 photographers from 122 countries submitted 83,044 entries. The participants are listed here according to nationality as stated on the contest entry form. In unclear cases the photographers are listed under the country of postal address.

AFGHANISTAN
Zalmaï Ahad

ALBANIA
Bevis Fusha
Petrit Kotepano

ALGERIA
Idjeraoui Atmane
Mustafa Qasmi

ARGENTINA
Marcelo F. Aballay
Rodrigo Abd
Martin Acosta
Manuel Arce
Fer Arias
Walter Astrada
Carlos Barria
Marcos Brindicci
Victor R. Caivano
Capotosti
Pablo Castagnola
Maria Eugenia Cerutti
Gustavo Cherro
Daniel Cima
Pablo Cuarterolo
Daniel Dapari
Gerardo Dell'Oro
Benito Francisco Espindola
Diego Fernandez Otero
Antonio Ferroni
Daniel Garcia
Diego Goldberg
Renzo Mario Gostoli
Juan Hein
Claudio Herdener
Bea Isabello
Gustavo Jononovich
Emiliano Lasalvia
Ali Burafi
Emiliana Miguelez
Ana Morán
Hernan Gustavo Ortiz
Julio Pantoja
Jorge Pérez
Ricardo Pristupluk
Angel Ricardo Ramírez
Héctor Rio
Miriam Rosales Trigo
Juan Sandoval
Sebastian Scheiner
Antonio Scorza
Jose Enrique Sternberg
Gustavo Suarez
Omar Torres
Tony Valdez
Horacio Villalobos
Hernan Zenteno

ARMENIA
German Avagyan
Hayk Bianjyan
Eric Grigorian
Piruza Khalapyan
Ruben Mangasaryan
Karen "Emka" Mirzoyan
Inna Mkhitazyan
Shakhidzanyan
Nelli Shishmanyan

AUSTRALIA
Michael Amendolia
Joe Armao
Jack Atley
Ben Baker
Robert Barker
Daniel Berehulak
Paul Blackmore
Torsten Blackwood
Philip Blenkinsop
Vasil Boglev
Michael Bowers
James Brickwood
Philip Brown
Patrick Brown
Britta Campion
Robert Carew

Sharon Cavanagh
Jason Childs
Steve Christo
Robert Cianflone
Warren Clarke
Tim Clayton
Nuno da Costa
Megan Cullen
Sean Davey
H. Davies
Toni Dore
Louie Douvis
Neale Duckworth
Stephen Dupont
Brenton Edwards
Brendan Esposito
Jenny Evans
George Fetting
Nicole Garmston
Tim Georgeson
Kate Geraghty
Ashley Gilbertson
Kirk Gilmour
Craig Golding
Steve Gosch
Philip Gostelow
David Gray
Robert Griffith
Mathias Heng
Ian Hitchcock
Chris Ivin
Martin Jacka
Anthony Johnson
David L. Kelly
Nicholas Laham
Tanya Lake
Wade Laube
Dean Lewins
Sylvia Liber
Jesse Marlow
Dean Martin
Régis Martin
Chris McGrath
Justin McManus
Darren Charles McNamara
Sam McQuillan
Andrew Meares
Andrew Merry
Paul Miller
Palani Mohan
Nick Moir
Fiona Morris
Debrah Novak
Renee Nowytarger
Jason O'Brien
Warrick Page
Steve Pennells
Jack Picone
Ryan Pierse
Adam Pretty
Andrew Quilty
Paul Raffaele
Mark Ralston
Tony Reddrop
Jason Reed
Jon Reid
Brad Rimmer
Moshe Rosenzveig
Melanie Russell
Sam Ruttyn
Dean Saffron
Sandy Scheltema
Russell Shakespeare
Steven Siewert
Barry Slade
Matthew Sleeth
Cameron Spencer
Marc Sinclair Stapelberg
Tasso Taraboulsi
Therese Tran
Mick Tsikas
Tamara Voninski
Ian Waldie
Craig Wilson
Tim Wimborne
Gregory Wood
Andy Zakeli

AUSTRIA
Heimo Aga
Harald Arnold
David Bacher
Philipp Horak
Alex Kals
Miro Kuzmanovic
Wolfgang Mayer
Herbert Neubauer
Helmut Ploberger
Josef Polleross

Reiner Riedler
Norbert Schiller
Aram Voves

AZERBAIJAN
Ancelika Babayera
Rafiq Ali Gambarov
Jegar Jafarov
Emil Khalilov
Etibar Mammadov
Jane Najafova
Azad Rzayev
Tabasaran Seyid-Aliev

BAHAMAS
Felipé Major

BANGLADESH
Abir Abdullah
Maruf Hasan
G.M.B. Akash
Shahidul Alam
Monirul Alam
K.M. Jahangir Alam
Didarul Alam
Abdul Malek Babul
Choudhury Luthfe Elahi
Shoeb Faruquee
Md. Shirazul Haque Shajib
Ashanul Haque Khan
Kajal Hazra
Morshed Hassin Himadri
Kabir Hossain
Rubaiyat
M.K. Islam
M. Shafiqul Islam
Juthika Howlader
Md. Anowarul Kader
Naymuzzaman Prince
Tanvir Murad Topv
Abu Taher Khokon
Saifel Huq Omi
Dilip Kumar Das
Tarek Mostafa Shahrear
Aminuzzaman
Shehzad Noorani
Shahadat Parvez
Kazi Md. Golam Quddus
Andrew Biraj
Jewel Samad
Oviek Sarwar
Khaled Sattar
Din M. Shibly
Partha Talukdar
Shamsul Hoque Tanku
Zobaer Hossain Sikder

BELARUS
Vasily Fedosenko
Kliashchuk Anatoli
Nikolai Titov

BELGIUM
Rudi van Beek
Anne Bois d'Enghien
Nicolas Bouvy
Michael Chia
Gert Cools
Tineke D´Haese
Thomas Dashuber
Joost De Raeymaeker
Patrick De Roo
Fabrice Demoulin
Tim Dirven
Kris van Exel
Bruno Fahy
Thierry Falise
Brigitte Grignet
Nick Hannes
Wim Hendrix
Tomas van Houtryve
Yorick Jansens
Eddy Kellens
Christophe Ketels
Carl De Keyzer
Christophe Licoppe
Peter Maenhoudt
Firmin de Maitre
Olivier Matthys
Roger Milutin
Bart van der Moeren
Samer Mohdad
Didier Mossiat
Dario Pignatelli
Philip Reynaers
Sébastien Smets
Bruno Stevens
Laurent van der Stockt
Marc de Tollenaere

Gaël Turine
Alex Vanhee
Eva Vermandel
Jo Voets
Warnand

BOLIVIA
Martin Alipaz
Patricio Crooker
Pedro Laguna
Gonzalo Ordóñez L.

BOSNIA-HERZEGOVINA
Mediha Fejzagic Dimartino
Ziyah Gafic
Milan Radulovic
Damir Sagolj
Drago Vejnovic
Darko Zeljkovic

BRAZIL
Rosa Albari Silva
Célio Jr
Paulo Amorim
Débora Amorim
Alberto Cesar Araújo
João Bacellar
Nário Barbosa
Alexandre Belém
Mônica Bento
Jamil Bittar
Oiram Bourges
Oslaim Brito
Gil Vicente
André Camara
Rubens Cardia
Weimer Carvalho
Rogério Cassimiro
Castelo Branco
Antonio Cazzali
Maurilio Cheli
Adalmir Chixaro
André Coelho
Julio Cordeiro
Antonio Costa
Ione Costa Guedes Da
Marizilda Cruppe
Orlando Filho
Fernando Dantas
José Francisco Diorio
Bruno Domingos
Evilazio Bezerra
Robson Fernandjes
Alcione Ferreira
Eduardo Nicolau
Nilton Fukuda
Dado Galdieri
Jair Grandin
Antonio Iaccovazo
Andrea Motta
Andréa Iseki
Beto Figueirôa
Ulisses Job Lima
Mauricio Lima
Rodrigo Lôbo
Helvio Romero Lopes
Pablo De Luca
Celso Luiz
Benito Maddalena
Gustavo Magnusson
Teresa Maia
Leticia Freire
Eduardo Martino
Antonio Gauderio
Alexandre Meneghini
Clovis Miranda Pereira
Sergio Moraes
Sebastião Moreira
Fabio Motta Lins
Marcelo Ferrelli
Genna Naccache
Gaspar Nóbrega
Tom Boechat
Ricardo Olivieira
Renata Fernandes
Euler Paixao
Vinicius Souza
Eraldo Peres
Jean Pimentel
Paulo Pinto
Claudinei Plaza
Marcos Ramos
Marcio Resende de Mendonca e Silva
Evelson de Freitas
Maria Eugênia Sá
Patricia Santos
Anderson Schneider
Marcio Silva

Beto Barata
Raimundo Valentim
Rogério Stella
Andrea Testoni
Daniel Tossato
José Varella
Djalma Vassao
Fabio Vicentini
Luciano Vicioni
Tuca Vieira
André Vieira
Ed Viggiani
Luis Tadeu Vilani
Rodrigo Zanotto

BULGARIA
Mladen Antonov
Svetlana Bahchevanova
Mimi Chakarova
Nick Chaldakov
Dimitar Dilkoff
Hristo Hristov
Valentina Kristeva
Dimitar Kyosemarliev
Mehmed Aziz
Stoyan Nenov
Georgy Velichkov
Yellowman
Boris Voynarovitch

CAMEROON
Eustache Désiré Djitouo
Ngouagna
Happi Raphaël Mbiele

CANADA
Carlo Allegri
Chris Anderson
Benoit Aquin
Terry Asma
Olivier Asselin
Brian Atkinson
Anthony Shiu Hung Au
Anne Bayin
Grant Black
Christopher Black
Mike Blake
David Blumenfeld
Bernard Brault
Peter Bregg
Edward Burtynsky
Kitra Cahana
Ryan Carter
Dave Chidley
Kathie Coward
Charlene Cowling
Derek Crowe
Paul Darrow
Barbara Davidson
Bruce Edwards
Rick E. Eglinton
Darren Ell
Heather Faulkner
Edward Gajdel
Benoit Gariépy
Brian J.Gavriloff
Greg Girard
Jacques Grenier
Guang Niu
Jane Eaton Hamilton
John Hasyn
Veronica Henri
Gary Hershorn
Harry How
Adam Huggins
Emiliano Joanes
Charla Jones
Darya Khameseh
Marko Kokic
Tibor Kolley
Joshua Kraemer
David J Langer
Aislinn Leggett
Rita Leistner
Roger Lemoyne
Laura Leyshon
Karen Longwell
John Lucas
Fred Lum
Rick Madonik
Jeff McIntosh
Sandy Nicholson
Gary Nylander
Finbarr O'Reilly
Lucas Oleniuk
George Omorean
Carlos Osorio
Kevin van Paassen
Louie Palu

Wendell Phillips
André Pichette
Vincenzo Pietropaolo
Peter Power
Ryan Pyle
Jim Rankin
Ryan Remiorz
Marc Rochette
Jim Ross
Steve Russell
Derek Ruttan
Robert Semeniuk
Peter Sibbald
Steve Simon
Jack Simpson
Sami Siva
Lana K. Slezic
Gregory Southam
Lyle Stafford
Andrew Stern
Nayan Sthankiya
Robert Tinker
Maciej Tomczak
Larry Towell
Martin Tremblay
Walter Tychnowicz
Andrew Vaughan
Steve Wadden
Christopher Wahl
Julian Abram Wainwright
George Webber
Donald Weber
Bernard Weil
Larry Wong
Nick Wong
Iva Zimova

CHILE
Paco Arévalo Varela
Luis Enrique Ascui
Alejandro Balart
Orlando Barría
Roberto Candia
Gustavo Corvalán
Marco Fredes
Edgard Garrido
Rodrigo Garrido Fernández
Luis Alexis Hidalgo Parra
Hugo Infante
Tomás Munita
Waldo Nilo
Claudio Pérez
Pedro Ugarte
Carlos Villalon
Anibal Vivaceta
Ernesto Zelada

COLOMBIA
Luis Cristobal Acosta Castro
Henry Agudelo
Gabriel Aponte Salcedo
Juan Manuel Barrero
Daniel Bustamante
Felipe Caicedo Chacón
Nelson Cárdenas
Abel E. Cardenas O.
Gerardo Chaves
Milton Diaz
Edgar Domínguez
Jose Miguel Gomez Mogollon
Juan Pablo Gomez
Mauricio Moreno
Daniel Munoz
Eduardo Munoz
Oswaldo Paez
Jaime Pérez
Federico Puyo
Henry Romero
Manuel Saldarriaga
Rodrigo Sepulveda
John W. Vizcaino

COSTA RICA
Jeffrey Arguedas
Alexander Arias
Garrett Britton
Marvin Caravaca
Jorge Castillo
Jose Diaz
Carlos González Carballo
Cleon
Mayela López
Alexander Otarola
Mónica Quesada
J.C. Rubi
David Vargas Chacón

CROATIA
Miroslav Kis

Vanda Kljajo
Dragan Matic
Darije Petkovic
Kristina Vidanec
Ivo Vucetic

CUBA
Gonzalo Gonzalez
Noel Miranel
Alejandro Ernesto
Luis Quintanal
Giorgio Viera

CYPRUS
Nicolas Iordanou
Petros Karadjias

CZECH REPUBLIC
Jaroslav Bocek
Josef Bradna
Jan Cága
Vladimir David
Alena Dvorakova
Viktor Fischer
Radek Kalhous
Antonin Kratochvil
Standa Krupar
Veronika Lukasova
Dan Materna
Marketa Navratilova
Michal Novotny
Lucie Parizkova
Jiri Rezác
Slavek Ruta
Jan Sibik
Filip Singer
Tomas Svoboda
Jan Symon
Ales Vasicek
Vaclav Vasku
Vondrous Roman
Martin Wágner
Jan Zatorsky

DENMARK
Steven Achiam
Christian Als
Nicolas Asfouri
Casper Balslev
Lars Bech
Lars Bertelsen
Soren Bidstrup
Michael Boesen
Thomas Borberg
Sisse Brimberg
Jakob Carlsen
Klavs Bo Christensen
Fredrik Clement
Jan Dago
Casper Dalhoff
Jakob Dall
Miriam Dalsgaard
Jacob Ehrbahn
Bardur Eklund
Finn Frandsen
Thomas Fredberg
Jan Grarup
Mads Greve
Bjorn Stig Hansen
Tine Harden
Peter Hauerbach
Maria Hedegaard
Rudy Hemmingsen
Jorgen Hildebrandt
David Høgsholt
Jens Honore
Niels Hougaard
Jeppe Michael Jensen
Michael Jensen
Simon Jeppesen
Martin Johansen
Rune Johansen
Nils Jorgensen
Anna Kari
Lars Krabbe
Joachim Ladefoged
Claus Bjørn Larsen
Stine Larsen
Martin Lehmann
Bax Lindhardt
Nicolai Lorenzen
Poul Madsen
Uffe Weng
Nils Meilvang
Lars Moeller
Mads Nissen
Thorsten Overgaard
Panduro
Ulrik Pedersen

Lene Esthave
Torben Raun
Karl Ravn
Erik Refner
Peter Grosen
Thomas Sjoerup
Betina Skovbro
T. Kaare Smith
Jacob Aue Sobol
Johan Spanner
Michael Svenningsen
Kare Viemose
Robert Wengler

DOMINICAN REPUBLIC
Miguel Gomez

ECUADOR
Alvaro Avila Simpson
Mievel Canales
Richard Castro
Stalin Agustin Diaz Suarez
Francisco Ipanaqué
Alex Lima
Gina Lupera
Daniela Merino
Gerardo Mora
César Morejón
Galo Paguay
Diego Pallero
Bolivar A. Parra
Daniel Patino Flor
Armando Prado
Edison Riofrío Barros
Angela Salgado
Eduardo Teran
Jonathan Miranda
Jorge Vinueza G.

EGYPT
Khaled El Fiqi
Nasser Nouri
Ahmed Tamboly

EL SALVADOR
Francisco Alemán
Félix Amaya
Roberto Antillon
Mauro Arias
José Cabezas
Francisco Campos
Yuri Cortez
Rony González
Gabriela Hasbun
Oscar Leiva Marinero
Borman Marmol
Salvador Melendez
Garcia Nilton
Salomón Vasquéz

ERITREA
Eyob Ogbai Gebre Kidan
Abubeker Hussien Gass
Girmay Gebremicael Abraha
Afewerki Haile
Yoseif Idrisadem

ESTONIA
Tairo Lutter

ETHIOPIA
Michael Isegaye

FINLAND
Tommi Anttonen
Mikaela
Seppo Haavisto
Esko Jämsä
Markus Jokela
Martti Kainulainen
Petteri Kokkonen
Kari Kuukka
Rami Lappalainen
Elina Moriya
Petri Mulari
Juhani Niiranen
Pekka Pääkkö
Timo Pyykkö
Jukka Ritola
Heikki Saukkomaa
Eetu Sillanpää

FRANCE
Lahcène Abib
Pierre Adenis
Pascal Aimar
Guilhem Alandry
Céline Anaya Gautier
Patrick Artinian

Maher Attar
Jean-Claude Aunos
Patrick Aventurier
Alain Le Bacquer
Vincent Baillais
Capucine Bailly
Jean-Christophe Bardot
Gilles Bassignac
Pascal Bastien
Patrick Baz
Benjamin Béchet
Arnaud Beinat
Salah Benacer
Bernard Bisson
Cyril Bitton
Alain Bizos
Romain Blanquart
Olivier Boëls
Samuel Bollendorff
Guillaume Bonn
Jerome Bonnet
Youssef Boudal
Denis Boulanger
Denis Bourges
Philippe Brault
Hervé Bruhat
Martin Bureau
Alain Buu
Christophe Calais
Bruno Calendini
Thibault Camus
Alvaro Canovas
Serge Cantó
Cyril Cavalié
Derrick Ceyrac
Olivier Chambrial
Patrick Chapuis
Julien Chatelin
Eric Chauvet
Frederique Cifuentes
Sebastien le Clezio
Thomas Coex
Guillaume Collanges
Jerome Eagland-Conquy
Magali Corouge
Olivier Corsan
Vincent Couarraze
Christophe Courteau
Pierre Crom
Olivier Culmann
Francois Daburon
Denis Dailleux
Viviane Dalles
Thomas Dandois
Julien Daniel
William Daniels
Georges Dayan
Beatrice De Gea
Gautier Deblonde
Manoocher
Jean-Michel Delage
Michel Delaunay
Marc Delaunay
Francis Demange
Michel Denis-Huot
Philippe Desmazes
Xavier Desmier
Miquel Dewever-Plana
Hervé Dez
Agnes Dherbeys
François Dominguez
Marie Dorigny
Claudine Doury
Alexis Duclos
Thierry Dudoit
Frédéric Dufour
Sébastien Dufour
Emmanuel Dunand
Philippe Dupuich
Rachida El Ghazali
Laurent Emmanuel
Alain Ernoult
Isabelle Eshraghi
Eric Facon
Cédric Faimali
Hubert Fanthomme
Gilles Favier
Eric Feferberg
Pascal Fellonneau
Franck Fife
Corentin Fohlen
Sylvie Francoise
Simon Gade
Eric Gaillard
Raphaël Gaillarde
Matilde Gattoni
Georges Gobet
Julien Goldstein
Mathieu Grandjean

Jacques Grison
Marion Gronier
Olivier Grunewald
Jean-Paul Guilloteau
Valery Hache
Philippe Haÿs
Guillaume Herbaut
Jean-Marie Huron
Mat Jacob
Fred Jagueneau
Olivier Jobard
Armineh Johannes
Sylvette Kandel
Alain Keler
Vincent Kessler
Stephane Klein
Jean Philippe Ksiazek
Benedicte Kurzen
Olivier Laban Mattei
Brigitte Lacombe
Fréderic Lafargue
Nathan Lainé
Patrick Landmann
Francis Latreille
Didier Lefevre
André Lejarre
Lekic Dragan
Vincent Leloup
Christophe Lepetit
Rene Limbourg
Christian Lombardi
Jean-Marc Lubrano
Jean-Luc Luyssen
John MacDougall
Tariq Mahmood
Gregoire Maisonneuve
Etienne de Malglaive
Alexandre Marchi
Pierre-Philippe Marcou
Francois Xavier Marit
Ali Moon
Catalina Martin-Chico
Elizabeth Maslard
Sébastien Mathé
Andrew McLeish
Georges Merillon
Pierre Mérimée
Gilles Mingasson
Michel le Moine
J.F. Monier
Olivier Morin
Jean Claude Moschetti
Vincent Mouchel
Frédéric Mouchet
Freddy Muller
Farooq Nahem
Hervé Negre
Hop Nguyen
José Nicolas
Alain Noguès
Cécile Ollier
François Paolini
Anne Paq
Hertzog Patrick
Guillaume Pazat
Gilles Peress
Martine Perret
Serge Picard
Philippe de Poulpiquet
Vincent Prado
Franck Prevel
Noël Quidu
Gérard Rancinan
Patrick Richard
Laurent Richhard
Olivier Roller
Gérard Rondeau
Ari Rossner
Johann Rousselot
Elisabeth Rull
Lizzie Sadin
Joël Saget
Stephane De Sakutin
Lise Sarfati
David Sauveur
Franck Seguin
Thierry Seray
Jérôme Sessini
Jean-Michel Sicot
Guillaume Squinazi
Philippe Taris
Joanna Tarlet-Gauteur
Pierre Terdjman
Ambroise Tézenas
Laurent Theillet
Patrick Tourneboeuf
Eric Travers
Jerome Tubiana
Jean-Michel Turpin

Jacques Valat
Muriel Valmont
Eric Vandeville
Pierre Verdy
Veronique de Viguerie
Pedro Violle
Loïc Vizzini
Marc Wattrelot
Cyrille Weiner

GEORGIA
Mariam Amurvelashvili
Tamaz Bibiluri
Giorgi Bukhaidze
Beso Gulashvili
Khatia Jijeishvili
Levan Kherkheulidze
Nana Kherkheulidze
Yuri Lobodin
Ketevan Mgebrishvili
Mzia Saganelidze
Niko Tarielashvili

GERMANY
Valeska Achenbach
Ingo Arndt
David Baltzer
Christoph Bangert
Lars Baron
Theo Barth
J. Bauer
Christian Bauer
Michael Bause
Siegfried Becker
Markus Benk
Fabrizio Bensch
Guido Bergmann
Klaus Beth
Birgit Betzelt
Peter Bialobrzeski
Erika Bialowons
Dieter Blum
Anja Bohnhof
Stefan Boness
Michael Braun
Hermann Bredehorst
Frank Bredel
Carsten Bredhauer
Gero Breloer
Ulrich Brinkhoff
Hansjürgen Britsch
Franka Bruns
Hans-Jürgen Burkard
Janni Chavakis
Sven Creutzmann
Peter Dammann
Claudia Daut
Jesco Denzel
Karin Desmarowitz
Kathrin Doepner
Birgit-Cathrin Duval
Thomas Dworzak
Winfried Eberhardt
Thorsten Eckert
Wolfgang Eilmes
Stephan Elleringmann
Norbert Enker
Klaus Fengler
Walter Fogel BFF
Guido Frebel
Sascha Fromm
Rainer Fromm
Ronald Frommann
Klaus-Dietmar Gabbert
Federico Gambarini
Maurizio Gambarini
Dirk Gebhardt
Tobias Gerber
Christoph Gerigk
Peter Ginter
Vidaluz
Jörg Gläscher
Henning Gloystein
Bodo Goeke
Nina Greipel
Jens Grossmann
Phillipp Gülland
Hanno Gutmann
Thorsten Gutschalk
Patrick Haar
Kirsten Haarmann
Doerthe Hagenguth
Matthias Hangst
Alfred Harder
Benjamin Haselberger
Gerhard Heidorn
Katja Heinemann
Oliver Heisch
Andreas Herzau

Katharina Hesse
Markus C. Hildebrand
Karl-Josef Hildenbrand
Annegret Hilse
Joachim Hirschfeld
Jan von Holleben
Thomas Holtrup
Helge Holz
Eva Horstick-Schmitt
Sandra Hoyn
Wolfgang Huppertz
Thorge Huter
Claudia Janke
Carmen Jaspersen
Kati Jurischka
Raimund Kagerer
Dariusz Kantor
Enno Kapitza
Claus Kiefer
Thomas Kienzle
Lorenz Kienzle
Silke Kirchhoff
David Klammer
Wolfgang B. Kleiner
Jens Knappe
Herbert Knosowski
Carsten Koall
Christof Köpsel
Michael Korte
Reinhard Krause
Oliver Kröning
Stephan Krudewig
Dirk Krüll
Andrea Künzig
Georg Kürzinger
Peter Lammerer
Karl Lang
Martin Langer
Ralph Larmann
Joerg Letz
Ralf Lienert
Michael Löwa
Maximilian Ludwig
Sabine Lutzmann
Werner Mahler
Hans von Manteuffel
Sigi Martin
Fabian Matzerath
Vinzenz Mell
Dieter Menne
Veit Mette
Jens Meyer
Roland Michels
Marcus Liebestat
Thorsten Milse
Christian Mladenovic
Jörg Modrow
Bernhard Moosbauer
Katharina Mouratidi
Cathrin Mueller
Bernd Müller
Hardy Müller
Achim Multhaupt
Loredana Nemes
Anja Niedringhaus
Klaus Nigge
Ogando
Reimar Ott
Jens Palme
Laci Perenyi
Thomas P. Peschak
Hans-Gerhard Pfaff
Kai Pfaffenbach
Thomas Pflaum
Daniel Pilar
Plambeck
Christophe Püschner
Ulrich Reinhardt
Helge Reinke
Pascal Amos Rest
Sascha Rheker
Hojabr Riahi
Astrid Riecken
Julian Röder
Frank Roeth
Daniel Roland
Martin Rose
Daniel Rosenthal
Frank Rothe
Stephan Sagurna
Martin Sasse
Sabine Sauer-Hetzer
Simone Scardovelli
Susanna Schaffry
Rüdiger Schall
Achim Scheidemann
Christiane J.B. Scheidt
Walter Schels
Guido Schiefer

145

Günter Schiffmann
Alexander Schirrmann-Ayeni
K.W. Schlie
Jordis Antonia Schlösser
Roberto Schmidt
Baerbel Schmidt
Axel Schmidt
Harald Schmitt
Harry Schnitger
Gesa Schöneberg
Lioba Schöneck
Anne Schönharting
Stefan Schorr
Markus Schreiber
Annette Schreyer
Kai-Uwe Schulte-Bunert
Frank Schultze
Stephan Schütze
Tobias Schwarz
Patrick Seeger
Oliver A. Sehorsch
Stephan Siedler
Michael Sohn
Ralph Sondermann
Bert Spangemacher
Martin Specht
Kathrin Spirk
Henrik Spohler
Christof Stache
Gabriela Staebler
Marc Steinmetz
Björn Steinz
Peter Steudtner
Carsten Stormer
Julian Stratenschulte
Jens Sundheim
Isadora Tast
Andreas Teichmann
Andreas Thelen
Karsten Thielker
Bernd Thissen
Michael Trippel
Murat Türemis
Friedemann Vogel
Heinrich Völkel
Wolfgang Volz
Tim Wegner
Maurice Weiss
Bernd Weissbrod
Gordon Welters
Petra Welzel
Philipp Wente
Sabine Wenzel
Jennifer Weyland
Kai Wiedenhöfer
Arnd Wiegmann
Claudia Yvonne Wiens
Ann-Christine Woehrl
Michael Wolf
Xiaoling Wu
Christian Ziegler
Gregor Zielke
Ulrich Zillmann
Samuel Zuder
Marcus Zumbansen

GHANA
Charles Aidoo Ewusie
Thomas Fynn
Emmanuel Quaye

GREECE
Yannis Behrakis
Alexander Beltes
Bougiotis Evangelos
John Cazolis
Androniki Christodoulou
Nikos Chrisikakis
Angelos Gavrias
Petros Giannakouris
Harris Gikas
Ippo Navridis
Christina Kalligianni
Yiorgos Karahalis
Athina Kazolea
Yannis Kolesidis
Yannis Kontos
Aris Messinis
Maria Paschali
Nikos Pilos
Yannis Psathas
Vladimir Rys
Sophie Tsabara

GUATEMALA
Jesús Alfonso
Moisés Castillo

HONDURAS
Orlando Sierra

HONG KONG, S.A.R. CHINA
Ko Chung Ming
Lei Jih Sheng
Wing Shya

HUNGARY
Éva Arnold
Balázs Róbert Zsolt
Szabolcs Barakonyi
Imre Benkö
Judit Berekai
Gyula Czimbal
Végel Dániel
Tamas Dezso
Bela Doka
Tivadar Domaniczky
Balazs Gardi
György Gáti
Fazekas István
Andrea Jaroka
Tamas Korponai
Szilárd Koszticsák
Daniel Kovalovszky
Gabor Arion Kudasz
Szilvia Marton
Zoltan Molnar
Reviczky
Gergely Ronai
Soós Lajos
Gyula Sopronyi
Péter Szalmás
Bela Szandelszky
Lilla Szász
József L. Szentpéteri
Illyés Tibor
Bala'zs Turay
Gergely Túry
Imre Varga
Péter Zádor

ICELAND
Gisli Pall Gudjonsson
Vilhelm Gunnarsson
Jóhann Kristjánsson
Thorkell Thorkelsson

INDIA
Adnan Abidi
Piyal Adhikary
Ajay Aggarwal
Sanjay Ahlawat
Aijaz Rahi
V.C. Ajilal
Srinivas Akella
Bindu Arora
Anand Bakshi
Narayana Balila
Tarapada Banerjee
Vikram S. Barwal
Shyamal Basu
Shome Basu
Salil Bera
Kamalendu Bhadra
Amit Bhargava
Kedar Bhat
Gopal Bhattacharjee
Piyal Bhattacharjee
Prabir Bhattacharya
Pradeep Bhavsar
Rana Chakraborty
Amit Chakravarty
Rahul Chandawarkar
Suvendu Chatterjee
Sajal Chatterjee
Anindya Chattopadhyay
Chou Chiang
Rupak De Chowdhuri
Kousik Chowdhury
Saurabh Das
Pradip Das
Sucheta Das
Sanjit Das
Rashbehari Das
Arko Datta
Rajib De
Rahul Deshpande
J. Durai Raj
Nilayan Dutta
Gireesh G.V.
Anumalla Gangadhar
Subhendu Ghosh
Soumitra Ghosh
Anirudh Goel
Ashish Shankar
Subir Halder

Jayanta Halder
Haran
G.K. Hegde
R. S. Iyer
G. Jain
C.K. Jayakrishnan
J. Suresh
Sebastian John
Naveen Jora
Kiran D. Joshi
Fayaz Kabli
Bhagya Prakash Kadire
Rajanish Kakade
Devadasan K.P.
Sankha Kar
Soumik
Harikrishna Katragadda
Anita Khemka
Santhosh Kiliyankandy
Kamal Kishore
Ajeeb Komachi
Vishal Kullarwar
Ajit Kumar
Pawan Kumar
Amit Kumar
Naleen Kumar
Dije Laishram
M. Lakshman
Atul Loke
Shalini Maheshwari
Shyamal Maitra
Samiran Majumdar
Sailendra Mal
Bhaskar Mallick
Rafiq Maqbool
S.K. Mohan
Dar Yasin
Arindam Mukherjee
Sabuj Mukhopadhyay
Mahesh Bhat
Omprakash Munisamy
Anand Ishwarappa Murgod
Prashant Nadkar
Unni Krishnan Nair
G.V. Narayana
Ch. Narayana Rao
Swapan Nayak
Vino Kutt
Gurinder Osan
Josekutty Panackal
Shailendra Pandey
Prashant Panjiar
Dinesh Parab
Shriya Patil
G. Pattabiraman
Neeraj Paul
Indranil Paul
Vipin Pawar
Pal Pillai
Ravi Posavanike
Vasant Prabhu
Singh Prakash
Neeraj Priyadarshi
Samson P. Samuel
Altaf Qadri
Mustafa Quraishi
Tamal Roy
R. Senthil Kumaran
K. Ramesh Babu
Shailesh Raval
Raman Raveendran
Prashant Ravi
Nilanjan Ray
Manpreet Romana
Sampath Kumar G.P.
Ruby Sarkar
Sarkar
Utpal Sarma
Sibi Sebastian
Sanjay Sekhri
Pankaj Sekhsaria
Arijit Sen
Samik Sen
Bijoy Sengupta
Hemendra Shah
Javeed Shah
Shantanu Das
Subhash Sharma
Anand Shinde
Ganesh Shirsekar
Selvan Shiv Kumar
Adeel Halim
Bharat Sikka
Ajoy Sil
Virendra Singh
Bandeep Singh
Prakash Singh
Gautam Singh

Rajesh Kumar Singh
Sumeet Inder Singh
Rajib Singha
Manish Sinha
Nitin Sonawane
Shekhar Soni
Gopinath S.
R.R. Srinivasan
Pradeep Shankar Sutar
Manish Swarup
T. Srinivasa Reddy
Ishan Tankha
Mustafa Tauseef
Pradeep Tewari
Harish Tyagi
Ritesh Ramchand
Uttamchandant
Regi Varghese
Manan Vatsyayana
Santosh Verma
V. Christopher Jesudesan
Ch. Vijaya Bhaskar
Vishal Srivastava
Prashanth Vishwanathan
Danish Ismail

INDONESIA
Yuniadhi Agung
Muhamad Ali
Arif Ariadi
Abdul Kadir Audah
Arie Basuki
Beawiharta
Wibudiwan Tirta Brata
Surya Efendi
Bambang Fadjar
Muhammad Faisal
Raji
Riza Fathoni
Junaidi Gandy
Didin Hamid
Jongki Handianto
Tarmizy Harva
Eddy Hasby
Achmad Ibrahim
Stefanny Imelda
Bagus Indahono
Mast Irham
Jakop Iskandar
Kemal Jufri
Heru Sri Kumoro
Lasti Kurnia
Adhi Kusumo
Danu Kusworo
P.J. Leo
Aris Liem
Ali Lutfi
Mak Pak Kim
Zarqoni
Hadibrata Mantik
Molamarbun
Agung Mulyajaya
Chalid MN
Ng Swan Ti
Nogo Agusto Alimin
Nunu Nugraha
Mosista Pambudi
Pang Hway Sheng
Ivan N. Patmadiwiria
Romi Perbawa
Lucky Pransiska
Hermanus Prihatna R.
Priyombodo
Edy Purnomo
Raka Denny
Arbain Rambey
Ardiles Rante
Fadjar Roosdianto
Roy Rubianto
Toto Santiko Budi
Julian Sihombing
Ferdy Siregar
Yusnirsyah Sirin
Poriaman Sitanggang
Saptono
Sinartus Sosrodjojo
Jurnasyanto Sukarno
Supri
Daniel Supriyono
Agus Susanto
Edy Susanto
Arief Suhardiman
Maha Eka Swasta
Tjitra Winarno
Nuraini Tjitra Widya
Dadang Tri
Irvien
Agus

Sophan Wahyudi
Wasis Wibowo
R. Berto Wedhatama
Albertus Widi Nugroho
Adek Berry
Taufan Wijaya
Totok Wijayanto
Ujang Zaelani
Ahmad Zamroni

IRAQ
Ghaith Abdul-Ahad
Faissal Azziz
Awmid Bard
Atef Hassan
Ali Jasim
Azad Lashkari
Ibrahim S. Nadir
Adel Qassim
Kareem Raheem
Hilmi
Bahjat Rahhou
Aysar Saleem
Ali Youssef

IRELAND
Alan Betson
Marcus Bleasdale
Matthew Browne
John Carlos
Niall Carson
Aidan Crawley
Kieran Doherty
Andrew Downes
Colman Doyle
Damien Eagers
Donall Farmer
Joe Fox
Steve Humphreys
Cillian Kelly
Brian Lawless
Dan Linehan
Eric Luke
David Maher
Andrew McConnell
Ross McDonnell
John D. McHugh
Ian McIlgorm
Ray McManus
Cathal McNaughton
Frank Miller
Denis Minihane
Brendan Moran
Seamus Murphy
Pat Murphy
Bryan O'Brien
Alan O'Connor
Kenneth O'Halloran
Jim O'Kelly
John O'Neill
Tara O'Reilly
Joe O'Shaughnessy
Ivor Prickett
Gavin Quirke
Morgan Treacy
Eamon Ward

ISLAMIC REPUBLIC OF IRAN
Saman Aghrami
Masoud Ahmadzadeh
Arash Akhtari Rad
Kiavang Alaei
Aslon Arfa
Mohammad Babaei
Kaveh Baghdadchi
Ebrahim Bahrami
Maryam Bakhshi
Bastami
Kaveh Bazargan
Danial Bouzarjomehri
Esmaeil Davari
Mani Elahi
Aalimanesh
Ali Esfidani
Hengameh Fahimi
Mahdi Fathi
Caren Firouz
Marjan Foroughi
Shadi Ghadirian
Hassan Ghaedi
Ali Ghalamsiah
Hasan Ghareeb
Mehdi Ghasemi
Amir Ghassemnegad
Babak Ghoorchian
Farzin Golpad
Siyavash Habibollahi
Seid Reza Hashemi

Raheb Homavandi
Kazem Hosseini
Seyyed Jalil Hosseinizahraei
Navid Irani
Javad Jalali
Hashem Javadzadeh
Atta Kenare
Mojtaba Khatami
Mohammad Kheirkhah
Katayoun Massoudi
Hadi Mehdizadeh
Behrouz Mehri
Mina Momeni
Javad Montazeri
Aref Mostafazadeh
Karim Mottaghi
Morteza Mousavi
Jalal Sepehr
Ahad Nazarzadeh
Morteza Nikoobazl-e Motlagh
Morteza Noormohammadi
Mohammad Norozi
Labkhand Olfatmanesh
Amir Masoud Oskouilar
Payam Rouhani
Ali Sabbaghi
Taher Sadati
Vahdat Sadr Mohammadi
Karim Sahib
Hosein Saki
Mohsen-Salehi
Nousha Salimi
Mohsen Sanei Yarandi
Babak Sedighi
Ali Seyedi
Nasrin Shahmohammadi
Shahpari Sohaie
Alireza Sotakbar
Newsha Tavakolian
Ghadir Vaghari Shurcheh
Alfred Yaghobzadeh
Shahrnaz Zarkesh

ISRAEL
Esteban Alterman
Tomer Appelbaum
David Bachar
Oded Balilty
Dan Balilty
Daniel Bar-on
Nili Bassan
Rafael Ben-Ari
Jonathan Bloom
Yaron Brener
Elinor Carucci
Rina Castelnuovo
Gil Cohen Magen
Yori Costa
David Dector
Edward Dox
Jorge Duro
Natan Dvir
Nir Elias
Kevin Frayer
Eddie Gerald
Amnon Gutman
Eitan Haddok
Shuli Hallak
Liza Hamlyn
Nir Kafri
Menahem Kahana
Kaprov Edward
Julia Komissaroff
Ziv Koren
Rafi Kotz
Miki Kratsman
Yoav Lemmer
Yoray Liberman
Ilan Mizrachi
Lior Mizrahi
Nadav Neuhaus
Eldad Rafaeli
Ricki Rosen
Ariel Schalit
Nati Schohat
Shaul Schwarz
Ahikam Seri
Amit Shabi
Zvi Shperling
Uriel Sinai
Ariel Tagar
Gali Tibbon
Eyal Warshavsky
Yonathan Weitzman
Anat Zakai
Yossi Zamir
Ronen Zvulun

ITALY

Francesco Acerbis
Salvatore Alagna
Douglas Andreetti
Max Schenetti
Guglielmo dal campo
Giampiero Assumma
Fabiano Avancini
Paolo Balanza
Danilo Balducci
Isabella Balena
D. Barile
Rudi della Bartola
Massimo Bassano
Cristiano Bendinelli
Alessandra Benedetti/Corbis
Guia Besana
Alessandro Bianchi
Alfredo Bini
Valerio Bispuri
Tommaso Bonaventura
Marcello Bonfanti
Roberto Brancolini
Massimo Brega
Giovanni Del Brenna
Marco Bulgarelli
Alberto Buzzola
Giuseppe Cacace
Roberto Caccuri
Jean Marc Caimi
Guy Calaf
Simona Caleo
Daniele Calisesi
Federico Caponi
Marco Casale
Luciano del Castillo
Lorenzo Castore
Marina Cavazza
Sergio Cecchini
Enzo Cei
Giancarlo Ceraudo
Cesare A. Cicardini
Ciol Elio
Giordano Cipriani
Francesco Cito
Ignacio Maria Coccia
Francesco Cocco
Paolo Cocco
Elio Colavolpe
Gianluca Colla
Alberto Colusso
Antonino Condorelli
Daniele Coricciati
Matt Corner
Marzia Cosenza
Alessandro Cosmelli
Lidia Costantini
Giorgio Cosulich de Pecine
Claudio Cricca
Marco Cristofori
Pietro Cuccia
Massimo Cutrupi
Fabio Cuttica
Mauro D'Agati
Antonio D'Albore
Alfredo D'Amato
Mario D'Angelo
Marco D'Antonio
Daniele Dainelli
Daniel Dal Zennaro
Paolo Degiampietro
Marco Di Lauro
Armando Di Loreto
Mario Di Salvo
Giovanni Diffidenti
Alessandro Digaetano
Valeriano di Domenico
Simone Donati
Sara Elter
Salvatore Esposito
Enrico Fantoni
Gughi Fassino
Cristina Ferraiuolo
Gianluca Ferroni
Nanni Fontana
Gianfranco Forza
Andrea Frazzetta
Alessandro Gandolfi
Luigi Gariglio
Marco Garofalo
Tony Gentile
Carlo Gianferro
Giovanni Giansanti
Giuseppe Giglia
Paolo Gioia
Pierluigi Giorgi
Helen M. Giovanello
Alberto Giuliani

Maria Elena Giuliani
Roberto Giussani
Olivia Gozzano
Stefano De Grandis
Paola de Grenet
Mirko Guarriello
Gianluigi Guercia
Daniele Gussago
Edoardo Hahn
Marco Iaconelli
Luca Lo Iacono
Roberto Isotti
Franco Lannino
Laudanna Saba
Igino Lazzarin
Alessandro Lazzarin
Marco Longari
Fabio Lovino
Stefano de Luigi
Guillermo Luna
Alessandro Majoli
Ettore Malanca
Livio Mancini
Emiliano Mancuso
Annunziata Manna
Milko Marchetti
Claudio Marcozzi
Carlo Marras
Giovanni Marrozzini
Claudio Martinelli
Andrea di Martino
Max De Martino
Enrico Mascheroni
Masi Roberto
Massimo Mastrorillo
Daniele Mattioli
Andrew Medichini
Giovanni Mereghetti
Nino Milone
Chiara Mirelli
Dario Mitidieri
Mimí Mollica
Luana Monte
F. Filippo Monteforte
Davide Monteleone
Silvia Morara
Morelli Stefano
Alberto Moretti
Michele Morosi
Lorenzo Moscia
Federico Mozzano
Emanuele Mozzetti
Filippo Mutani
Giulio Napolitano
Luca Nizzoli
Massimo Di Nonno
Antonello Nusca
Piero Oliosi
Oliviero Olivieri
Giuseppe Onorati
Diego Orlando
Agostino Pacciani
Isabela Pacini
Franco Pagetti
Giorgio Palmera
Stefano Paltera
Alessia Paradisi
Partesi
Samuele Pellecchia
Paolo Pellegrin
Paolo Pellizzari
Viviana Peretti Cegramante
Fabrizio Perilli
Maurizio Petrignani
Carlo Pettinelli
Alessandro Pianalto
Alessia Pierdomenico
Pierpaolo Mittica
Vincenzo Pinto
Alberto Pizzoli
Rino Pucci
Raffaello Raimondi
Alberto Ramella
Ezio Ratti
Stefano Rellandini
Giada Ripa di Meana
Lillo Rizzo
Max Rossi
Michela Rufini
Andrea Sabbadini
Arturo Safina
Ivo Saglietti
Adriana Sapone
Marco Saroldi
Maurizio Sartoretto
Loris Savino
Andrea Scaringella
Max & Douglas

Danilo Schiavella
Stefano Schirato
Massimo Sciacca
Emanuele Scorcelletti
Fabio Sgroi
Gianluca Simoni
Massimo Siragusa
Stefano Snaidero
Andreas Solaro
Pasquale Sorrentino
Mauro Spanu
Marina Spironetti
Shobha
Stefano Torrione
Kash G Torsello
Alessandro Tosatto
Ivano Trabalza
Francesco Troina
Cristian Umili
Giuseppe Ungari
Marco Vacca
Antonio Vacirca
Giorgio Vacirca
Riccardo Venturi
Daniele Vergaro
Paolo Verzone
Alessandro Villa
Fabrizio Villa
Paolo Volponi
Marta Zaccaron
Fabrizio Zani
Francesco Zizola
Dana de Luca
Vittorio Zunino Celotto

IVORY COAST

Issouf Sanogo

JAMAICA

Norman Grindley
Headly G. Samuels

JAPAN

Noriyuki Aida
Kazuyoshi Ehara
Fumiaki Fukuda
Chieko Hara
Shiro Harada
Takumi Harada
Masako Imaoka
Yasunari Itayama
Takaaki Iwabu
Takeshi Iwashita
Osamu Kanasawa
Hitoshi Katanoda
Satomi Kato
Chiaki Kawajiri
Michihiro Kawamura
Kazuhiro Yokozeki
Takao Kitamura
Yoshi Kitaoka
Taro Konishi
Naoki Maeda
Fumiko Matsuyama
Kimimasa Mayama
Shizuka Minami
Shigeki Miyajima
Toru Morimoto
Takuma Nakamura
Motoya Nakamura
Tomoaki Nakano
Masataka Namazu
Kazuhiro Nogi
Etsuko Nomachi
Yasuhiro Ogawa
Yoshikazu Okunishi
Jiro Ose
Takashi Ozaki
Tamako Sado
Quijiro Sakamaki
Koji Sasahara
Ken Satomi
Shuzo Shikano
Yoshi Shimizu
Kazu Shirahata
Akira Suemori
Dai Sugano
Ryuzo Suzuki
Kunihiro Suzuki
Kuninori Takahashi
Kimitaka Takeichi
Atsushi Taketazu
Hidetoshi Tanaka
Yuzo Uda
Daisuke Wada

JORDAN

Amira Al-Homsi

Hanady Al-Ramahi
Khalil Al-Ramahi
Ali Al-Sahouri
Khalil Aljermi
Majed Jaber
Amjed Iwheep
Aktham Jarrar
Salman Madanat
Taher Tahtamoni

KAZAKHSTAN

Aziz Mamirov

KENYA

Thomas Mukoya
Maxwell Agwanda
Eric Bosire
Eric Santos Kadima
Antony Kaminju
Benedict Wasiche Were

KYRGYZSTAN

Vyacheslav Oseledko
Vladimir Pirogov
Vladimir Voronin

LATVIA

Aigars Eglite
Ruta Kalmuka
Janis Pipars

LEBANON

Maroun G. Akiki
Paul Assaker
Mohamed Azakir
Joseph Barrak
Jeff Fares
Ramzi Haidar
Saër Karam
Wael Ladki
Haisam Moussawi

LITHUANIA

Aleksandravicius Algimantas
Giedrius Baranauskas
Ramunas Danisevicius
Zenonas Gricius
Gedmantas Kropis
Kazimieras Linkevicius
Renaldas Malychas
Rolandas Parafinavicius
Pliadis
Olga Posashkova
Gediminas Savickis
Sigitas Stasaitis
Jonas Staselis
Andrius Ufartas
Romualdas Vaitkus
Kestutis Vanagas
Gediminas Zilinskas
Saulius Ziura

LUXEMBOURG

Jean-Claude Ernst

MACEDONIA

Ivan Blazhev
Marko Georgiev

MALAWI

Amos Gumulira
Bonex Julius

MALAYSIA

Jaafar Abdullah
Sawlihim Bakar
Joel Chan
Anuar Che Amat
Art Chen
Chin Mui Yoon
Eulee Chng
Glenn Guan
G.C. Tan
Lee Keng Siang
Jimin Lai
Liew Wei Kiat
Swee Giok Lim
Lucas Lim
Jeffery Lim Chee Yong
Azhar Mahfof
Bazuki Muhammad
Victor K.K. Ng
Noor Azman Zainudin
Alexander Ong
Raja Faisal Hishan
Abd Rahman Saleh
Kamal Sellehuddin
Kevin Tan

Tan Ee Long
Vincent Thian
Yau Choon Hiam

MALI

Yaya Alpha Diallo

MALTA

Michael Ellul
Darrin Zammit Lupi

MAURITIUS ISLAND

Georges Michel

MEXICO

Javier Aguilar
Cristina Aguilar
Daniel Aguilar
Jorge Carlos Alvarez Diaz
J. C. Alvarez
Hector Amezcua
Guillermo Arias
Armando Arorizo
Jerónimo Arteaga-Silva
Sergio Bautista
Jaime Boites
Luis Castillo
Julieta Cervantes
Ray Chavez
Rodrigo Cruz
José Luis Cuevas
Tonatiuh Figueroa
Allan Fis
Natalia Fregoso
Javier Garcia
Héctor García
José Carlo González Moreno
Claudia Guadarrama
Alejandro Guerrero
Carla Guerrero Farías
Hector Guerrero Skinfill
Edgar Hernández Barrera
Gilberto Hernández
Carlos Ibarra
Victor Ibarra
David Jaramillo
Elizabeth Dalziel
Miguel Juarez Lugo
Leopoldo Kram
Raul Mendez
Gilberto Meza
David Morales
Ernesto Muñoz
Karina Nevarez
Enrique Ortiz
Mauricio Palos
Paulo Peña
Alberto Puente
Arturo Ramos Guerrero
Rafael del Rio
Oskar M. Ruizesparza H.
Luis
Enrique Sifuentes Ramos
Jorge Silva
Miguel Varela
Federico Vargas Somoza

MOLDAVIA

Vadim Caftanat
Alexander Tripolski

MONGOLIA

Erdenetuya Gurrinchen
Vandandorj Battulga

NAMIBIA

Karel Prinsloo

NEPAL

Dhruba Ale
Mukunda Kumar Bogati
Rajesh Gurung
Rajesh K.C.
Chandra Shekhar Karki
Bikash Karki
Rajendra Manandhar
Ravi Manandhar
Prakash Mathema
Kiran Kumar Panday
Bibi Phunyal
Sagar Shrestha
Narendra Shrestha

NEW ZEALAND

Mark Baker
Greg Baker
Scott Barbour
John Borren

Melanie Burford
Bruce Connew
Marion van Dijk
Mark Dwyer
David Hallett
David Hancock
Jimmy Joe
Iain McGregor
Mark McKeown
Peter Meecham
Mike Millett
Dean Purcell
Phil Reid
Richard Robinson
Kenny Rodger
Martin de Ruyter
John Selkirk
Dwayne Senior
Mark Taylor

NICARAGUA

Manuel Esquivel
Rossana Lacayo
M. M. Matute R.
Alejandro Sánchez

NIGERIA

Kunle Ajayi
Akintunde Akinleye
George Esiri
Gbadamosi Kehinde Olawale
Sunday Ohwo
Mr Ayodele Ojo
Lukman Olapenikun
Gbile Oshadipe
Muyiwa Osifuye
George Osodi

NORWAY

Odd Andersen
Oddleiv Apneseth
Lise Aserud
Jonas Bendiksen
Jon-Are Berg-Jacobsen
Stein Jarle Bjorge
Terje Bringedal
Per Stale Bugjerde
Pal Christensen
Tomm W. Christiansen
Bjorn Steinar Delebekk
Oyvind Elvsborg
Thierry Gourjon
Pal Christopher Hansen
Pål Hermansen
Elin Hoyland
Allan Klo
Hakon Mosvold Larsen
Daniel Sannum Lauten
Gunnar Mjaugedal
Mimsy Moller
Otto von Münchow
Fredrik Naumann
Karin Beate Nøsterud
Kristine Nyborg
Christopher Olsson
Espen Rasmussen
Hans Kristian Riise
Haavard Saeboe
Pia Solberg
Kai Skvellingen Flatekval
Knut Egil Wang

PAKISTAN

Ameer Hamza
Zahid Hussein
Saeed Khan
Akhtar Soomro

PALESTINIAN TERRITORIES

Mohamed Abed
Jamal Aruri
Jaafar Ashtiyeh
Hazem Bader
Mahmud Hams
Nayef Hashlamoun
Ahmed Jadallah
Abid Katib
Abed Omar Qusini
Suhaib Salem
Mohammed
Osama Silwadi

PANAMA

Alejandro Bolivar
Anselmo Mantovani

PARAGUAY

Luis Vera

PEOPLE'S REPUBLIC OF CHINA

BaiYing
Bai Tao
Oliver Bang
Jiang Baocheng
Bing Hong Cheng
Cao Tong
Cao Yingxun
Cao Zhi-gang
Chan Kwok Cheung Martin
Chan Man Lung
Chang Gang
Chang He
Chen Guoqing
Chen Li
Chennan
Laoking
Chen Da Yao
Chen Gensheng
Chen Jie
Jiang Cheng
K. Y. Cheng
Cheng Gang
Cheng Gong
Cheng Heping
Chenghua Gao
Cancan Chu
Chung
Yue Yong Cui
Dalang Shao
Dan Han
Deng Bo
Deng Jia
Du Hai
Du Jianxiong
Fan Jinyu
Fang Qianhua
Fang Yingzhong
Fei Maohua
Fuli Zheng
Gang Zhao
Gao Wei
Gao Baoyan
Gao Yong
Jisong Geng
Li Guang Fu
Guo Guang Yu
Guo Tieliu
Guo Xiang-he
Haibo Yu
He Jianrong
He Haiyang
Hei Feng
Hou Jie
Hou Shu Wang
Hu Tie Xiang
Hu Qing Ming
Huang Yiming
Huang Jingda
Jia Guo rong
Jiang ShengLian
Jiang Bo
Jason Lee
Jiao Huiming
Jinjun
Jin Cheng
Jin Siliu
Li Jinhe
Edward Ju
Ju Guangcai
Lai Kin Lun
Hongguang Lan
LeYuan
Lee Nim Ting
Lei Yu
Leng Zhimin
Zhen Qi Li
Zhen Yu Li
Li Qizheng
Li Yue
Weijun Li
Li Guoqiang Yimengshan
Li Jiangang
Li Lin Lin
Li May
Li Wending
Mr Li Xiaoguo
Li Yan
Lian Xiang Ru
Liang Daming
Liao Yujie
Stan Lim
Shuquan Lin
Changhai Lin
Liu Hong Qun
Liu Heng
Liu Gen Tan
Liu Jin

Liu Liqun
Liu Wei
Liu Yuan
Long Hai
Lu Haitao
Lu Guang
Lu Xu Yang
Ly Yong
Ma Xiao-guang
Ma Hongjie
Mai
Mingjia Zhou
Nahr
Nan Hao
Ni Huachu
Ning Feng
Ning Zhouhao
Pan Haiqi
Pan Songgang
Pang Zheng Zheng
Pei Jingde
Peng Hui
Feng Pu
Qi Xiaolong
Qi JieShuang
Qi Hao
Qi Hong
Qian Dong Sheng
Qin Bin
QiuYan
Qiu Weirong
Ran Yujie
Ren Xihai
Ren Shi Chen
Shang Xin
Sheng Hong-xu
Sheng Jia Peng
Sheng Kun Yang
Shi Jian Xue
Yi Shi
Shi Lifei
Xufeng Shi
Aly Song
Mok Suet Chi
Sun Yuting
Sun Hai
Ning Dong Sun
Tan Wei Shan
Tian Fei
Tian Li
Ryan Tong
Tong Jiang
Wang Rui Lin
Huisheng Wang
Wang Jing
Wang Pan
Wang Zi Cheng
Wang Hai Ying
Wang Tian
Wang Jian
Wang Chen
Fei Wang
Wang Guijiang
Wang Jie
Wang Juliang
Wang Qiu Hang
Wang Tao
Wang Xiao
Wang Yao
Wang Yuguo
Wang Zhao-hang
Wang Zi
Wei Tao Tian
Wei Xiaoming
Wei Zheng
Cao Weisong
Wenhao Yu
Alex Wong
Wu Zhonglin
WU Xiaotian
Wu Fang
Wu Huang
Wu Niao
Wu Zhangjie
Xi Haibo
Xiao Huaiyuan
Xie Minggang
Xie Fucheng
Xin Zhou
Xu Dongsong
Ying Hong Xu
Haifeng Xu
Xu Cheng Ai
Xu Jing Xing
Yan Bailiang
Yan Jing
Yasheng Yan
Yang fu-sheng

Guanghoi Yang
Lei Yang
Bo Yang
Yang Huan
Ri Yue
Yang Xin Yue
Yanguang He
Yin Gang
Jing Wang
Bobby Yip
Yong Jun Fu
Vincent Yu
Yu Jiang-tao
Long Yu
Gongjia Yu
Yuan Jingzhi
Yuanbin Zhu
Jerry Lu
Yushun Zhou
Zhan Xiaodong
Zhang Feng
Deng Wei Zhang
Dong Zhang
Zhang Yanhui
Wei Zhang
Zhang Kefei
Paul Zhang
Zhang Guo Hua
Zhang Mohan
Lijie Zhang
Jian Zhang
Zhang Changming
Zhang Hai-er
Zhang Yan
Zhang Yi
Zhang Yi Bin
Zhang Zhaozeng
Zhao Jianwei
Xi Chun Zhao
Jing Zhao
Zhao Qing
Zhao Kang
Zheng Qiwen
Zhong Guilin
Zhou Guoqiang
Zhou Chang You
Zhou Chao
Youlin
Zhu Yan
Zhuang Yingchang
Zong Lu Fan

PERU

Eitan Abramovich
Mariana Bazo
Martin Bernetti
Manuel Berrios
Cris Bouroncle
Roberto Cáceres
Ana M. Castaneda
Juan Sebastian Castaneda
Hector Emanuel
Oscar Farje
Raúl García Pereira
Ana Cecilia Gonzales-Vigil
Silvia Izquierdo
Cecilia Larrabure
Gary Manrique
Hector Mata
Karel Navarro
Pilar Olivares
Susana Raab
Jaime Razuri
Mario Alesssandro Razzeto
Andy M. Rios Jara
Yael Rojas Medina
Wayo
Guillermo Venegas Cabrera
Sulsba Yepez Schwartz
Karenz

PHILIPPINES

Edwin Bacasmas
Patrick Castillo
Claro Cortes IV
Antonio E. Despojo
Aaron Favila
Pepito D. Frias
Romeo Gacad
Joe Galvez
Hadrian Nebaleza Hernandez
Marvi Sagun Lacar
Junjie Mendoza
Jesse M. Narrazo
Max Pásion
Romeo Ranoco
Lyn Rillon
Joaquin S. Ruste

Dennis Sabangan
Amelito Tecson
Bernard Testa
Rem Zamora

POLAND

Bartek Barczyk
Anna Bedynska
Piotr Bernas
Piotr Blawicki
Robert Boguslawski
Witold Borkowski
Jan Brykczynski
Ms Monika Bulaj
Grzegorz Celejewski
Katarzyna Chadzynska
Davido Chalimoniuk
Antoni Chrzastowski
Wojciech Chrzastowski
Filip Cwik
Lukasz Cynalewski
Jacenty Dedek
Irek Dorozanski
Arkadiusz Dziczek
Wojciech Eksner
Tomasz Gudzowaty
Zbigniew Fiolka
Ania Freindorf
Tomasz Gawalkewicz
Arkadiusz Gola
Wojciech Grzedzinski
Tomasz Gudzowaty
Rafat Guz
Maciej Jarzebinski
P. Jasiczek
Przemek Jendroska
Agnes Jeziorska
Tomasz Kaminski
Mariusz Kapala
Jaroslaw Klej
Gerda Kochanska
Roman Konzal
Grzegorz Kosmala
Robert Kowalewski
Przemyskaw Kozlowski
Milosz Krajewski
Damian Kramski
Witold Krassowski
Przemyslaw Krzakiewicz
Bartlomiej Kudowicz
Malgorzata Kujawka
Jerzy Lapinski
Maciej Laprus
Arkadivsz Lawrywianiec
Katarzyna Mala
Piotr Malecki
Franciszek Mazur
Justyna Mielnikiewicz
Karolina Misztal
Andrzej Nasciszewski
Chris Niedenthal
Piotr Nowak
Ryszard Nowakowski
Wojciech Oksztol
Adam Panczuk
Janczaruk Pawel
Mieczyslaw Pawlowicz
Leszek Pilichowski
Marek Pindral
Ryszard Poprawski
Aleksander Prugar
Agnieszka Rayss
Dominik Sadowski
Michal Sierszak
Joanna Siwiec
Maciej Skawinski
Czarek Sokotowski
Mikolaj Suchan
Swiderski Prezemyslaw
Darek Szczygielski
Lukasz Trzcinski
Pawel Ulatowski
Piotr-Mariusz Urbaniak
Piotr Wittman
Luke Wolagiewicz
Bartek Wrzesniowski

PORTUGAL

José Carlos Carvalho
Augusto Soares
Sérgio Azenha
José Bacelar
Miguel Lopes
Paulo Duarte
Rodrigo Cabrita
José Caria
Antonio Carrapato
João Pina

Carla Carvalho Tomás
Leonel de Castro
Luís Costa
António Pedrosa
Hugo Delgado
Paulo Escoto
Nuno Ferreira Santos
Joel Santos
Jorge Firmino
Paulo Freitas
Pedro Saraiva
Francisco Leong
Artur Machado
Marcos Martins
Frederico Colarejo
Rui M. Leal
Vitor Mota
Bruno Neves
Vasco Célio
Gabriel Penedo
Julio Soares Pereira
Adão Moreira
Luís Ramos
Armando Ribeiro
António Luís Campos
Gonçalo Rosa da Silva
Marisa Salvador
Carlos Costa
Pedro Sarmento Costa
Miguel De Sousa Dias
Joao-Manuel Simoes
Goncalo Lobo Pinheiro
Manuel Teles
Alexandre Vaz
Bruno Rascão
Tiago Venancio
Pedro Lemos Vieira
Marta Vitorino

PUERTO RICO

Alicea
Xavier Araújo Berrios
José Jiménez Tirado
Ramón Tonito Zayas

ROMANIA

Horia Calaceanu
Dragos Lumpan
Liviu Maftei
Silviu Matei
Daniel Mihailescu
Marius Nemes
Mircea Restea
Radu Sigheti
Timi Slicaru
Andreea Tanase
Tudor Vintiloiu

RUSSIA

Lana Abramova
Alexei Alraun
Andrey Arkchipov
Armen Asratyan
Alexandre Astafiev
Dmitri Azarov
Beliakov Dmitry
Roin Bibilty
Elena Blednykh
Alexei Boitsov
Sergey Bondarev
Bushov
Evgeni Chteherbakov
Alexey Chuguy
Sasha Demenkova
Nikolay Dementiev
Boris Dolmatovsky
Grigory Dukor
Viktor Durmanov
Boris Echin
Mikhail Evstafiev
Vladimir Fedorenko
Alexander Fedorenko
Mikhail Galustov
Alexei Goloubstov
Grigory Golyshev
Pavel Gorshkov
Solmaz Guseynova
Yuri Kabodnov
Sergei Karpukhin
Pavel Kashaev
Vladimir Kharitonov
Victor Kirsanov
Roman Kitashov
Denis Koyevnikov
Timur Koksharov
Sergei A. Kompaniychenko
Yevgeni Kondakov
Gleb Kosorukov

Tatiana Kotova
Yuri Kozyrev
Yuri Kuznetsov
Vladimir Lamzin
Oleg Lastochkin
Julia Leydik
Sergei L. Loiko
Evgeny Luchinsky
Alexander Makarov
Tatjana Makeyeva
Nekto V
Maxim Marmur
Sergey Maximishin
Olga Mirkina
Tatiana Mylnikova
Ilya Naymushin
Nikolskiy
Valeri Nistratov
Vladimir Novikov
Maks Novikov
Alexander Petrosyan
Alexander Petrov
Alexey Pivovarov
Alexandr Polyakov
Sergey Ponomarev
Vladimir Rodionov
Andrey Rudakov
Musa Sadulaev
E. Safian
Savintsev Fedor
Marat Saychenko
Sergei Shchekotov
Dmitriy Shihin
Denis Sinyakov
Andrey Sladkov
Pavel Smertin
Jouri Strelets
Vladimir Syomin
Nikolay Titov
Mikhail Tyntarev
Viktor Vasenin
Vladimir Velengurin
Viktor Velikzhanin
Sergey Vinogradov
Vi Vyatkin
Vyacheslav Yurasov
Andrey Zadorozhnyy
Konstantin Zavrazhin
Anna Zolotina

SAUDI ARABIA

Musleh Jameel

SERBIA AND MONTENEGRO

Zoran Anastasijevic
Dejan Bozic
Aleksandar Dimitrijevic
Marko Djurica
Boza Ivanovic
Pedja Milosavljevic
Mihály Moldvay
Branislav Puljevic
Hazir Reka
Nikola Solaja
Monika Stojanovic
Goran Tomasevic
Tanja Valic

SIERRA LEONE

Bockarie Koroma

SINGAPORE

Bryan van der Beek
Caroline Chia Su-Min
Chin Fook Chew
Zhuang Wubin
Chua Chin Hon
Andrew Chuah
Chuah-Choong Eng Chuan
Ernest Goh
Ho Peng Yew
Huang Zhi Ming
Aziz Hussin
Edwin Koo
Kwong Kai Chung
Gary Lau Keng Seng
Lim Wui Liang
Ng Sor Luan
Ong Chin Kai
Leonard Phuah Hong Guan
Rajasegeran
Casey Seyu
Ashleigh Sim
Su Xiaomin
Terence Tan
Trevor Tan
Ray Tan
Terence Teo

Thiang Yu Ming
Thong Kah Hoong Dennis
Wang Hui Fen
Desmond Wee Teck Yew
Wong Maye-E
Woo Fook Leong
Zann Huizhen Huang

SLOVAKIA
Jana Cavojska
Dusan Guzi
Vladimir Kampf
Joe Klamar
Martin Kollár
Marian Meciar

SLOVENIA
Igor Skafar

SOUTH AFRICA
Bonile Bam
Werner Beukes / SAPA
Jodi Bieber
Ruvan Boshoff
Paul Botes
Leon Botha
Nic Bothma
Theana Calitz
Felix Dlangamandla
Dudu Zitha
Jillian Edelstein
Brenton Geach
Anton Hammerl
Johann Hattingh
Oliver Hermanus
Pieter Hugo
Nadine Hutton
Andrew Ingram
Fanie Jason
Jeremy Jowell
Nonhlanhla Kambule
Halden Krog
Steve Lawrence
Shivambu Lefty
Tebogo Letsie
Charlé Lombard
Kim Ludbrook
Liam Lynch
Lebohang Mashiloane
Phil Massie
Simphiwe Mbokazi
Nanette Melville
Gideon Mendel
Eric Miller
Matimba Herbert Mpangane
Thobeka Zazi Ndabula
Boxer
Marupu
Simphiwe Nkwali
Tony Ntombela
Neo Ntsoma
Lucky Nxumalo
James Oatway
Johnny Onverwacht
Tertius Pickard
Raymond Preston
Marianne Pretorius
Alet Pretorius
Inge Prins
Antoine de Ras
Chris Reilly
Samantha Reinders
John Robinson
Shayne Robinson
Mujahid Safodien
David Sandison
Sydney Seshibedi
Justin Sholk
Dumisani Sibeko
Joao Silva
David Silverman
Lisa Skinner
Alon Skuy
Garth Ivan Stead
Brent Stirton
Mikhael Subotzky
Waldo Swiegers
Duif du Toit
Muntu Vilakazi
Deaan Vivier
Rogan Ward
Mark Wessels
Gary van Wijk
Debbie Yazbek
Siyabulela Obed Zilwa
Schalk Van Zuydam
Anita van Zyl

SOUTH KOREA
Cho Youngho
Choi Byung Ki
Young Kong Choo
Kim Kyung Sang
Seung Eun Lee
Kye R. Lee
Lee Jin-Man
Noh, Sun-tag
Park Seogang
Changwoo Ryu

SPAIN
Tomàs Abella
Miguel Alcalde
Genín Andrada
Carlos de Andrés
Jesus Antoñanzas
Samuel Aranda
Javier Arcenillas
Eugenio Arenas de los Rios
Pablo Argente
Mikel Aristregi
Pedro Armestre
Ariadna Arnés
David Arranz
Eduardo Arrillaga Santolaya
Pablo Balbontin Arenas
J.C. Barberá
Sergio Barrenechea
Alvaro Barrientos
Raúl Belinchón
Daniel Beltrá
Pep Bonet
Francisco Bonilla
Mireia Bordonada
Santi Burgos
Nacho Calonge
Luis Camacho
Sergi Camara
Juan Carlos Cárdenas
Dani Cardona
Sergio Caro
Andres Carrasco Ragel
Daniel Casares Román
Juan Manuel Castro Prieto
Aranzazu Cedillo
Ignacio Cerezo Ortega
Xavier Cervera Vallve
Oriol Clavera
Andrea Comas Lagartos
Albert Corbí Llorens
Matias Costa
Pol Cucala
Norberto Cuenca
Marcelo Del Pozo Perez
Eduardo D. de San Bernardo
Miguel Diez Perez
Nacho Doce
Daniel Duart
Rosmi Duaso
Javier Echezarreta
Sergio Enríquez - Nistal
Ramón Espinosa Tebar
Fosi Vegue
Erasmo Fenoy Nuñez
Paco Feria
Pere Ferre Caballero
Victor Fraile
Paco Campos
Zacarias Garcia
Rubén García
Ricardo Garcia
Albert Gea
Lluis Gene
Miguel Muniz
Pedro Armestre
Pasqual Gorriz
Jordi Gratacòs
Jose Haro
Francisco de las Heras
Javier Izquierdo
Frank Kalero
X. M. Laburu
Aitor Lara
Daniel Loewe
J. M. Lopez
Angel Lopez Soto
Jose Lores
Carlos Luján
Hermes Luppi
César Manso
Rafael Marchante
Fernando Marcos Ibanez
Xurde Margaride
J.A. Martin
David Martinez
Carlos Martínez de la Serna

Pere Masramon
Fernando Moleres
Alfonso Moral
Roberto N. Cataluña
Benito Pajares
Oscar Palomares
Alberto Paredes
Parellada Palau
Yolanda Peláez
Ramon L. Perez
Raúl Pérez
Elisenda Pons
Mariano Pozo
Joan Pujol-Creus
Ramsés Radi
David Ramos
Sergi Reboredo
Eva Ripoll
Eduardo Ripoll
Begoña Rivas
Rafa Rivas
Nando Rivero
Diego Alquerache
AmayaRoman
Víctor Romero
Abel F. Ros
Lorena Ros
Jesus F. Salvadores
Moises Saman
Cesar Sanchez
Luís Davilla
Fernando Sánchez Fernández
Pablo Sánchez
Alexandra dos Santos
Lourdes Segade
Patricia Sevilla Ciordia
Miguel Sierra
Tino Soriano
Nelson Souto
Carlos Spottorno
Alex Stockert
Luis Tejido
Javier Teniente
Gabriel Tizón
Fran Torrecilla
Daniel Torrelló
Jose Antonio Torres
Elena de la Vega
Susana Vera
Miguel Vidal
Pere Virgili
Enric Vives-Rubio
Alvaro Ybarra Zavala
Rosina Ynzenga

SRI LANKA
K. Dushiyanthini
Ranawila Premalal

ST. KITTS AND NEVIS
Wayne Lawrence

SUDAN
Mohamed Nureldin Abdallah
Osama Mahdi Hassan
Sidi Moctar Khaba

SURINAM
Roy Ritfeld

SWEDEN
Bea Ahbeck
Chris Anderson
Urban Andersson
Roland Bengtsson
Elin Berge
Jocke Berglund
Sophie Brandstrom
Anna von Brömssen
Henrik Brunnsgard
Swen Connrad
Lars Dareberg
Ake Ericson
Magnus Eriksson
Jan Fleischmann
Anders Forngren
Magnus Forsberg
Leif Forslund
Dick Gillberg
Jessica Gow
Johnny Gustavsson
Magnus Hallgren
Paul Hansen
Anders Hansson
Martina Holmberg
Jurek
Torbjörn Jakobsson
Eva-Lotta Jansson

Ann Johansson
Thor Jonsson
Gerhard Jörén
Jonas Karlsson
Tomas Karlsson
Peter Kjelleras
Martin Von Krogh
Peter Krüger
Christian Leo
Larseric Linden
Jonas Lindkvist
Staffan Löwstedt
Beatrice Lundborg
Joachim Lundgren
Chris Malusynski
Markus Marcetic
Tommy Mardell
Paul Mattsson
Karl Melander
Linus Meyer
Jack Mikrut
Thomas Nilsson
Jenny Nilsson
Matilda Nilsson
Daniel Nilsson
Brita Nordholm
Fredrik Persson
Per-Anders Pettersson
Lennart Rehnman
Anders Ryman
Kristofer Sandberg
Torbjörn Selander
Linnea Sellersjö
Hakan Sjöström
Åsa Sjöström
Susan Sjösward
Göran Stenberg
Per-Olof Stoltz
Katarina Stoltz
Ylva Sundgren
Maja Suslin
Gisela Svedberg
Ola Torkelsson
Roger Turesson
Joachim Wall
Magnus Wennman
Jon Wentzel
Agnes Wikmark
Jan Wiridén
Karl-Göran Z. Fougstedt

SWITZERLAND
Pius Amrein
Philippe Antonello
Frederic Aranda
Gaëtan Bally
Franco Banfi
Manuel Bauer
Markus Bühler-Rasom
Stéphanie Couson
Ladislav Drezdowicz
Andreas Frossard
Mariella Furrer
Laurent Gilliéron
Barbara Graf Horka
Michael von Graffenried
Yvonne Hartmann
Boris Heger
Tobias Hitsch
Dominik Huber
Karl-Heinz Hug
Steeve Iuncker
Alexander Keppler
Thomas Kern
Patrick B. Kraemer
Pascal Lauener
LeNeff
Cédric Marsens
Beat Marti
Yann Mingard
Nadia Natario
Massimo Pacciorini-Job
Germinal Roaux
Didier Ruef
Meinrad Schade
Andreas Seibert
Rif Spahni
Hansueli Trachsel
Mara Truog
Olivier Vogelsang
Luca Zanetti
Marco Zanoni
Michael Zumstein

SYRIA
Thanaa Arnaout
Munzer Bachour
Mohammad Fakhjg

Mohammad Hajkab
Nouh Ammar Hammami
Ali Jarekji
Akef Kammouch
Hisham Zaweet

TAIWAN
Chao-Yang Chan
Keye.Chang
Chang Tien Hsiung
Boheng Chen
Chiang Yung-Nien
W. Huang
Ben Huang
Ko Cheng Hui
Tsung Sheng Lin
Ma Li-Chun
Shen Chao-Liang
Wu, Po-Yuan
Wu Yi-ping
Rick Yi
Yu Chih-Wei

THAILAND
Pornchai Kittiwongsakul
Sarot Meksophawannagul
Jetjaras Na Ranong
Kittinun Rodsupan
Manit Sriwanichpoom
Rungroj Yongrit

THE NETHERLANDS
Marc van der Aa
Jan Banning
Shirley Barenholz
Maurice Bastings
Peter van Beek
Martijn Beekman
Bram Belloni
Birgit Berger
Peter Blok
Chris de Bode
Morad Bouchakour
Mirjam Brinkhof
Joost van den Broek
Alek
Erik Christenhusz
Rachel Corner
Roger Cremers
Gerald van Daalen
Peter Dejong
JanJaap Dekker
Marc Deurloo
Rineke Dijkstra
Basri Dogan
Kjeld Duits
Michel Ebben
Evert Elzinga
Sander Foederer
Flip Franssen
Ilse Frech
Philippe van Gelooven
Martijn van de Griendt
Raymond De Haan
Remon Haazen
Christine den Hartogh
John van Hasselt
Rob Hendriks
Piet Hermans
Gerrit de Heus
W.S. Hiralal
Dick Hogewoning
Pieter ten Hoopen
Sjoerd van der Hucht
René van der Hulst
Jan van IJken
Harmen de Jong
Martijn de Jonge
Jasper Juinen
Ama Kaag
Eddy Kaijser
Karijn Kakebeeke
Geert van Kesteren
Chris Keulen
Arie Kievit
John Klijnen
Toussaint Kluiters
Robert Knoth
Olaf Kraak
Jeroen Kramer
Raoul Kramer
Jerry Lampen
Inez van Lamsweerde
Gé-Jan van Leeuwen
Jaco van Lith
Kadir van Lohuizen
Emile Luider
Vinoodh Matadin

Brian George Melchers
Vincent Mentzel
Eric de Mildt
Robert Mulder
Benno Neeleman
Theodoor Niekus
Jeroen Nooter
Fahrettin Gürkan Örenli
Willem Poelstra
Frans Poptie
Patrick Post
Judith Quax
Mischa Rapmund
Guus Rijven
Martin Roemers
Raymond Rutting
Diana Scheilen
Peter Schrijnders
Nicole Segers
Ruben Smit
Geert Snoeijer
Anoek Steketee
Marco de Swart
Yee Ling Tang
Arno Tijnagel
Sven Torfinn
Robin Utrecht
Kees van de Veen
Marian van de Veen-Van Rijk
Marieke van der Velden
Rosa Verhoeve
Jan Vermeer
Dirk-Jan Visser
Cor Vos
Rob Voss
Paul Vreeker
Richard Wareham
Koen van Weel
Klaas Jan van der Weij
Eddy van Wessel
Emily Wiessner
Herbert Wiggerman
Petterik Wiggers
Paolo Woods
Herman Wouters
Daimon Xanthopoulos
Mark van der Zouw

TRINIDAD AND TOBAGO
Karla Ramoo
Andrea de Silva

TUNISIA
Karim Ben Khelifa

TURKEY
Tolga Adanali
Aytunc Akad
Abdurrahman Antakyali
Sinan Cakmak
Kutub Dalgakiran
Hatice Ezgi Özçelik
Ilker Maga
Ozan Emre Oktay
Riza Ozel
Gökhan Tan
Hasan Tüfekci
Firat Yurdakul

UGANDA
Henry Bongyereirwe
John Omoding

UKRAINE
Sergey Avramenko
Gleb Garanich
Kagan
Alexander Kharvat
Maksym Levin
Sergiy Pasyuk
Viktor Suvorov
Alexander Toker
Oleg Velikiy

UNITED ARAB EMIRATES
Alia Al Shamsi

UNITED KINGDOM
Andy Aitchison
Ed Alcock
Timothy Allen
Richard Allenby-Pratt
Brian Anderson
Kirsty Anderson
Julian Andrews
Tom Ang
Cedric Arnold
Olivia Arthur

David W. Ashdown
Helen Atkinson
Jocelyn Bain Hogg
Richard Baker
Patrick Baldwin
Roger Bamber
Jane Barlow
Alistair Beattie
Guy Bell
Piers Benatar
Neil Bennett
Mark Bickerdike
David Birkin
Andy Blackmore
George S. Blonsky
Harry Borden
Steve Bould
Stuart Boulton
Anna Branthwaite
Fraser Bremner
Paul Brooks
Henry Browne
Clive Brunskill
Emma Bryant
Jon Buckle
Annie Bungeroth
Tessa Bunney
Richard Burbridge
Andrew Buurman
Brian Cassey
Angela Catlin
Gareth Cattermole
Jon Challicom
Dean Chapman
John Chapple
Dave Charnley
William Cherry
Wattie Cheung
Daniel Chung
CJ Clarke
Nick Cobbing
Caroline Cortizo
Jez Coulson
Ben Curtis
Eleanor Curtis
Simon Dack
Nick Danziger
James Darling
Prodeepta Das
Jason Dawson
James Deavin
Peter Dench
Adrian Dennis
Anthony Devlin
Nigel Dickinson
Kieran Dodds
Matt Dunham
Lucy Duval
Patrick Eden
Glenn Edwards
Stuart Emmerson
Mark Evans
Tony Feder
Tristan Fewings
Liz Finlayson
Tim Foster
Andrew Fox
Mike Fox
David Fraves
Stuart Freedman
Wilde Fry
Peter Fryer
James Robert Fuller
Christopher Furlong
Sam Furlong
Rob Gallagher
Kieran Galvin
Yishay Garbasz
George Georgiou
John Giles
David Gillanders
Cate Gillon
Trevor Gliddon
Martin Godwin
David Graham
Richard R. Grange
Ben Graville
Laurence Griffiths
Stuart Griffiths
Jonathan Guegan
Paul Hackett
Andy Hall
Alex Handley
Paul Harding
Austin Hargrave
Rebecca Harley
Graham Harrison
Gary Hawkins

Richard Heathcote
Mark Henley
Tim Hetherington
Michael Hewitt
James Hill
Jack Hill
Paul Hilton
Adam Hinton
Dave Hogan
Jim Holden
Kate Holt
Rip Hopkins
Jason P. Howe
Mark Howell
Richard Humphries
Jeremy Hunter
Mike Hutchings
Darrell Ingham
Caroline Irby
Chris Jackson
John James
Justin Jin
Reseph Keiderling
Clare Kendall
Des Kilfeather
Geoffrey Kirby
Dan Kitwood
Hilary Knox
Stan Kujawa
Nicola Kurtz
Kalpesh Lathigra
Bryn Lennon
Barry Lewis
Theodore Liasi
Sacha Lilla
Dominic Lipinski
Alex Livesey
Morag Livingstone
Paul Lowe
Mikal Ludlow
Amy Lyne
Peter Macdiarmid
Alex MacNaughton
Toby Madden
Fung-Wah Man
Paul Marriott
Guy Martin
Dylan Martinez
Leo Mason
Clive Mason
Jenny Matthews
Mary-Jane Maybury
Gerry McCann
Neil McCartney
Peter McCartney
Jamie McDonald
Bill McLeod
Colin Mearns
Toby Melville
Allan Milligan
Richard Mills
Jane Mingay
Rizwan Mirza
Jeff Mitchell
Najeeb Modak
Pramod Mondhe
Andrew Moore
Jeff Moore
Thomas William Morley
Eddie Mulholland
Gautam Narang
Peter Nicholls
Paul Nicholls
Lucy Nicholson
Ian Nicholson
Phil Noble
Simon Norfolk
Craig O'Brien
Heathcliff O'Malley
Charles Ommanney
Jeff Overs
Manu Palomeque
Fabio De Paola
Peter Parks
Nigel Parry
Andrew Parsons
Brijesh
Andrew Paton
Mark Pearson
John Perkins
Charles Pertwee
Celine Philibert
Steve Phillips
Tom Pietrasik
Tom Pilston
Olivier Pin Fat
Nick Ponty
Jonathan Pow

Gary Prior
David Purdie
Steve Pyke
Louis Quail
Lucy Ray
Simon Renilson
Gary Roberts
Simon C. Roberts
Graeme Robertson
Scott Robertson
Stuart Robinson
Mark Robinson
Paul Rogers
Bruce Rollinson
David Rose
Anita Ross Marshall
Dave Ruffles
Martin Ryan
Honey Salvadori
Oli Scarff
Mark Seager
Stephen Shepherd
Matt Shonfeld
Dominic Simmons
Jamie Simpson
Alex Smailes
Richard Smith
Tim Smith
David Smithson
Ewen Spencer
Michael Steele
Christopher Steele-Perkins
Dave Stewart
Tom Stoddart
Christopher Stowers
Tim Sturgess
Justin Sutcliffe
Sean Sutton
Jeremy Sutton-Hibbert
Ian Teh
Edmond Terakopian
Andrew Testa
Hazel Thompson
Mike Tipping
Kurt Tong
David Trainer
Abbie Trayler-Smith
Simon de Trey-White
Francis Tsang
Dominick Tyler
Ant Upton
Andy Vaines
Neelakshi Vidyalankara
Richard Wainwright
Howard Walker
Aubrey Washington
Zak Waters
Amiran White
Neil White
Lewis Whyld
Niva Whyman
Greg Williams
Vanessa Winship
Andrew Wong
John Wreford
Matt Writtle
Robert Yager
Alexander Yallop
Dave Young
Chris Young

URUGUAY
Leo Barizzoni
Gabriel Cusmir Cúneo
Giovanni Sacchetto
Quique Kierszenbaum
Pablo Porciúncula
Pablo Rivara

USA
Daniel Acker
Gabriel L.uis Acosta
Michael Adaskaveg
Lynsey Addario
Peter van Agtmael
Max Aguilera-Hellweg
Michael Ainsworth
Nabil Al-Jurani
Alaa al-Marjani
Jim Albright, Jr
Kwaku Alston
Stephen L. Alvarez
Joe Amon
Daniel A. Anderson
Kathy Anderson
Dave Anderson
Patrick Andrade
Ron C. Angle

Ryan Anson
Mario Anzuoni
Samantha Appleton
Michael Appleton
Charlie Archambault
Timothy Archibald
Ricardo Arduengo
Jason Arthurs
Glenn Asakawa
Kristen Ashburn
Christopher T. Assaf
Lacy Atkins
Giovanni Auletta
Ara Ayer
Brian Baer
Frank W. Baker
Shawn Baldwin
Karen Ballard
Ballas
Roger Ballen
Marice Cohn Band
Leslie Barbaro
Jeffrey Barbee
Candace B. Barbot
Jim Bartlett
David Bathgate
Will Baxter
Liz O. Baylen
Max Becherer
Natalie Behring
Al Bello
Hakob Berberyan
Paul J. Bereswill
David Bergman
Ruediger Bergmann
Nina Berman
Alan Berner
Adam Berry
Brian Bielmann
Keith Birmingham
Mark Black
Victor James Blue
Michael Bonfigli
Meggan Booker
Peter Andrew Bosch
Mark Boster
Khampha Bouaphanh
Gilbert R. Boucher II
Dana René Bowler
Rick Bowmer
Gary Braasch
Heidi Bradner
Alex Brandon
Scott Brennan
William Bretzger
Thomas Broening
Kate Brooks
Frederic J. Brown
Michael Brown
Tiffany Brown
Milbert O. Brown Jr.
Andrea Bruce
Brian van der Brug
Simon Bruty
Vernon Bryant
Khue Bui
Gregory Bull
Jeff Bundy
Joe Burbank
Gerard Burkhart
David Burnett
David Butow
Brett Butterstein
Renée C. Byer
Zbigniew Bzdak
Dennis P. Callahan
Mary Calvert
Billy Calzada
Alicia Wagner Calzada
D. Ross Cameron
Steve Campbell
Dyana Van Campen
Marc Campos
Nyxolyno Cangemi
Robert Caplin
Christopher Capozziello
Lou Capozzola
Jason Carrier
Antrim Caskey
Natalie Caudill
Joe Cavaretta
Sean Cayton
Ken Cedeno
Lee Celano
Bruce Chambers
Gus Chan
Bryan Chan
Tim Chapman

Richard A. Chapman
Tia Chapman
John Chapman
Jake Chessum
Alan Chin
Paul Chinn
Ringo Chiu
Ben Chrisman
Andre Chung
Chien-Min Chung
Christopher Chung
Mary Circelli
Lionel Cironneau
Matthias Clamer
John Clark
Lashinda Clark
Jay Clendenin
Douglas R. Clifford
Bradley E. Clift
Jodi Cobb
Victor José Cobo
Stephen J. Coddington
Carolyn Cole
Jed Conklin
Frank H. Conlon
Fred R. Conrad
Kevin Cooley
Dean Coppola
Thomas R. Cordova
Ron Cortes
Carl Costas
Daniel J. Cox
Andrew Craft
Bill Cramer
Bill Crandall
Chris Crisman
Manny Crisostomo
Ed Crisostomo
Bob Croslin
Stephen Crowley
Chris Curry
Anne Cusack
Bassem Daham
Jim Damaske
Dang Ngo
Meredith Davenport
Bruce Davidson
Amy Davis
Willie Davis
Sam Dean
Roger Deccker
James Whitlow Delano
Louis DeLuca
Lou Dematteis
Chris Detrick
Charles Dharapak
Stephanie Diani
Al Diaz
Stephen Digges
Timothy Dillon
Jessica Dimmock
Kevork Djansezian
Gino Domenico
Nellie Doneva
Larry Downing
Jonathan Drake
Carolyn Drake
Karen Ducey
Michel DuCille
Lori Duff
Brett Duke
David Duprey
Robert Duyos
Lilly Echeverria
Charles Eckert
Aristide Economopoulos
Michael Edwards
Scott Eells
Debbie Egan-Chin
Bruce Ely
Douglas Harrison Engle
Ronald W. Erdrich
Jonathan Ernst
Jason Eskenazi
Josh Estey
James Estrin
Jim Evans
Gary Fabiano
Timothy Fadek
Steven M. Falk
Chris Faytok
Gina Ferazzi
Gloria Ferniz
Jonathan Ferrey
Karl Merton Ferron
Stephen Ferry
Rob Finch
Brian Finke

Ted Fitzgerald
Deanne Fitzmaurice
Mikel Flamm
Kate Flock
Kathleen Flynn
Lloyd Fox
Tom Fox
Bill Frakes
Ric Francis
Jamie Francis
Danny Wilcox Frazier
Ruth Fremson
Stacie Freudenberg
Frey
Adam Friedberg
Noah Friedman-Rudovsky
Rich Frishman
Susanna Frohman
Nicole Frugé
Ana Elisa Fuentes
Jason Fulford
David Furst
Hector Gabino
Julia Gaines
Robert Galbraith
Wyatt Gallery
Erin Galletta
Kathleen Galligan
Preston Gannaway
Juan Garcia
Marco Garcia
Mark Garfinkel
Ben Garvin
Robert Gauthier
Eric Gay
Jim Gehrz
Kevin Geil
Sharon Gekoski-Kimmel
Catrina Genovese
Jim Gensheimer
Hugh Gentry
Fred George
Rick Gershon
Bruce Gilbert
Kent Gilbert
Mark Gilchrist
Thomas E. Gilpin
Matthew Gilson
Penni Gladstone
Sarah J. Glover
Jose Goitia
David Goldman
Scott Goldsmith
Chet Gordon
Bridget Besaw Gorman
Mark Gormus
Michael Goulding
Jeff Grace
Ronna Gradus
Chris Granger
Michael Grecco
Jill Greenberg
Stanley Greene
Lauren Greenfield
Mike Greenlar
Sergei Grits
Karl Grobl
Norbert von der Groeben
Daniel J. Groshong
David I. Gross
David Grunfeld
Jorgen Gulliksen
Joshua Gunter
CJ Gunther
Barry Gutierrez
David Guttenfelder
Carol Guzy
Bill Haber
Dan Habib
Gerry Hadden
Sean M. Haffey
Robert Hallinen
Scott S. Hamrick
Mark M. Hancock
Richard Alan Hannon
Andrew Harrer
Mark Edward Harris
David Hartung
Nanine Hartzenbusch
Ron Haviv
Alexei Hay
Jeff Haynes
Gregory Heisler
Todd Heisler
Andrew Henderson
Mark Henle
Helen L. Montoya
Brian Henry

yler Hicks
rik Hill
than Hill
ros Hoagland
velyn Hockstein
ritz Hoffmann
eremy Hogan
im Hollander
David S. Holloway
Chris Hondros
Kevin Horan
Brad Horrigan
ugene Hoshiko
Rose Howerter
Dan Hubbell
Aaron Huey
Heather S. Hughes
Nathan Hunsinger
ason Hunt
Ellison Vasha Hunt
Thomas James Hurst
effrey Daniel Hutchens
Ethan Hyman
Andrew Innerarity
Walter Iooss, Jr.
Nasser Ishtayeh
Lance Iversen
Ted Jackson
S.N. Jacobson
Terrence Antonio James
Rebecca Janes
Kenneth Jarecke
Lawrence Jenkins
Angela Jimenez
Lynn Johnson
Mark Allen Johnson
Lisa Johnson
Barbara Johnston
Christie Johnston
David Joles
Bonnie Josephson
Lisa Kahane
Nikki Kahn
Michael Kamber
Nicholas Kamm
Mike Kane
Sylwia Kapuscinski
Anthony Karen
Ed Kashi
Carolyn Kaster
Nancy Kaszerman
Andrew Kaufman
Chris Kaufman
Edward Keating
Scott Keeler
Michael Kelley
Caitlin M. Kelly
Bryan Kelsen
Mike Kepka
Asia Kepka
Laurence Kesterson
Yunghi Kim
John J. Kim
John Kimmich-Javier
Robert King
Scott Kingsley
Jed Kirschbaum
Paul Kitagaki, Jr
Katherine Kiviat
Torsten Kjellstrand
Heinz Kluetmeier
David E. Klutho
Kim Komenich
Jim Korpi
Brooks Kraft
Benjamin Krain
Lisa Krantz
Suzanne Kreiter
Sara Krulwich
Charles Krupa
S. Mahesh Kumar
Amelia Kunhardt
Teru Kuwayama
Stephanie Kuykendal
Vincent Laforet
Christopher LaMarca
Kevin Lamarque
Ken Lambert
André Lambertson
Rodney Lamkey, Jr.
Nancy Lane
Justin Lane
Jerry Lara
Rikard Larma
Adrees Latif
B. Conrad Lau
Gillian Laub
Michael Laughlin

David Lauridsen
Jim Lavrakas
Tony Law
Jared Lazarus
Streeter Lecka
Daniel LeClair
Chang W. Lee
James Lee
Sarah Meghan Lee
Neil Leifer
Mark Lennihan
Josie Lepe
James Lerager
Paula Lerner
Will Lester
Catherine Leuthold
Andy Levin
Mike Levin
Heidi Levine
Mike Levy
William Wilson Lewis III
Andrew Lichtenstein
Ariana Lindquist
Edward Linsmier
Steve Liss
Scott Lituchy
Jim Lo Scalzo
John Lok
David Longstreath
Brad N. Loper
Monica Lopossay
Mark M. Lorenz
Benjamin Lowy
Robin Loznak
Pauline Lubens
Gerd Ludwig
Richard Lui
Eric Luse
William Luther
Lutton, Matt
Joshua Lutz
Patsy Lynch
John Mabanglo
Jim MacMillan
Jeffrey MacMillan
Michael Macor
M. Scott Mahaskey
Joe Mahoney
David Maialetti
John Makely
Michael Maloney
Jeff Mankie
Mary Ellen Mark
Dan Marschka
Dave Martin
Pablo Martinez Monsivais
Charles Mason
Marianna Massey
AJ Mast
Edgar Mata
Peter Matthews
Rob Mattson
Matt May
Robert Mayer
Aric Mayer
Clay Patrick McBride
Nicholas Hegel McClelland
Darren McCollester
Linda McConnell
John McConnico
Cyrus McCrimmon
John McDonough
Benjamin J. McElroy
Rick McKay
Clay McLachlan
W. Ted McLaren
Robert McLeroy
Win McNamee
David McNew
Donna McWilliam
Michael Melford
Eric Mencher
Ms Sheryl Mendez
Jim Merithew
Justin Merriman
Nhat V. Meyer
Emily Michot
Boogie
Peter Miller
Greg Miller
Matt Miller
Lester J. Millman
Doug Mills
Donald Miralle, Jr.
Hadi Mizban
Samir Mizban
Logan Mock-Bunting
Khalid Mohammed

Andrea Mohin
Genaro Molina
M. Scott Moon
John Moore
Andrew Moore
Zayra Morales
Jose M. More
Abelardo Morell
Emilio Morenatti
P. Kevin Morley
Christopher Morris
Toby Morris
Graham Morrison
Peter Morrison
Muhammed Muheisen
Michael Mulvey
Vincent Musi
Myung Chun
James Nachtwey
Adam Nadel
Ana Nance
Donna E. Natale Planas
Scott Nelson
Andy Nelson
Robin Welson
Gregg Newton
Ray Ng
Jehad Nga
Bao Oanh Nguyen
James Nielson
Kyle Niemi
Zia Nizami
John Nordell
John O'Boyle
Michael O'Neill
Stephanie Oberlander
Charlotte Oestervang
Eyal Ofer
Eric Ogden
Scott Olson
Randy Olson
Dale Omori
Metin Oner
Francine E. Orr
José M. Osorio
L.M. Otero
Kevin Oules
Will van Overbeek
Darcy Padilla
Brian Palmer
Aldo Panzieri
Nancy Pastor
Bryan Patrick
Sarah Smith Patrick
Pete Pattisson
Frank Payne
Peggy Peattie
John Pendygraft
Michael Perez
Lucian Perkins
Fredy Perojo
Brian Peterson
Andrew Phelps
David J. Phillip
Melissa Phillip
Holly Pickett
Terry Pierson
Chad Pilster
Platon
Spencer Platt
Suzanne Plunkett
James Pomerantz
Smiley Pool
Wes Pope
Pedro Portal
Michelle Posey
Carol T. Powers
Carrie Pratt
Joshua Prezant
Jake Price
Jacob Pritchard
Richard Michael Pruitt
Gene J. Puskar
Bill Putnam
Joe Raedle
Asim Rafiqui
Ramin Rahimian
Reed Rahn
Matt Rainey
Mark Randall
Jim Rassol
Pat Ratliff
Prof. Steven L. Raymer
Lucian Read
Jerry Redfern
Jim Reed
Mona Reeder
Barry Reeger

Tom Reese
John H. Reid III
Dusan Reljin
Tim Revell
Damaso Reyes
Reynolds
Eugene Richards
Helen H. Richardson
Phil Rider
Theo Rigby
Molly Riley
Joe Rimkus
Jessica Rinaldi
Steve Ringman
Aivlis Sofia Rios Villanueva
Josh Ritchie
Michael Robertson
Katherine Robertson
Michael Robinson-Chávez
Paul E. Rodriguez
Rickey Rogers
Dana Romanoff
Oleg Romanov
Bob Rosato
Carrie Rosema
Matthew Rosenberg
Jenny Ross
Jeffrey L. Rotman
Michael Rubenstein
Mario E. Ruiz
Benjamin Lee Rusnak
Jeffrey Russell
Orin Rutchick
David L. Ryan
Robert Sabo
Jeffery A. Salter
Scott Saltzman
Amy Sancetta
RJ Sangosti
Joel Sartore
April Saul
Howard Schatz
Michael Schennum
Erich Schlegel
Chris Schneider
Jake Schoellkopf
Heidi Schumann
Jim Scolman
David Scull
Eric Seals
Camille Seaman
Evan Semon
Richard Sennott
William Serne
Marc Serota
Gregory Shaver
Scott Shaw
Ezra Shaw
Callie Shell
Allison Shelley
Reena Rose Sibayan
Jacob Silberberg
Denny Simmons
Meri Simon
Taryn Simon
Stephanie Sinclair
Luis Sinco
Keith Sirchio
Ben Sklar
John Slavin
Matt Slocum
Bryan Smith
Brett K. Snow
Brian Snyder
Bahram Mark Sobhani
Brian Sokol
Armando Solares
Lara Solt
Chip Somodevilla
Alec Soth
Pete Souza
Stacia Spragg
Jonathan Sprague
Fred Squillante
Jamie Squire
Clayton Stalter
John Stanmeyer
Shannon Stapleton
R. Marsh Starks
Susan Stava
Maggie Steber
Sharon Steinmann
George Steinmetz
Lezlie Sterling
Chris Stewart
Thomas C. Stewart
Sean Stipp
Mike Stocker

Robert Stolarik
Wendy Stone
Matt Stone
Saul Stoogenke
Scott Strazzante
Art Streiber
David Strick
Joanne Rathe
Bruce C. Strong
Bob Strong
Essdras Suarez
Anthony Suau
Robert Sullivan
Justin Sullivan
Dan Sullivan
Matt Sumner
Akira Suwa
Chitose Suzuki
Rob Sweeten
Joseph Sywenkyj
Shannon Taggart
Paul Taggart
Ramin Talaie
Mario Tama
Teresa Tamura
Adam Tanner
Naomi Solomon
Ross Taylor
David Teagle
Patrick Tehan
Alex Tehrani
Michael Tercha
Mark J. Terrill
Sara Terry
Ted Thai
Shmuel Thaler
Brandon Thibodeaux
Irwin Thompson
Stephen B. Thornton
Scott Threlkeld
Thu Hoang Ly
Al Tielemans
Lonnie Timmons III
Peter Tobia
Amy Toensing
Jonathan Torgovnik
Pierre Tostee
Alan Traeger
Charles Trainor, Jr
Erin Grace Trieb
Linda Troeller
Alessandro Trovati
Terry Tsiolis
Richard Tsong-Taatarii
Scout Tufankjian
Peter Turnley
Susan Tusa
Jane Tyska
Mohammed Uraibi
Gregory Urquiaga
Chris Usher
Nuri Vallbona
John VanBeekum
Raul Vasquez
Bryce Vickmark
Alejandra Villa
José Luis Villegas
Ami Vitale
Nicholas Von Staden
Stephen Voss
Fred Vuich
Kat Wade
Chriss Wade
Diana Walker
Craig Walker
Jim Walker
Mark Wallheiser
E. Jason Wambsgans
Emile Wamsteker
Ting-Li Wang
Steve Warmowski
Jennifer Warren
David M Warren
Lannis Waters
Guy Wathen
Billy Weeks
Apichart Weerawong
Laura Weisman
Diane Weiss
Nathaniel Welch
Candace West
Brad Westphal
Glen Wexler
Thomas Whisenand
Kimberley White
John L. White
Max Whittaker
John Wilcox

Rick T. Wilking
Avedon William
Anne Chadwick Williams
Holly Wilmeth
Mark Wilson
Lisa Wiltse
Terry Winn
Damon Winter
Vincent Winter
Dan Winters
Michael S. Wirtz
Thomas E. Witte
Patrick Witty
Mandi Wright
Taro Yamasaki
Mitsu Yasukawa
Dave Yoder
Matt York
Craig A. Young
Stefan Zaklin
Mark Zaleski
Zdon
Jeff Zelevansky
Chris Zuppa

UZBEKISTAN
Vladimir Jirnov

VENEZUELA
Kike Arnal
Hernández Augusto
Juan Barreto
Fernando Bonet
Larry Camacho
Joaquin Cortes
Joaquin Ferrer
Galindo
Freddy Henriquez
Juan Carlos Hernandez
Leo Liberman
Jacinto Jose Oliveros Perez
Carlos Ramirez
Efrain Vivas

VIETNAM
Dang Van Tran
Doan Duc Minh
Tuan Hai Hoang
Hoang Quoc Tuan
Hoang Xuan Tri
Huynh Tri Dung
Huynh My Thuan
Huynh Nhu Luu
Lê Hoài Nam
Le Anh Tuan
Thai Son
Luong Van Hung
Luong The Tuan
Luu Thuan Thoi
Ly Hoang Long
Ngo Huy Tinh
Duc Can Ngo
Ngo My
Nguyen Ngoc Hai
Nguyen Dinh Hai
Nguyen Huynh Mai
Pham A'nh
Pham Ba Thinh
Pham Thi Kim Thanh
Pham Thi Ai Nghia
Pham Thi Thu
Tran Huu Cuu
Tran Ky
Tran Phong
Anh Tuan

ZAMBIA
Thomas Nsama
Timothy Nyirenda
Henry Salim

ZIMBABWE
Howard Burditt
Alexander Joe
Tsvangirayi Mukwazhi
Danai Nyamuchengwa

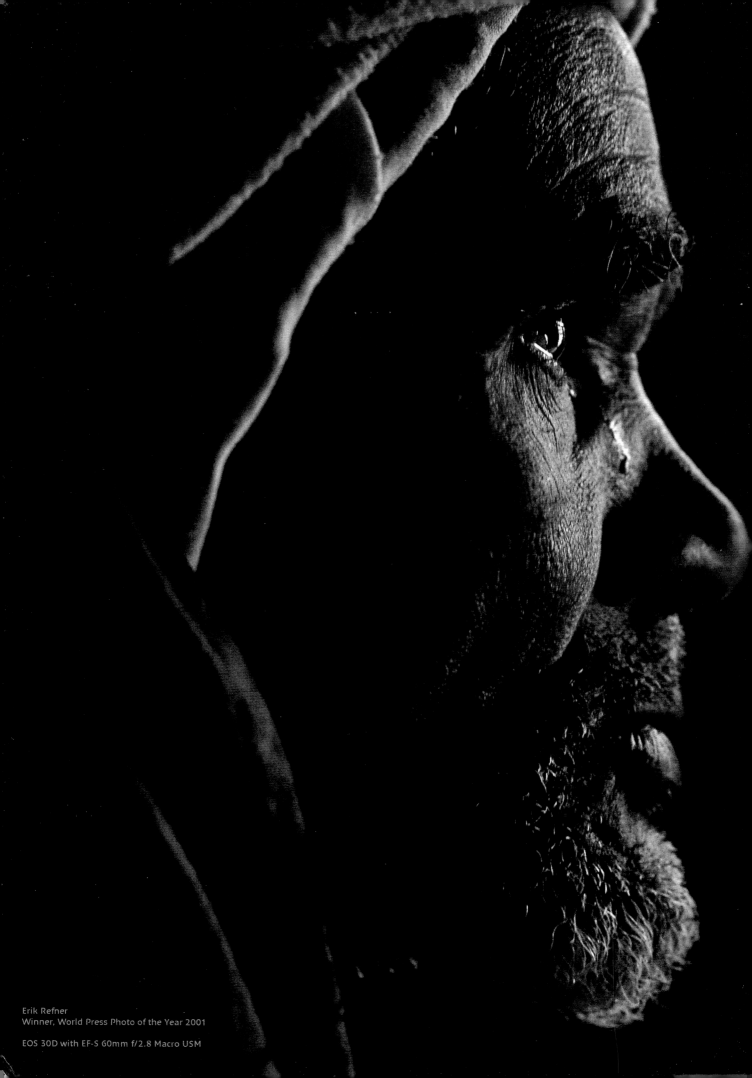

Erik Refner
Winner, World Press Photo of the Year 2001

EOS 30D with EF-S 60mm f/2.8 Macro USM